The LIGHTING Cookbook

The LIGHTING Cookbook

Jenni Bidner

Foolproof Recipes for Perfect Glamour, Portrait, Still Life, and Corporate Photographs

AMPHOTO BOOKS
New York

Acknowledgments

This book was made possible through the generosity of six photographers, Eric Bean, Harvey Branman, Alan Farkas, Bobbi Lane, Robert Thien, and Meleda Wegner. They not only provided their photographs, but also gave their candid insights and valuable time during countless interviews. I greatly appreciate their willingness to share their techniques, artistry, and "trade secrets."

I also wish to thank the many models whose pictures grace the pages of this book.

And many thanks to my husband, Jeff Antonelli, who was a computer widower while I worked on this book.

Jenni Bidner is the owner of Bidner Communications, a company specializing in public relations. She is also currently the East Coast Editor of *Petersen's Photographic* magazine. Before starting her own business in 1995, she held the top editorial position at the magazine. Bidner is also a former account supervisor at Bozell Worldwide and the former Editor-in-Chief of *Outdoor & Travel Photography* magazine. Her photographs have been published in numerous magazines, newspapers, and books in the United States and abroad, including *Sierra*, *Walking*, and *The Miami Herald*. She earned a bachelor of science degree in professional photography from the Rochester Institute of Technology.

Senior Editor: Robin Simmen
Editor: Liz Harvey
Designer: Jay Anning
Production Manager: Ellen Greene

The equipment pictures on pages 13–21 appear courtesy of Calumet Photographic, Inc.

Copyright © 1997 by Jenni Bidner
First published 1997 in New York by Amphoto Books,
an imprint of Watson-Guptill Publications,
a division of BPI Communications,
1515 Broadway, New York, NY 10036

Each photograph appearing in this book is copyrighted in the name of the individual photographers. The rights remain in their possession.

Library of Congress Cataloging in Publication Data

Bidner, Jenni.
 The lighting cookbook : foolproof recipes for perfect glamour,
portrait, still life, and corporate photographs / by Jenni Bidner.
 p. cm.
 Includes index.
 ISBN 0-8714-4196-4 (pbk.)
 1. Photography—Lighting. I. Title.
TR590.B55 1997 96-51982
778.7'2—dc21 CIP

Picture information:

© Eric Bean: pages 24 (2), 26 (3), 27, 28, 29 (2), 31, 38, 39 (3), 40, 41, 42 (2), 43, 49, 50, 51, 52

© Harvey Branman: pages 33, 47, 48

© Alan Farkas: pages 61, 62, 64, 75, 82, 83, 87, 89 (2), 90, 91, 92, 96, 98, 99, 101, 102, 104, 105 (2), 106, 110, 123, 124, 125, 135, 136 (2), 140, 141, 142

© Bobbi Lane: pages 2–3, 8–9, 10–11, 25, 34, 35, 37, 45, 53 (2), 63, 67 (2), 68, 69 (2), 70–71, 73, 76 (top), 79, 80 (2), 81, 84 (2), 85, 88, 94–95, 108, 109, 111 (2), 112, 113, 114, 115, 116, 117, 118, 119 (2), 133, 134, 137 (2), 139

© Robert Thien: pages 1, 126–127, 128, 129, 130 (3), 131, 132 (2)

© Meleda Wegner: pages 22–23, 46, 55, 56, 57 (2), 58, 59 (3), 60, 65, 76 (bottom), 77, 97 (3), 121, 122 (2), 138

This book is dedicated to my father, Robert Bidner, who helped me take my first photographs with his Argus C3 before I could even write a sentence; and to my mother, Jo Heinritz Bidner, who helped me to finally write that first sentence! I thank you both for always encouraging me in my artistic and professional endeavors.

CONTRIBUTORS

Eric Bean is a New York-based fashion photographer. His photographs have appeared in numerous magazines, and he has worked for most of the major modeling agencies.

Harvey Branman is a portrait and wedding photographer in Burbank, California, where he owns and operates a storefront business called Photography as an Art.

Alan Farkas is a professional photographer from Rochester, New York, who works in both advertising and fine-art photography. His professional clients range from small local companies and Fortune 500 corporations, to business magazines and advertising agencies. Farkas is a frequent lecturer at the Rochester Institute of Technology and is Co-President of the Western New York chapter of the American Society of Media Photographers (ASMP).

Bobbi Lane is both an award-winning commercial and travel photographer and a highly respected photography instructor. She was recently named a UCLA Teacher of the Year. Her stock and assignment pictures have been published globally in advertisements, magazines, films, and other media. Lane's clients include AT&T, Blue Cross, Boeing, GTE, and Mattel.

Robert Thien is a professional architectural photographer whose home base is Atlanta, Georgia. His clients include many of the Southeast's best architects and design firms. He has an exclusive contract with *Architectural Digest* to cover the South, and he is a regular freelancer for *Atlanta Homes & Lifestyles* magazine.

Meleda Wegner is a commercial, fine-art, and editorial photographer based in New York City and Tampa, Florida. Her images are regularly used in magazines, advertisements, and public-relations capacities.

CONTENTS

INTRODUCTION

Photography is an interesting mix of pure artistry and technical science. Of course, everyone gets lucky once in a while, but if you lack an understanding of the "hows" and "whys" of your equipment, film, and lighting, successful photography will be a hit-or-miss proposition for you. And without an instinctive or learned creative understanding of composition, color, and artistry, you won't be able to achieve consistently great shots.

Six photographers who masterfully integrate technique and artistry have worked with me to provide the game plan for more than 40 studio-lighting techniques. These pros reveal in step-by-step detail how they made the photographs presented here, and how you can produce similar images on your own.

This book consists of dozens of their "recipes for success." But as every good cook knows, there is far more to being a gourmet chef than just copying someone else's recipe down to the last grain of salt. The best cooks use a recipe as a starting-off point, from which they let their own creativity spring. Eventually they develop the instincts and know-how that free them from relying on others' recipes.

This cooking metaphor prompted me to call this *The Lighting Cookbook.* It is my goal that these recipes will help to interest you in many types of photography you might never have considered trying or have never had success with. Wherever possible, I've tried to provide insights into the thought processes that went into each picture. By learning why a photographer made a certain choice regarding lighting or composition, you can begin to understand how to make the right decisions in your own studio—decisions that will result in great pictures on a regular basis.

Please remember that these recipes aren't meant to be definitive. For example, the animal-lighting method described here is by no means the only possible approach. But it is a tried-and-true technique that will get your ideas off the back burner, as well as give you an excellent chance of success.

Part One

THE WELL-STOCKED STUDIO

WALK INTO THE STUDIOS of a number of professional photographers, and you'll be surprised to find so many of the same pieces of equipment. True, a variety of manufacturers make photographic equipment, and some photographers even make their own gear. Nevertheless, the equipment is similar in quite a few ways.

In this chapter, I'll introduce you to types of equipment found in many studios. Depending on your photographic specialties and aspirations, you might not ever need some of the products. Others, you'll choose to invest in, borrow, or rent when necessary. Either way, you should at least learn what each of these items is so you can understand how they can help you in your photographic efforts.

GATHERING THE INGREDIENTS

Cameras and Lenses

The well-stocked studio starts with quality cameras, whether you choose to use state-of-the-art, automated equipment or 20-year-old gear you purchased second-hand. Most photographers have several different cameras (and camera formats) that they switch between depending on the type of image they're shooting. Some professional photographs, such as fashion and glamour, can be shot with 35mm or medium-format cameras. Other images, especially ones that show still lifes and architectural interiors, are best made with one, or more, large-format view cameras. But to know exactly what you need, you must know what is available. This part of the book provides an overview of many of the popular camera formats, lens types, and camera accessories.

Bellows

The standard bellows is an accordion-type structure that stretches from the film plane to the lensboard on a view camera, creating a light-tight tunnel for light to pass through. This bellows is flexible enough for you to move, stretch, and compress during focusing and view-camera movements. A bag bellows enables you to shoot with wide-angle lenses because there is less distance between the front and back standards. An extension bellows allows for close focusing, and a macro bellows designed for some 35mm and medium-format cameras also facilitates close focusing.

Extension Rail

This device lets you move view-camera standards farther apart than usual.

Film Holder

A view camera utilizes a film holder that holds one sheet of film on each side, unlike a 35mm camera, which calls for rolls of film. The advantage of this is that you can either process one sheet of film at a time, or transfer the film holder from one camera to the next for a multiple-camera setup.

Flat-Field Lens

If you plan to do a lot of copy work, a flat-field lens might be a good investment. This type of lens is corrected specifically for photographing subjects that are exactly parallel to the film plane.

Focusing Screen

This piece of groundglass or other material "catches the light" and shows the image that is coming through the camera lens.

Intenscreen

This is a brand name for a kind of focusing screen that is brighter than the typical groundglass variety.

Polaroid Back

This device is an interchangeable film holder for a view camera, or a camera back for medium-format cameras and sometimes 35mm cameras. Depending on the model, you can make Polaroid single-sheet or pack-film test prints with the same camera that shoots conventional film. This is incredibly helpful when you want to check exposures or show an art director or client the photographs before you process the final film.

Rollfilm Back

Unlike a standard 4 x 5 film holder, this device lets you shoot 120- or 220-format film with a 4 x 5 view camera.

Shifts

These view-camera movements, of either the lensboard or the film plane in relation to each other, cause the image to shift on the groundglass without your tilting the camera. As such, architectural photographers use view cameras because the cameras enable them to shoot a tall building without having to position the camera at an obtuse angle. A few medium-format and 35mm cameras offer limited shift capabilities.

Soft-Focus Lens

If you plan on doing a lot of soft-focus effects, you should consider buying a soft-focus lens; this lens works better than so-called soft-focus filters or diffusion filters. You can "dial in" soft focus, which creates more spherical aberration. This, in turn, results in a sharp image surrounded by a soft halo.

Swings and Tilts

A swing is a view-camera movement that involves the side-to-side rotation of the lensboard or film plane around a vertical axis. Conversely, a tilt calls for rotation of the lensboard or film plane around a horizontal axis. Both movements affect the final image. Rear swings and tilts (of the film plane) can alter the shape of the image and cause the convergence or separation of lines. Front swings and tilts (of the lensboard) can alter the plane of sharp focus.

View Camera

This is the camera that architectural and studio photographers commonly use. It is indispensable because of various movements that can alter an image's shape,

placement on the film, and focus plane. These are also called *field cameras*. View cameras come in 4 x 5-, 5 x 7-, and 8 x 10-inch formats, among others. The large-size film is a big benefit in commercial applications. Rollfilm backs, Polaroid backs, and hundreds of accessories make these cameras very versatile.

Lighting Equipment and Accessories

Lighting is the heart and soul of photography, whether the light is natural, modified, or completely artificial. Artificial lighting comes in many "flavors," from tungsten, quartz, and flash, to fluorescent, sodium vapor, and more. Each type of light source has different characteristics and "colors." Regardless of which kind of light photographers are working with, they can modify it via the use of such gear as diffusion materials, gobos, and reflectors. Photographers have many important lighting tools at their disposal.

Barndoors
These are small, matte-black doors attached to light heads on either two sides or four sides. You can open or close each door to varying degrees to help block light from certain parts of a set.

Black Card
This is a great studio tool for "cutting" down a light and preventing it from hitting specific parts of a set. You can also use black cards to reduce reflections. They can be made of black Fome-Cor, matboard, or other materials found in art-supply stores.

Bookend
This accessory consists of two large flats hinged together. When opened like a book, they stand by themselves, creating a V-shaped reflector. Many photographers paint one side white for fill, and the other side black to block light.

Boom Arm
This is a long arm attached to a lightstand. Photographers often use boom arms to hold lights, scrims, and other light modifiers at a high angle, or to dangle these pieces of lighting equipment over a set from a distance.

Cinefoil
This is the brand name for a product that is tied for the title of "Photographer's Best Friend" with gaffer's tape. Cinefoil looks like super-thick tinfoil that is matte black in color. It comes in a tinfoil-like roll, but it costs a comparative fortune (about $25). Cinefoil is worth the price, however: its matte color controls flare and bouncing light; its thickness lets you mold it into

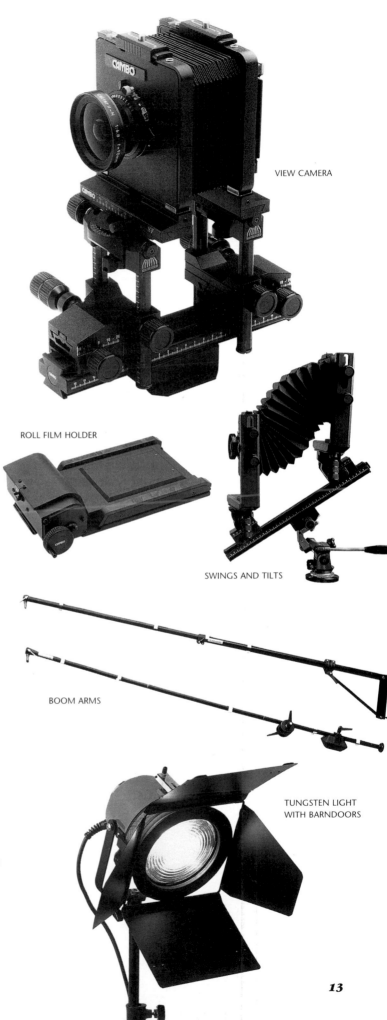

VIEW CAMERA

ROLL FILM HOLDER

SWINGS AND TILTS

BOOM ARMS

TUNGSTEN LIGHT WITH BARNDOORS

13

almost any shape; and it is, of course, fire-resistant. Cinefoil is most commonly used as a homemade snoot. Another version of Cinefoil, which is white on one side and black on the other, is available.

Color-Compensating (CC) Filters

These filters are handy for fine-tuning color balance when color rendition is important. They are available in three primary colors (red, green, and blue) and three complementary colors (cyan, magenta, and yellow). Photographers use these filters to match one film emulsion to another, to correct for a color-balance shift, and to correct light with the "wrong" color temperature, as well as for other color-control functions.

Color Meter

This kind of meter reads the color temperature of a light source, so you can predict what color it will record as on a particular type of film. For example, 3200K tungsten bulbs record as neutral on tungsten-based films but look extremely yellow on daylight films. Since the human eye adjusts itself to neutral within seconds of viewing a different light source, a meter is handy for judging the colors.

Color Temperature

Different light sources have different color temperatures. The human brain, however, has "automatic white balance," which causes you to automatically see slight variations of light as neutral. For example, if you're wearing greenish sunglasses (filtered), everything will look pink for a few moments when you take them off until your brain can get used to the new (unfiltered) color cast. But film doesn't have the ability to readjust itself, so lights of different color temperatures will appear as different colors on film—even if they look the same to you. You can control this in the final image by carefully selecting your film, using filters on both your camera and the lights, turning certain lights on and others off, using multiple exposures (with different filters during the different exposures), overpowering the scene with another type of lighting (so the first is insignificant), or by combining several of these methods.

Conversion Filters

These filters convert tungsten light (3200K) to a daylight balance (5500K), and vice versa, to match your film in use. CTO (orange) gels are designed to be put over windows or flash heads when you shoot tungsten film, while CTB (blue) gels are designed to be placed in front of tungsten and quartz-halogen light sources when you shoot daylight film. If you prefer to filter your camera, use an 85B filter with tungsten films in daylight, or an 80A filter with daylight films in tungsten lighting.

Cooling Filters

Filters that have a blue color are considered to be cooling filters. This is because people associate the color blue with "cold" or "cool" feelings; reds and yellows, on the other hand, suggest "warm" feelings. Cooling filters for lights come in 100K and larger increments. Cooling filters for camera lenses are the 82-series filters.

CTB Gel

A CTB (color temperature blue) gel is a blue gel or filter designed for use in front of tungsten and quartz-halogen light sources to convert them to daylight balance.

CTO Gel

A CTO (color temperature orange) gel is an orange gel or filter designed to be put over windows or flash heads when working with tungsten film.

Cutter

This is a black card or black gobo used to "cut" a light down, blocking some of its illumination from hitting the set.

Diffuser

This is any translucent material placed between the light and the subject. Diffusers are used to soften the light. The front panel of a softbox, for example, is a diffuser.

Diffusion Filters

These filters produce soft images by bending some, but not all, of the light rays. This produces an unsharp image (bent rays) overlaid with a sharp image (unbent rays). Don't confuse diffusion filters with fog filters.

81-Series Warming Filters

This series of filters for the camera is designed to add warm tones in the form of a slight orange cast to a picture, or to correct a cool, or bluish, cast. Warming filters for lights come in 100K and larger increments.

82-Series Cooling Filters

A series of filters for the camera designed to add cool tones (a slight bluish) to a picture, or to correct a warm (orange) cast. Cooling filters for lights come in 100K and larger increments.

Fiber Optics

This new technology enables light to be bent and directed through tiny, flexible tubes.

Finger

This is a long, narrow, finger-shaped gobo or reflector card.

Flash Bracket

This system is designed to hold on-camera flash units or other small flash units slightly off the camera axis. Off-axis flash is generally more pleasing than on-camera flash and prevents the red-eye problem. Photographers use flash brackets when they need something more portable than a monolight or studio unit, yet stronger and more versatile than most on-camera flash units.

Flash Head

This is the portion of the flash unit that includes the flash tube and sometimes a cooling fan and small reflector. Monolights and on-camera accessory flashes have the flash head built into the power unit. Studio-style flash units have separate powerpacks that enable the heads to fit in smaller spaces and be lighter.

Flat

This is any large reflector or gobo that has legs or a wide enough base to let it stand by itself.

Flexfill

This is the brand name for collapsible, disc-shaped reflectors. They fold down to about 1/3 their full size.

Focusing Spot

This is a hot light or flash head with a focusing lens on it, for aiming the light in a precise direction.

Fog Filters

These filters make a scene look foggy by scattering the light. This, in turn, softens the image, lowers the contrast, mutes the colors, and produces soft halos around light sources. Don't confuse fog filters with diffusion filters. Fog filters are available in more than one strength. You can also vary the outcome with your choice of aperture and exposure. Wide-open apertures increase the effect, as does overexposure.

Fome-Cor

This is a brand name for a rigid, foam-like product sandwiched between two pieces of laminated paper to create a hard sheet of varying thicknesses. The most common Fome-Cor color is white, although black and other colors are available.

Fresnel Lens

This type of lens is used to focus spotlights.

Gel

A gel is a colored acetate or other material used for correcting color shifts or adding color to a light. Heat-resistant gels can be used near light fixtures. Quality gels are available in exact filtrations. Optically corrected gels are used for camera filtration.

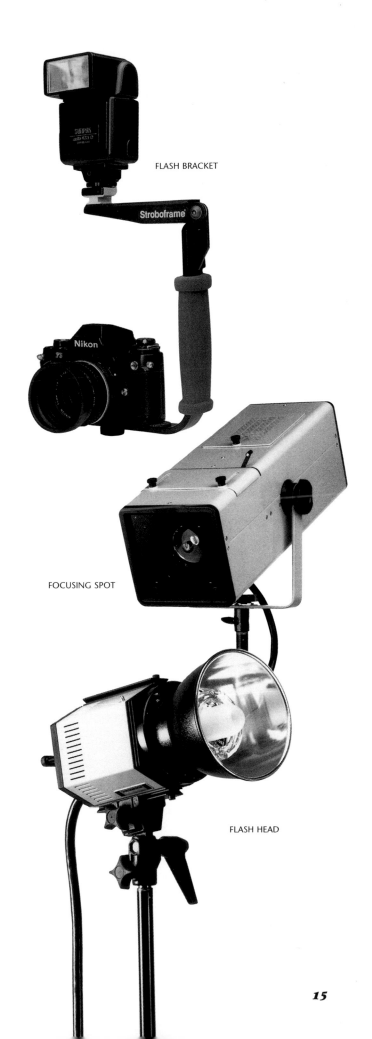

FLASH BRACKET

FOCUSING SPOT

FLASH HEAD

Gobo

This light modifier is placed between the light and the subject in order to create shadows, reduce reflections, or shade the camera lens from the potential of flare. Gobos can be made out of almost any opaque object, but most commonly they're cut from pieces of black cardboard or matte-black metal. Small gobos are called "flags."

Grid

This accessory attaches to the front of a light source and works to prevent the lateral spread of light. This, in turn, reduces the amount of flare and fill light caused by the scattering of rays, thereby increasing color saturation on film. The extent to which a grid does this depends on both its color (black or white) and the degree it is rated at, such as 3, 10, 20, or 40 degrees.

HMI

This metal-halide lamp is commonly used in the video and film industry. HMI lights are daylight balanced and quite powerful. When Hollywood technicians illuminate a street at night to film a "daylight" scene, they ordinarily set up a bank of HMIs.

Hosemaster

This is a brand name for a fiber-optic product designed specifically for painting with light.

Hot Lights

This slang term for tungsten and quartz lights comes from the extreme heat that the units generate.

Incident Light Meter

This is a light meter that reads the light falling on the subject, rather than the light reflected off it. As such, incident meter readings are taken from the subject position rather than the camera position.

Light Disc

This is a collapsible, disc-shaped reflector that folds down to about 1/3 of its full size.

Light Panel

This popular type of light modifier breaks apart for transit and storage. A frame of varying sizes can be built out of modular pieces. Diffusion material (for the sun to shine through), scrims (to reduce the light output), gobos (to block the light), or reflector material (to reflect the light) is then strung across the frame. The most complete light-panel sets offer counterweight pockets, wide stands, turf spikes, clamps, and other accessories.

Light Tent

These small, commercial tents are used for shooting jewelry and other soft-light applications. Some light tents are made of soft diffusion materials, while others, like the Light Dome, are literally Plexiglas domes.

Mirror

This accessory is a great choice when you need very strong fill light, such as behind a dark-colored bottle.

Modeling Light

This fairly weak light near the flash tube on the flash head approximates what the flash illumination will look like. Since flash occurs too quickly for the eye to register (with the exception of the after-image phenomenon), a modeling light is a lifesaver when you set up your lights. Some units leave the modeling light turned on during the exposure; others automatically turn it off during exposure, which is important during slow flash sync.

Monolight

This is a type of flash unit in which the power unit is attached to the flash head, eliminating the need for a powerpack. Monolights are popular for location work because of their relative light weight and minimal power requirements.

Neutral-Density Filters

If too much light is hitting the film at your chosen aperture and with your chosen film speed, you can reduce the amount of light by using a neutral-density (ND) filter on your camera. Densities range from 0.10 to 4.00, with each 0.10 reducing the light by 1/3 stop. So, for example, a 0.30 ND filter reduces the light by 1 stop; a 0.60 ND filter by 2 stops.

Photoflood

This is a daylight-balanced continuous light bulb, generally used inside a reflector.

Potato Masher

This is the large, portable, accessory-flash unit generally associated with wedding photographers. "Potato masher" is a slang term that comes from the general shape of the units.

Powerpack

This device is the control unit for many types of studio flash units. Usually you can plug several small, light flash heads into one powerpack. Top-of-the-line systems enable photographers to adjust the power ratio between the flash units, turn on or off the modeling lights, test-fire the flash, and more.

Quartz Light
This is an abbreviation for a quartz-halogen lamp. This type of tungsten-balanced light offers high power in a small unit, along with consistent output over the life of the bulb. These lights can range from a $7 household, quartz-halogen bulb on a $15 up-lightstand, to units with barndoors and focusing lenses made specifically for photography and videography.

Reflected-Light Meter
A light meter that reads the light reflected off the subject, rather than the light falling on it. Hence, reflected meter readings are taken from camera position, not the subject position. Keep in mind that these meters assume that the subject is 18 percent gray in tone and, accordingly, base their suggested exposure to make the subject look 18 percent gray on film. For accurate exposures, you can place an 18 percent gray card on the set, and take your reading off it.

Reflector
A reflector can be any piece of cardboard, Fome-Cor, paper, mirror, fabric, or other material used to bounce light back onto the subject. Shiny surfaces bounce back strong, directional light; matte surfaces give weaker, more diffused light; and colored surfaces throw back a color cast. Reflectors are most commonly used to provide light that fills in shadows, but they can serve as the main light if the subject is exposed for the fill light.

Ringlight
This lighting unit rings around the camera lens, such as the flash units sold for macro applications. The resultant light comes from the same axis as the camera lens, so the shadow around the subject looks like an outline. Because the unit is on the lens axis, the red-eye phenomenon becomes a problem when you use a ringlight flash in dim situations.

Rosco
This is the brand name for a popular line of filters for lights.

Scrim
You place this product in between a light and a subject to reduce the light output. Commercially available scrims are made for this purpose with specific levels of blockage. Many photographers mistakenly refer to diffusers as scrims.

Snoot
This attachment goes onto the lighting unit's head to direct the light and concentrate it into a smaller area.

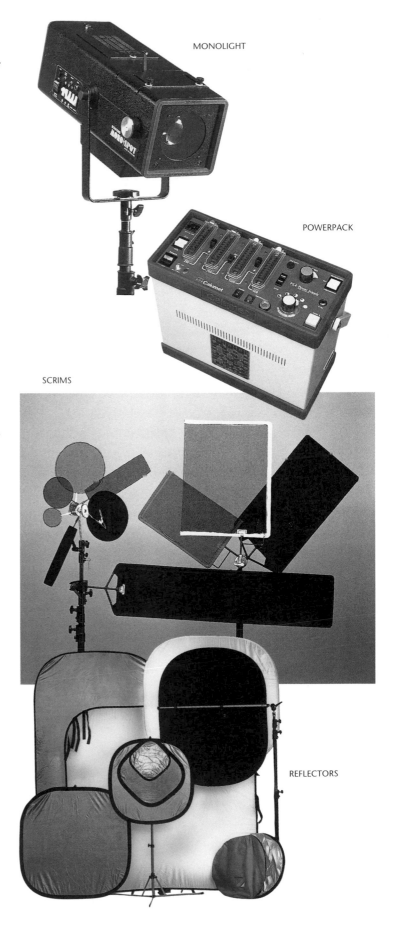

MONOLIGHT

POWERPACK

SCRIMS

REFLECTORS

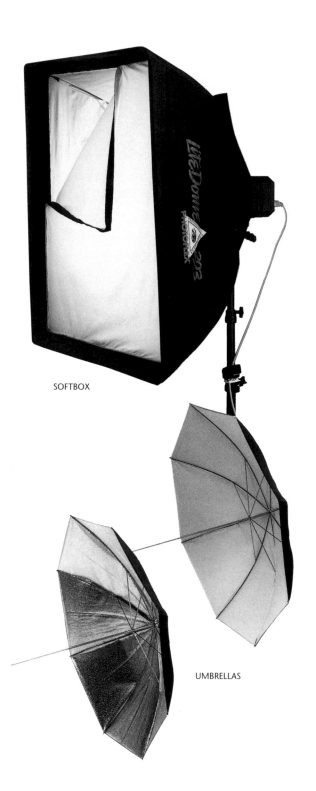

SOFTBOX

UMBRELLAS

By doing this, you can aim a light to hit a certain area, with little spillover into other parts of the set.

Softbox

This is a box that fits over a flash head, made of four black sides, with either white, black, or silver interiors, and a translucent front through which you shine the light. This type of illumination produces soft, appealing lighting. Some softboxes collapse for transit and storage.

Speed Ring

This device enables you to quickly attach accessories and light modifiers to the front of light units.

Spotlight

This is a hot light or flash unit that produces very directional light. Many spotlights have Fresnel or focusing lenses to help direct the light.

Spot Meter

A spot meter is a light meter with a narrow field of view, such as 3 degrees, that permits you to take reflected-light readings of a subject that is faraway or small. These light meters are most commonly used in outdoor photography, when you can't always approach your subject.

Strobe

This is jargon (but an incorrect term) for flash in general. A strobe is actually an electronic flash that provides stroboscopic effects, or rapidly flashing light, for stop-action sequences, etc.

Studio Flash

This term is jargon for the high-powered flash units that utilize a powerpack. Studio photographers prefer them because of their versatility, variable power ratios, high power, and advanced options. Their relative great weight makes them unpopular for location work.

Tungsten Lighting

This type of illumination is found in ordinary household bulbs. Precise, high-wattage, 3200K tungsten bulbs are available for photographic purposes. The slang term for these lights, as well as quartz lights, is "hot lights."

Umbrella

Photographic umbrellas are similar to rain umbrellas, but they're made of photo-specific (and not waterproof) materials and don't have hooked handles. They usually have white or black exteriors and white, silver, or gold interiors. Lighting units are usually reflected into them; if they are all white, the light can be shone through them.

Viewing Filters

Designed for color printing, these filters help you determine how strong a color cast you have in a print or transparency, and what the exact color is. They come in several strengths of cyan, magenta, yellow, red, green, and blue.

Warming Filters

This type of filter is designed to add a warm tone (a slight orange cast) or to correct a cool tone (a bluish cast). Warming filters for lights come in 100K and larger increments. Warming filters for cameras are the 81-series filters.

Set Equipment

What set equipment you stock largely depends on what type of photography you do on a regular basis. Some photographers might never need such an exotic piece of equipment as a fog machine or a rear-projection system. Others, however, might use this gear all the time or choose to rent pieces occasionally.

Apple Crate

This kind of small, wooden box comes in handy as a stepstool, a prop, a low table, and/or a weight.

Autopole

This is an adjustable pole, such as the Bogen Auto-Pole, with a lever-action that secures it to the ceiling. Hooks then hold a crossbar that slides into the core of a roll of seamless paper or secures a canvas backdrop.

Counterweights

These are important set accessories for securing booms, lightstands, tripods, and other easy-to-tip items. You can buy commercially manufactured counterweights, or you can make sandbags or use filled water jugs instead.

Dolly

A dolly is a tripod on wheels. It is usually associated with the film and video industry where smooth camera movement is necessary.

Fog Machine

This device makes dramatic fog effects. Fog machines, such as those Rosco makes, use FDA-approved chemicals to produce nontoxic, nonirritating fog or smoke. Sometimes this device is called a "smoke machine." Since what is made isn't actually smoke, it leaves no dirty residue, and, while it has a scent, it isn't unpleasant. If you don't do a lot of work with the theater, you should rent a fog machine when you need one since models start at $300.

Gear Head

This kind of tripod head helps you make precise camera movements, even with heavy view cameras.

High Boy

This is a lightstand with an extra-tall reach.

Monoball

Photographers either love or hate this type of tripod head. Its ball-and-socket construction allows free and fluid movement when loose, but you can instantly lock and tighten it by turning a knob or level. A monoball, which is also called a "ballhead," is great if you're working with moving subjects and want to recompose quickly or continually; however, it isn't the best choice if you want repeatability. The larger the ball, the heavier a camera setup you can use. The best units offer an adjustable tension screw that you can set to prevent a lens-heavy camera from falling forward if you remove your hands before locking the ball.

Monostand

This is a heavy-duty stand for view-camera support in the studio. Also called "studio stands," monostands generally have a large central column with a counterweighted crossarm assembly. The best units offer fingertip controls, geared movements, and precision scaling for quick repositioning. Locking wheels permit quick maneuverability. Be careful not to confuse a monostand with a monopod. A monostand is massive and too heavy to lift, while a monopod is a one-legged version of a tripod designed for portability.

Pan-Tilt Head

Often called a "video head," this type of tripod head enables you to independently lock or release pan or tilt movements. When following a moving subject and panning with it, these tripod heads are indispensable.

Posing Table

This prop, used in portrait studios, is designed to facilitate flattering poses.

Quick-Release System

With this system, instead of turning your camera around in a million circles in order to thread it onto a tripod, you simply mount a quick release onto your tripod and the matching plate onto your camera. Then when you need to change cameras or shoot handheld, you can release your camera with just a turn of a knob.

Rear-Projection System

This is a background system that involves projecting a slide, such as a beach scene, onto a translucent screen

from behind the set. The subject is then placed in front of the screen and illuminated so that none of the lights hit the screen. The goal is to have the lighting on the subject match the lighting in the slide.

Seamless Paper
Seamless is an easy source of background material. Simply slide a crossbar through its core, and hang it between two autopoles. Roll out a "sweep" as large as you need. When the seamless becomes marred, cut off the bad portion, and roll out some more. Seamless paper comes in numerous colors, but the most popular are white, black, and dove gray because almost any color can be added to them with gelled background lights.

Sweep
This is another name for a seamless backdrop that has been "swept" out into the studio to create a floor and background joined by the gentle curve of the paper or fabric.

Tripod
A tripod is a must-have item for most lighting setups. Don't skimp when it comes to weight. A heavy-duty tripod holds a camera much steadier than a lightweight tripod can. If you do a lot of traveling, consider buying both a heavy tripod for near home and a lighter one for location work.

Tripod Head
A tripod needs a tripod head to enable you to position the camera. Many different types are available, and the best one depends on your needs and preferences.

Wind Machine
If you're working in the studio with painted backdrops or rear-projected scenes, there is no better way to recreate the great outdoors than with a powerful wind. Unlike household fans, wind machines are highly directional and quite powerful. Remember, you can always rent one of these if you don't use one often enough to warrant buying one.

Additional Necessities
Photographers' studios are filled with numerous little devices. The selection is about as different from person to person as the contents of their refrigerators. Listed here are some of the more standard and indispensable items. Beyond that, the rule for shooting sessions and set creation is to use whatever works to get the job done—from carpenter's tools, to household furniture, art supplies, and kitchen gadgets.

Air Blower
An air blower is a necessity (along with a camel-hair brush) for removing hairs, dust, and other small debris from film holders, camera lenses, filters, and the set.

Air Release
This is similar to a conventional cable release, but some photographers feel that this type is smoother.

ANSI Lightbox
This is a color-correct lightbox for checking the color cast and sharpness of transparencies with a loupe.

Blackout Material
Available from several different manufacturers, blackout material is extremely light absorbent. Velvet is the classic blackout material, although some of the new synthetic materials work even better.

Bricks
These are always useful for securing canvas backdrops, weighing down cords, and propping up items on set.

Cable Release
A cable enables you to trigger the camera shutter without shaking the camera. Depending on the length of the cable, you can shoot from a remote distance. For example, if you want a dog to look to its left, you can stand to the right of camera to get its attention. A cable release also lets you do self-portraits.

Camel-Hair Brush
This soft brush is a necessity (along with an air blower) for removing hairs, dust, and other small debris from film holders, camera lenses, filters, and the set.

Canned Air
If used correctly, canned, or "compressed," air is great for clearing dust, hair, and other debris off camera lenses or film holders. Be careful to use the canned air upright: when it is used incorrectly, the cold spattering of the chemicals has been known to shatter lenses. You should also test its strength when using it on set since it could blow over reflector cards and lightweight props. Environmentally safe canned air products are now available.

Changing Bag
This is an important safety item to have when you work on location. In effect, a changing bag is a tiny, light-tight darkroom that permits you to load large-format film holders or salvaged jammed rolls of film in broken cameras.

Clamps

These accessories, which come in a variety of styles, are used everywhere in a photographer's studio. An A-clamp, for example, can prevent a roll of seamless paper from unwinding, as well as hold a white card to a stand. C-clamps secure large props to tables or lights to flats. You can get clips with swivel joints for flexible positioning. The Bogen Super Clamp system has dozens of photographer-specialized clamps and accessories, including jointed arms with clips and clamps attached, "forks" or rakes for securing cards, and reflectors and hooks for hanging things.

Clay

Nondrying clay is a great tool for propping up products on a still-life set.

Computer Vacuum

This miniature vacuum cleaner comes with tiny attachment wands, so it is ideal for cleaning up sets and keeping the interior of your camera spotless.

Dulling Spray

Also called "matte spray," this terrific product for still-life photographers takes the gleam off reflective objects. But make certain to test the object in a hidden place first because the spray might cause permanent damage to the finish. The best dulling sprays (at least from a cleaning viewpoint) are the water-soluble varieties. You can also use dulling spray to make homemade fog filters. Also, you can use artists' matte spray for charcoal drawings as a substitute if you can't find the photographers' variety.

Flower Forms

You can drop these flower-store gadgets into a vase in order to "stab" flower stems into them for precise positioning. Some forms are made from a synthetic, foam-like material. Others have close-knit prongs that the stems wedge in between. The prong variety is perfect for holding small reflectors in upright positions.

Gaffer's Tape

After film, I rate this the "Number-One Used Product" in photography. Don't confuse gaffer's tape with duct tape or masking tape—and at $20 a roll, you won't. The tape is cloth and comes in matte black, white, and gray. You can used it to secure and connect just about everything, and it still cleans up quickly and easily.

Loupe

This accessory is a virtual necessity for checking critical focus on negatives and transparencies. You can also lay a loupe against the groundglass on a view camera to check focus before exposure. Don't be too thrifty when choosing a loupe. Since you are in the business of optics and spend thousands on lenses, why skimp on this lens? Without a quality product, such as a Schneider loupe, you can't judge critical sharpness.

Model Release

This is a signed legal form that gives you full permission to sell photographs in which the model appears. It is a legal necessity in this day and age.

PC Repairer

This handy tool attaches to your keychain and enables you to repair crushed PC terminals.

Radio Remote

This unit triggers your camera or lights remotely.

Slaves (IR or Radio)

These small units attach to flash heads, causing them to fire when they see another flash go off or are given a radio signal from a transmitter.

Spirit Level

This is quite handy for quickly leveling a camera or making sure a prop is parallel to the film plane.

Stop Watch

This item is great for timing long exposures or Polaroid test prints.

Sync Cord

Also called a "PC cord," this runs from your camera to the lead flash unit and synchronizes the shutter with the flash. Additional flash units can be linked using infrared or radio slaves.

Tunnel Tape

This is designed specifically to tape down wires and cords to the floor. Because it has a nonstick tunnel running through the middle, the cords stay down and don't pick up a gummy residue.

Wax

Pliable wax is an excellent tool for propping up products on a still-life set.

SLAVES

Part Two
BASIC PORTRAITURE

*E*VERYBODY WANTS to have wonderful pictures of themselves, their family, and their friends as keepsakes. We also often respond better to advertisements if they include people. And magazine articles that depict actual people draw us into the story. So it is no wonder that ever since the Civil War era, photographs of people have been the number-one seller in photography. But photographing people can be difficult because we are alive and mobile and tend to move in relation to the light source. We also are vain and want to emphasize or de-emphasize certain features and create specific moods in the photographs. Fortunately, photographers can achieve all of this by controlling the lighting used.

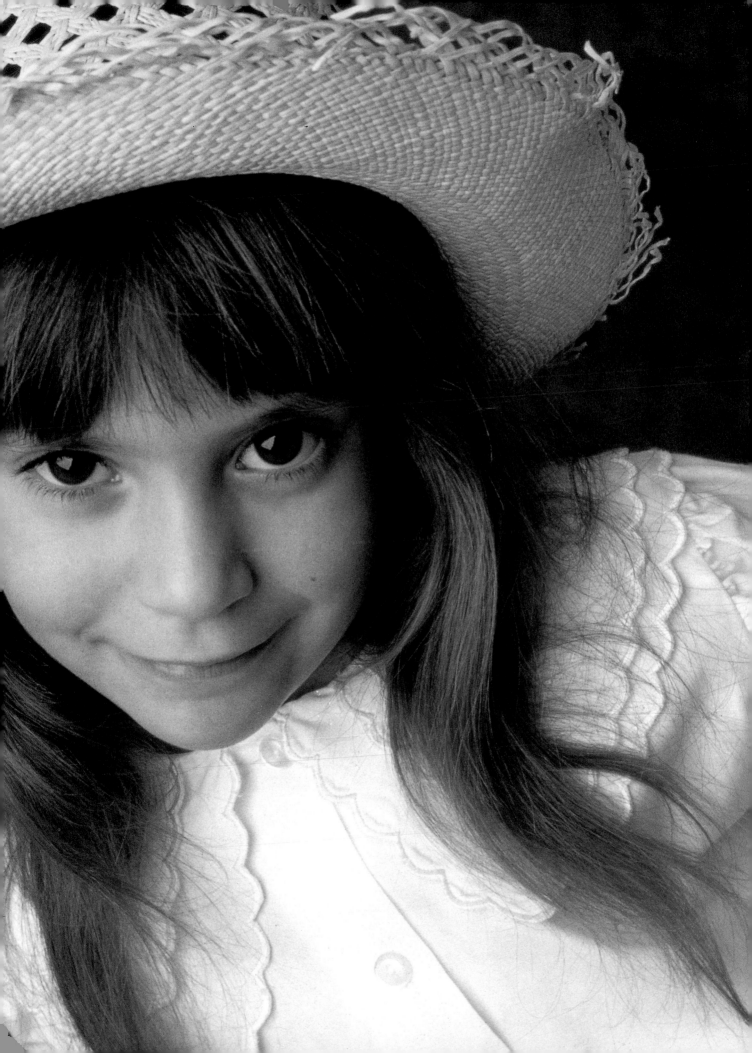

SIMPLE REFLECTORS

INGREDIENTS

- Bright sunlight
- A Model, or flower, or still life, or just about any subject
- 1 Reflector (This can be a card made out of Fome-Cor or posterboard; a commercially manufactured, collapsible, Flexfill-type of reflector; or a hand mirror. Common colors are white, shiny silver, matte silver, shiny gold, and matte gold.)

Requiring only three ingredients, this is one of the simplest techniques for lighting your subject. The sun does all the work; you merely modify the sunlight with a reflector. For example, midafternoon sunlight produces beautifully saturated colors that are perfectly balanced for daylight films. Keep in mind, though, that this type of light also produces deep, hard-line shadows, similar to using a bare bulb in the studio (see "Bare Bulb Artistry" on page 39). Unlike a bare bulb, however, you can't change the angle of the sun to suit your lighting needs. But you can use reflectors to help you.

Using a reflector is easy. Position it so that the sun hits it and bounces back onto the subject. Since the sun is uncontrollable, you must fuss a little with the angle and placement of the reflector and the subject until the reflected light hits the subject from the direction you want it to.

Photographers usually use a reflector to fill harsh shadows created by direct sunlight. But it can serve as the main light if your subject is completely in shadow. You can also use a golden reflector to mimic late-afternoon sunlight; it adds a warm glow to the reflected light. Alternately, you can creatively use a small reflector to highlight a certain feature. For example, as you shoot, you might decide to throw extra light on just your subject's eyes.

Quick Hint

Busy background when you're working outside? Change your camera angle, and shoot up (at the sky) rather than down (at the street). Here, you can actually see the reflector that photographer Eric Bean used in the model's sunglasses.

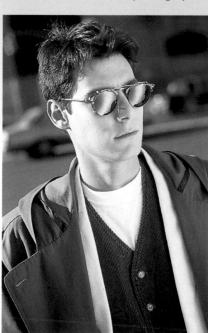

▶ In this shot of an adult helping a boy repair his bicycle, the photographer used a large, matte-gold reflector as a main light, catching the sun that is now the hair light. Because this reflector doesn't bounce all of the light back onto your subject, it is darker than the light falling directly on the subject from the sun. So, if you expose for the reflected light (here, the frontlight on the subjects), the sunlit portions (the hair light) will be overexposed. Lane also added a small, white card to the right of the camera in order to put the neutral reflection in the bicycle chains and to soften the overall illumination.

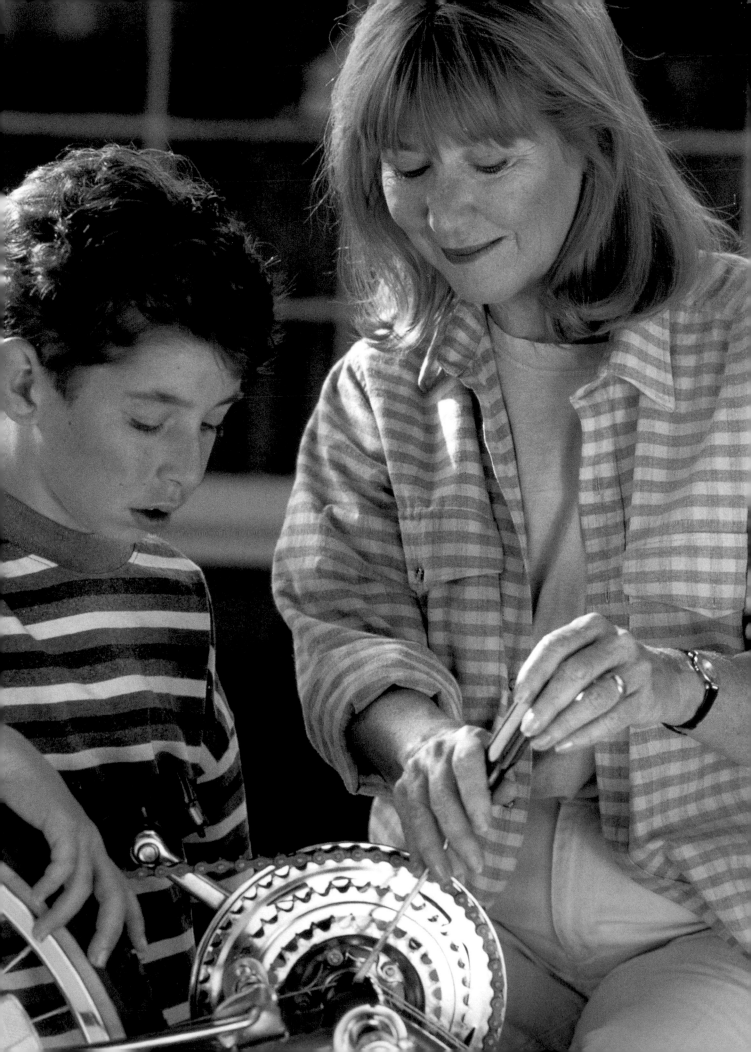

Choosing a Reflector

The type of reflector you use affects the quality and color of the light it reflects back at your subject. For example, the bounced light can be hard or soft depending on the reflective quality of the reflector itself. A mirror takes the hard light (called "hard" because it produces a hard-edged shadow) of direct sunlight and bends it, sending hard light back at the subject. A less reflective material, such as matte-silver or crumpled aluminum foil, disperses more of the light, which means that softer, more diffused light is reflected back at the subject. A dull, white card is even softer because it reflects an even smaller percentage of the light directly back at the subject.

Predicting the exact percentage of the light that a certain type of reflector will send back at the subject is difficult. Even mirrors vary in terms of their optical quality. But the general rule to remember is the less shiny and smooth the reflector is, the softer and weaker the reflected light will be. And if you're using a flexible reflector, you can aim or disperse this light even farther by making the reflector more concave or convex. So be sure to use a light meter to check the amount of light hitting your subject before making the exposure.

You can also use reflectors to introduce color tones into a picture. Add a colored tone to any of these reflectors, and you get a similar-toned but weaker fill light. Keep in mind that this can work against you sometimes. For example, a green wall can accidentally reflect a green light back at your subjects, creating unpleasant tones in the shadows on their face and body.

The least expensive choices you have are posterboard and Fome-Cor. Since they can be hard to carry and transport, especially on windy days, they are best left in the studio. The collapsible-frame, Flexfill-style reflectors are wonderful options. They quickly fold up to about 1/3 their original size—once you learn their secret—and come with a carrying case. Usually, they are white on one side and gold or silver on the opposite side, which provides you with two options. In addition, they come in a range of sizes, from tiny devices for flowers and other nature subjects, all the way up to circles that are more than 4 feet in diameter.

If you need an even larger reflector (more than 6 feet square), you can invest in a panel system. This includes an adjustable frame that you put together like an Erector set. Next, you simply have to stretch your fabric of choice over the frame, making it ideal for both reflective materials and diffusion materials.

When you use a mirror, you can achieve the exact shape you want by covering the unwanted portions with gaffer's tape. You can even create letters or icon shapes, such as stars or hearts, that can be reflected into the face for special effects. Keep in mind, too, that reflectors are also available in black, which reduces reflections and/or creates shadows (see "Gobos and Shadows" on page 27).

(You'll notice in Part Four of this book that reflectors are an important part of studio still-life photography as well. However, since products and still lifes are often much smaller than people models, you're generally working with much smaller cards and mirrors.)

Here, high-noon sunshine was hitting the top of the model's head. So the photographer used a simple reflector to throw some of the sunlight onto the front of the model.

Quick Hint

In a pinch for an appealing background? To create one, the photographer used a collapsible Flexfill reflector that is white on one side and gold on the other.

GOBOS AND SHADOWS

INGREDIENTS

- 1 or more models
- 1 Light source (natural or artificial)
- Gobos to cast shadows or reduce reflections
- Lightstands to hold gobos
- Clamps and tape to secure gobos to lightstands
- Counterweights to keep lightstands from tipping

For a winter shot, add:
- Winter clothes
- Fake snow
- 1 Flash with a reflector umbrella
- A hair and makeup artist
- A clothes stylist
- A mobile home to be used as a dressing room

Gobos are designed for three main purposes: creating shadows, reducing reflections, and shading the camera lens from the potential of flare. Gobos can be made of almost any opaque object, but most commonly they're cut from black cardboard or matte-black metal.

In people photography, gobos are often used to prevent harsh, high-angle sunlight from hitting the subjects. In product photography, gobos are most commonly used to darken an unimportant portion of the picture, thereby emphasizing the main subject (see "Single Light Still Lifes" on page 96).

The effect of the shadow that a gobo casts on the scene is controlled by the light source. Both a pin-light source and direct sunlight produce a hard-line shadow. Conversely, a broad light source results in soft-edged shadows. Be aware that a flash head or hot light can be a "pin" source, producing hard-line shadows if it is at a distance from the gobo. But up

The photographer posed this young male model in direct sunlight, so he decided to use gobos to cast interesting shadows in this white-on-white picture.

close, it is large in comparison to the gobo and creates fuzzier edges. Similarly, the sun, which is 865,400 miles wide, is a huge light source. But since it is so far from the earth, it appears small and acts like a pin-light source.

When clouds move in, they effectively become the light source. Because they are much closer to the sun and large in comparison to the gobo, the resulting shadow edges are soft. If this concept doesn't make sense, try an experiment. Remove the shade from a lamp, and put your hand with your fingers spread apart about 5 inches away from it. Notice that the shadow it casts on the floor is quite indistinct, so that you can

barely make out the fingers. Next, as you slowly move your hand farther away from the bulb and closer to the floor, watch the shadow come into focus. Now, your fingers appear distinctly separate.

In the two photographs shown here, gobos were used to create shadows, but the effects are quite different. In one photograph, the shadow of the photographer's hand becomes an important compositional element (below). In the other image, the use of shadows from gobos is much more subtle (opposite). The shadows focus your eyes on the model's face and create tonal variety in a picture that would otherwise be very high-key.

The photographer used his hand as a makeshift gobo to add a dramatic shadow to this picture. Because the photographer's hand was pretty far away from the light source, the shadow edge is fairly sharp.

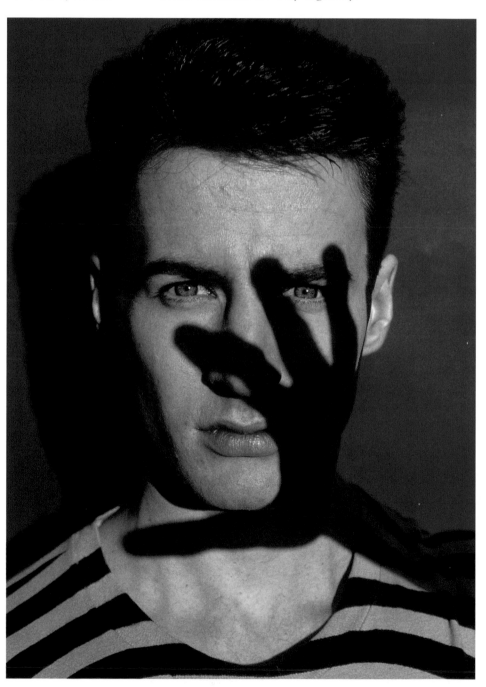

Creating Winter in July

In the next visual example, the use of gobos isn't as obvious. You might wonder what is really so difficult about shooting this wintry outdoor scene? Try the fact that it is midday in July. Photographer Eric Bean created this scene to sell the mittens, headband, and scarf for an Avon catalog. Without a budget to travel south of the equator for an appealing snow scene, he was forced to create winter on location in balmy, 90-degree weather.

Bean's first task was to find a suitable location, which turned out to be a Christmas tree farm. He rented the facilities from the farm and had a private outdoor studio to work in. Next, he chose his model, Jodi, with whom he'd often worked. She was specifically selected because, in addition to her obvious good looks and professionalism, she wasn't prone to sweating profusely—which is a definite advantage when you're wrapped up in warm winter clothes for an hour in the middle of summer. A sweat sheen on her makeup (which can appear on some models in a matter of seconds between makeup-matting sessions) would have been disastrous to the final product.

Next, Bean lined up a hair and makeup person and a clothing stylist. These two people were in charge of getting the model ready in the first place, and then noticing and fixing just about anything that went wrong during the shoot, from flyaway hair strands and a perspiration sheen, to wrinkled clothing and unflattering drapery. The photographer then rented a mobile home to transport everyone to the location, and to serve as a dressing and styling room. Bean's

final ingredient was purchasing fake snow, similar to the Hollywood styrofoam variety, which was shoveled onto the background trees. As long as he threw the trees and snow out of focus, the snow looked real. Of course, he had no choice: even the best snow-making equipment wouldn't be able to keep up with the heat of the day.

In Bean's bag of tricks, he had a lighting setup that contained portable flash units with battery packs, umbrellas, softboxes, reflectors, scrims, and gobos. He started with two tall, sturdy lightstands, which he extended to full height and counterbalanced with sandbags. Between the lightstands, he clamped a large, black card between the sun and the model. This effectively plunged the model into soft shade. Next, he pointed two Norman flash units into a large, white umbrella and directed this diffused light straight at the model. The end result was a believable wintry day, with soft lighting caused by overcast skies and plenty of white snow.

A combination of a long telephoto lens, a wide aperture, and the distance between the model and the trees ensured that the background would be soft. Depth-of-field preview at different apertures enabled Bean to choose exactly how out of focus he wanted it. However, he also used a medium-format camera with a Polaroid back, so he could create instant test prints for the client to view and approve.

After the shoot, Bean's last chore was cleaning up. But he had a problem. How do you get styrofoam snow off Christmas trees? The answer: the same way tree farms beautify them for selling—with a shop vacuum!

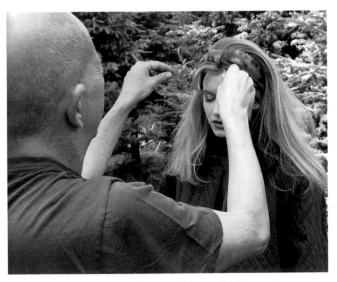

An experienced hair and makeup stylist was the key to the success of both this summertime shooting session and the final image. One of the hardest parts was preventing a sweat sheen from developing on the face of the model, who was dressed in winter attire.

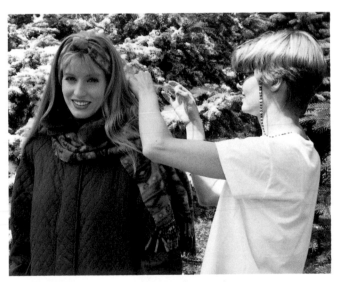

The stylist's first job is to select the model's clothing and accessories, and then to make certain that they look right throughout the entire shoot. Naturally, the stylist might have to make some adjustments as the session continues.

Fake Snow and Other Toys

Photographers have many trade secrets that help them create "reality" out of nothing. Many of these are designed just for photographers, while others are borrowed from the Hollywood special-effects crowd. When it comes to buying fake snow, be prepared to be asked, "What kind?" You'll have your pick of granular or fine, as well as slush, ice, or spray-on frost.

And don't forget the fake ice cubes that are often used in studio photography. The old, standard, blown-glass ice cubes never looked real because they didn't float. Now, however, state-of-the-art acrylic ice cubes and hollow glass cubes are almost indistinguishable from the real thing—to everyone but the photographer who doesn't have to worry about them melting.

Other common producers of special effects are fog-making machines, high-speed wind machines, glycerine for "water" droplets. and black or invisible wire for suspending objects in midair or mid-action. You might also have the need for a lawn paint, such as Oasis Lawngreen; these paints turn a less-than-perfect lawn into a forest-green lawn. Some of the major suppliers of photo props and special effects are The Set Shop, Photographer's Specialized Services, Calumet, and Trengrove Products (see the List of Suppliers on page 143).

EAGLE-EYE VIEW OF FAKE-WINTER SETUP

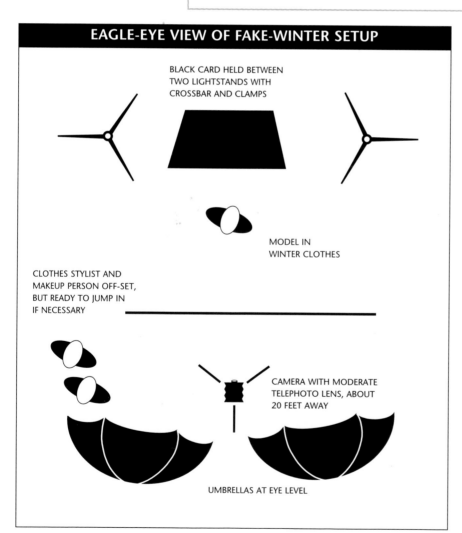

BLACK CARD HELD BETWEEN TWO LIGHTSTANDS WITH CROSSBAR AND CLAMPS

MODEL IN WINTER CLOTHES

CLOTHES STYLIST AND MAKEUP PERSON OFF-SET, BUT READY TO JUMP IN IF NECESSARY

CAMERA WITH MODERATE TELEPHOTO LENS, ABOUT 20 FEET AWAY

UMBRELLAS AT EYE LEVEL

GOBO SETUP: FAKE-WINTER SET

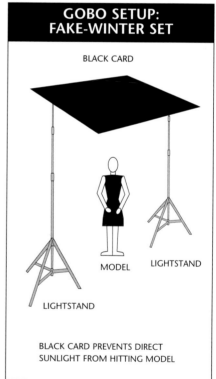

BLACK CARD

MODEL

LIGHTSTAND

LIGHTSTAND

BLACK CARD PREVENTS DIRECT SUNLIGHT FROM HITTING MODEL

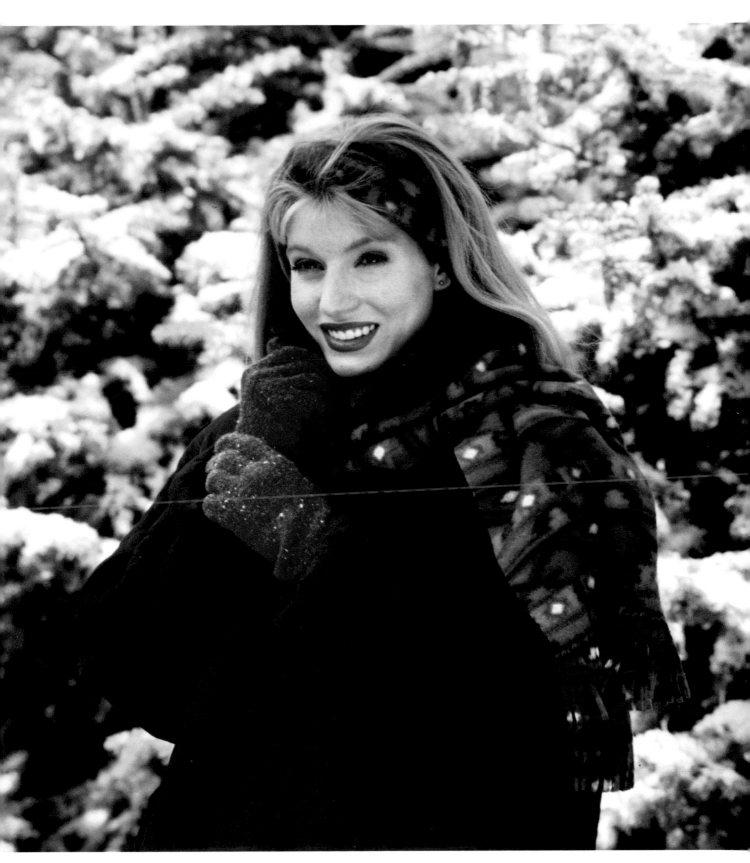

This is the final image from a shoot during which Eric Bean created winter in 90-degree weather. The fake snow and winter-day lighting help to firmly establish the illusion in this picture, which was done for an Avon catalog.

FAIL-SAFE PORTRAITS

This recipe is called "fail-safe" portraiture because the system is one of the easiest to set up, as well as one of the most forgiving. The heart of it is the use of umbrellas or a small softbox to modify the light source. A softbox is simply a box placed over the flash head that guides the light through a translucent panel in the front. Commercially made softboxes are usually lightweight and easy to attach, and are often collapsible for transport and storage. Their sides are usually black on the outside and either matte silver or black on the inside.

Umbrellas for photography come in different sizes and colors. They usually attach to your studio flash unit with a bracket through which you thread the umbrella's straight handle. One of the more common photography umbrellas is black on the outside and white on the inside. This type is designed to be positioned so that the concave inside of the umbrella points at the subject. As a result, the flash head is pointed away from the subject so it shines on the inside of the umbrella, and soft, reflected light is bounced onto the subject (see the top diagram on page 34). Other umbrellas have a silver or gold interior, which affects the color and reflectivity of their inside surfaces. These aren't designed to be shot through, just reflected into.

Another common type of umbrella is all white and translucent, so it can be used in this same way, albeit with a bit of lost light that shines through and isn't reflected. More commonly, photographers turn this umbrella around so the convex outside points at the subject. The flash head then shines through the umbrella, creating more of a softbox effect (see the bottom diagram on page 34). The most obvious

difference between a softbox and an umbrella used in this fashion is the shape of the highlight in your subject's eyes. Since eyes are reflective surfaces, the round umbrella or the square softbox will be clearly visible in them—unless it has been retouched out.

Professional flash heads usually come with a small reflector and umbrella bracket, through which you thread and attach the arm of the umbrella (unlike rain umbrellas, they don't have a curved handle). Alternately, you can attach a collapsible softbox to most flash heads with an accessory bracket as well. The biggest difference you'll see is in the shape of the highlight in glasses, on metals, or in the eyes.

Setting Up the Lights

There are a few variations of this portraiture setup, but all start with a single, large, diffused light source; this can be either a softbox or a white umbrella. First, mount a powerful flash head on a sturdy lightstand. Then after you attach a reflector and umbrella (or softbox) to it, position it at a high angle directly behind the camera or off to the side about 40 degrees, depending on which angle flatters your subject more. To judge the angles, turn on the flash head's modeling light, and eyeball the scene from the camera angle.

If the umbrella is black on the outside and white on the inside, you'll have to reflect the flash into the umbrella and let it bounce back onto your subject. With a pure white umbrella, you can do this as well or you can shoot through the umbrella. Once you've picked your lighting angle on the subject, it is time to look closely at the shadows. If they are too dark, you'll need to lighten them with a reflector or to use a separate fill light on the opposite side of the model as the flash. You'll usually want the facial shadows to be no more than two stops darker than the highlights (see "How Deep Should Shadows Be?" opposite).

At this point, it is time to work on the model's hair. Hair that has a similar tone to the background can seem to disappear, making it hard to define its shape in the final photograph. Also, your main light might illuminate the face well, but might not bring out the texture or shine of the hair. Therefore, a separate hair light is often necessary. This light should be more directional than the main light since its sole purpose is to add a highlight to the hair. Often a flash can be fitted with a commercial or handmade snoot for this purpose (see "Snoots and Foils" on page 38).

In photographer Bobbi Lane's pictures of the blonde-haired model, the main light source from its high-left position illuminates her hair and sets it off from the

background (see pages 34–35). But in photographer Harvey Branman's image of two dark-haired sisters, their black hair absorbs the light, which could have made their hair indistinguishable from the background (below). Because of this potential problem, Branman added two powerful hair lights to put a glint in the women's hair. Next, he carefully snooted the lights, so that light couldn't stray onto any other part of the picture or cause flare in the camera lens.

In some cases, a fourth light might be necessary in order to separate the subject from the background if the other lights haven't already done so. This light can be pointed at the background to create a lighter halo behind the subject, or it can be a rim light pointed at the subject's back or shoulders (see "Fore and Aft" on page 48).

Here, Lane's model didn't need a background light because her bright attire effectively separated her from the backdrop. And in the shot of the dark-haired sisters, the hair light does the trick, making a background light optional. Branman decided not to use a background light because the black backdrop adds to the drama and keeps the viewers' attention on the women's faces.

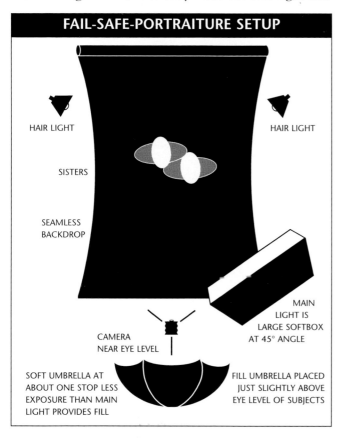

FAIL-SAFE-PORTRAITURE SETUP

HAIR LIGHT

HAIR LIGHT

SISTERS

SEAMLESS BACKDROP

MAIN LIGHT IS LARGE SOFTBOX AT 45° ANGLE

CAMERA NEAR EYE LEVEL

SOFT UMBRELLA AT ABOUT ONE STOP LESS EXPOSURE THAN MAIN LIGHT PROVIDES FILL

FILL UMBRELLA PLACED JUST SLIGHTLY ABOVE EYE LEVEL OF SUBJECTS

How Deep Should Shadows Be?

Film sees the world as much more contrasty than the human eye does. What might not look like a deep shadow to your eye could turn into a deep-black shadow without detail on film. Practice and experimentation will help you judge this. So will a spot meter. Read the highlights and shadows in a scene with the meter, and remember that most transparency films can provide details on film over only a 5- to 6-stop range. Beyond that, you get blown-out highlights, black shadows, or both.

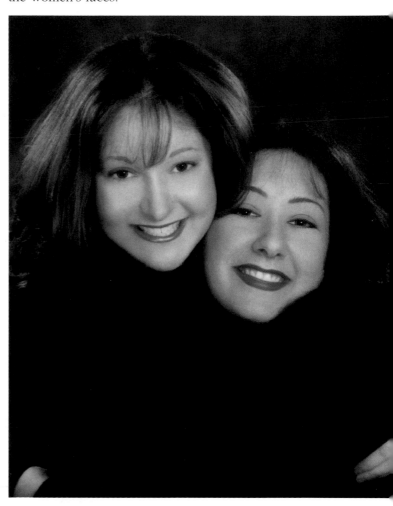

Harvey Branman photographed these sisters with a flash reflected into an umbrella. Small but powerful hair lights on either side of the women added a glint to their dark hair and effectively separated them from the background.

A lighting setup can't get any easier or quicker than one light. Photographer Bobbi Lane used a translucent, white softbox attached to a flash head as the main light, and a large piece of white cardboard for fill. She could have achieved a similar result with a large, white umbrella, either to reflect the light or to shoot through. The telltale giveaway is the shape of the reflector that is visible in the highlights in the model's eyes.

UMBRELLA AS REFLECTOR

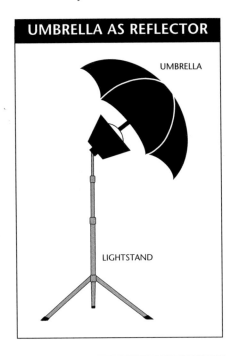

UMBRELLA

LIGHTSTAND

UMBRELLA AS DIFFUSER

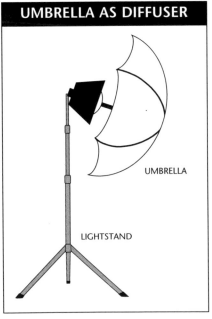

UMBRELLA

LIGHTSTAND

SCRIMS AND SHEETS

A scrim is an object placed between the light and the subject that reduces the light output. Good commercial scrims do this without affecting the quality of the light, just the amount of light that hits the subject. Homemade scrims, such as a sheet or a diffuser, are any translucent materials put in between the light source and the model to diffuse the light. By its nature, a diffuser also reduces the intensity of the light hitting the subject.

Photographer Bobbi Lane used the simplest form of diffusion while lighting a young model (opposite). She used gaffer's tape to cover a window in a baby's nursery with a white bed sheet. This prevented the direct sunlight from shining in the window. Instead of hard light with deep shadows, the result was much softer: the baby now seemed to be illuminated by soft north light. If Lane had chosen a tan sheet, the resulting image would contain a warm or pink glow because the sunlight would have picked up the color of the sheet. She also could have used gauze material or other fabrics purchased at a fabric store.

Homemade Versus Commercial Diffusion Material

If you're trying to soften direct sunlight in a large outdoor scene, such as a fashion shoot with multiple models, you might need to orchestrate a canopy-like system. By buying huge pieces of translucent, white material and sewing grommets into the corners and edges, you can string it up from poles or trees to cover the scene. You might even want to sew one or more pieces together. If you make your own diffusion material, be sure to test its translucency and color balance before you shoot an important job. Otherwise, you might get results you aren't happy with.

Depending on your location, you might have a hard time finding a way to hang your homemade diffuser in position. In these situations, light panels and other commercially produced scrim systems come in handy.

Several manufacturers offer mobile, modular light panels. You snap together a frame and then stretch the diffusion material of your choice over it. Some light panels come with legs or stands, and others come with lightstand clamps or even turf spikes. Whatever kind you opt for, you can clamp it to a heavy-duty lightstands and attach it between two boom arms.

Rather than use homemade diffusion material, you can play it safe by buying commercial diffusion material, which comes in various designs for different purposes. For example, if you plan to use the diffusion material next to a hot-light source, you'll want one of the special heat-resistant plastics. But if portability is the key, you'll want a material you can fold up and stuff into a carrying sack.

Commercial diffusion material is also rated by different amounts of diffusion. For example, Rosco makes diffusion filters for lights that come in 13 exact steps, from minimum to maximum diffusion. And by combining these 13 filters you can come up with considerably more variations.

Commercial scrims don't diffuse light at all; they're designed to reduce the output of a light source. You would use these if you liked the quality of the light, but wanted to control one light source in relation to another or in relation to the film in use. Matthews, a manufacturer well known in the movie industry, makes scrims that reduce light output by such increments as 30 percent and 50 percent.

(When you work on still-life images in the studio, your scrim or diffuser might be the size of finger—and hence called a "finger"—to diffuse or reduce the light output to one particular portion of the image. See Part Four for more details on product photography.)

On the other end of the spectrum and for complete portability, you can use an on-camera flash or a large, portable accessory flash (a "potato masher") that attaches to the side of the camera with a bracket. This is especially helpful if you're shooting weddings or public-relations photographs. Your diffuser can be as simple as a white handkerchief placed over the front of the flash, but not covering the infrared sensor, and held on with a rubber band. Another option is a commercially sold diffusion system that snaps on via an accessory bracket.

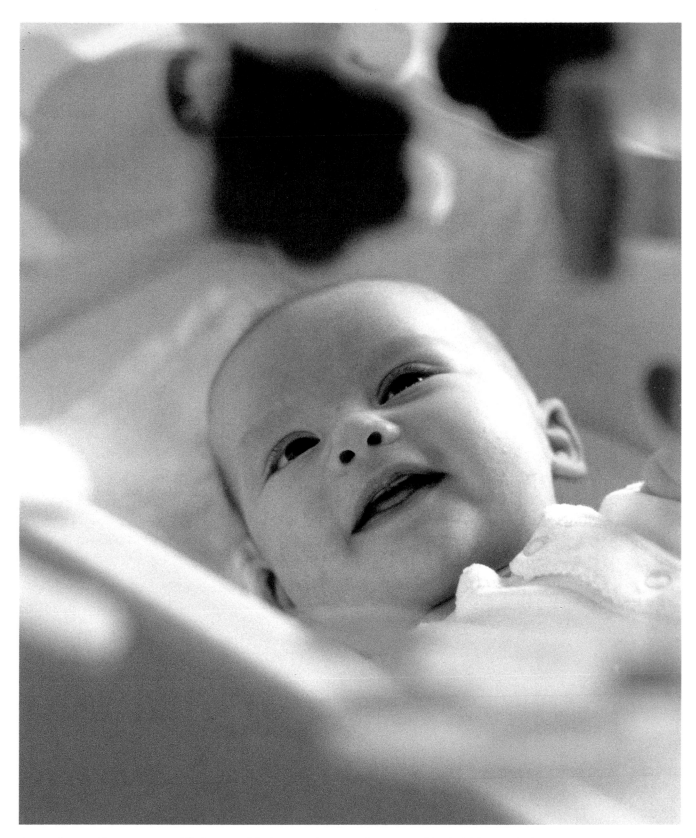

An easy but excellent way to use diffusion material when you shoot is to place it over a window. This will enable you to soften sunlight on an indoor subject. Commercially purchased diffusion material, white gauze material from a fabric store, or even an ordinary white bed sheet can work. Simply secure it with clamps or gaffer's tape when you position it. Make certain that you pay attention to the true color of the diffusion material because any color cast, no matter how slight, will be transferred to your subject. When you photograph people, it is better to go on the warm side (golds and tans) than the cool side (blues).

SNOOTS AND FOILS

Eric Bean used black Cinefoil to make a homemade snoot in the form of a "V" over a bare-bulb, quartz-halogen lighting unit. He positioned the light low and pointed it upward to create dramatic, unusual lighting.

Snoots are attachments that go onto the lighting unit head to direct the light and concentrate it into a smaller area. By using snoots, photographers can aim a light to hit a certain area, with little spillover into other parts of the set. The size of the opening at the far end of the snoot and the distance the light is from the subject combine to determine how much area the light covers.

The most common, commercially made snoots are funnel- or tube-shaped, making the lighting unit look like it has a nose or snout (hence the name). They are usually black and made out of heat-resistant material. Most quality studio flash heads come with brackets or accessory brackets for attaching snoots, barndoors, grids, and other light modifiers.

Heat buildup can be a real problem when you use a snoot. On tungsten and quartz-halogen lights, the heat can become excessive. Even with flash units, the modeling light can heat up the metal snoot quickly, so it is advisable to turn off the modeling light between shots.

Homemade Versus Commercial Snoots

Commercial snoots have the benefit of being sturdy, well made, and heat resistant. They're usually sold with brackets that mate with your individual flash-head system. But commercial snoots can be relatively expensive, especially if you need to purchase them in different sizes or shapes. For this reason, some photographers prefer to make their own snoots for each shooting session with a great product called Cinefoil. In fact, this accessory is tied with gaffer's tape for the title of "Photographer's Best Friend." This material looks like super-thick, matte-black tinfoil. It even comes in a tinfoil-type roll, but, remember, it costs a small fortune (about $25). However, the matte color controls flare and bouncing light; the thickness helps it hold its shape; and it is, of course, fire resistant.

Its thickness also enables you to mold Cinefoil into just about any shape in order to block off and aim the light in any direction. By simply molding the material into a conical shape and clipping it to your light source with clamps or nonflammable, nonmelting clothespins, you create an instant snoot. You can't use tape because it will melt if the flash head gets hot. Take a look at the shot at left. Here, photographer Eric Bean used Cinefoil to shape the light into a "V" pattern. This, combined with an unusual low-angle lighting direction and tight cropping, creates a compelling portrait.

BARE BULB ARTISTRY

Forget scrims, gobos, diffusion materials, and other light modifiers. Forget multiple-light setups as well. That is what photographer Eric Bean did when he shot the images in this section, relying on just one bare-bulb light source.

A bare bulb can be as simple as a typical household bulb without a lampshade of any kind, or a flash head without any reflectors. Quartz lights have built-in barndoors that can be left open or can close down the angle of the light. The Lowell lights that Bean prefers fall into this category.

The beauty of hot lights is twofold. First, they are relatively inexpensive. When shadows are critical, Bean prefers hot lights to flash because you can really see what the hot lights are doing to the highlights and shadows. You can get a close approximation with the modeling lamps on studio flash units, but these lamps aren't exactly the same as the flash. The shape of the bulbs, the placement of the bulbs, and the exact power ratio between the lighting units are close to what the flash will produce, but they aren't precise.

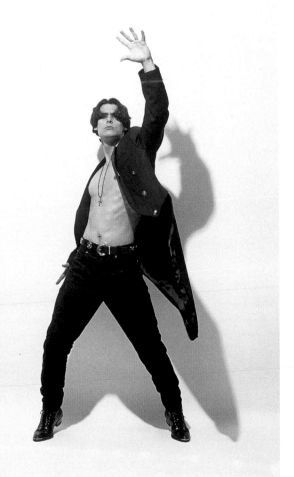

◄◄ Here, a bare bulb from a high angle to the left of the camera produced an interesting shadow on the sweep of the white seamless background.

◄ As the photographer moved the light higher overhead, the shadow was shortened and became less prominent.

▼ For this shot, the high, bare-bulb lighting without any fill light caused the eyes to turn into deep, almost impenetrable shadows. The dark background hid the shadow of the model's body.

Using Shadows

The trick is to use the shadows to your advantage. In Bean's first example, two large, black flats created a "doorway" through which the quartz light source was shone (below). He then stepped to the side of one of the flats and mounted his camera on a tripod. Next, he asked the model to step into the illuminated portion of the set and turn her head toward the light to avoid an uncomplimentary nose shadow. Hot lights helped Bean see the precise shadow he was going to get in the final image, and made it almost as important a picture element as the model.

If Bean had preferred to eliminate the shadow, he could have achieved this via creative lens selection, cropping, and altering the distance between the subject and the background. It is interesting to note that the backdrop was middle gray, thereby allowing the shadows to turn almost black and the highlights to go white when shot in black and white. The color version of this image is bluer.

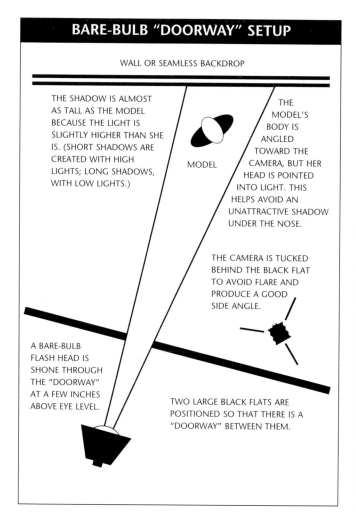

BARE-BULB "DOORWAY" SETUP

WALL OR SEAMLESS BACKDROP

THE SHADOW IS ALMOST AS TALL AS THE MODEL BECAUSE THE LIGHT IS SLIGHTLY HIGHER THAN SHE IS. (SHORT SHADOWS ARE CREATED WITH HIGH LIGHTS; LONG SHADOWS, WITH LOW LIGHTS.)

MODEL

THE MODEL'S BODY IS ANGLED TOWARD THE CAMERA, BUT HER HEAD IS POINTED INTO LIGHT. THIS HELPS AVOID AN UNATTRACTIVE SHADOW UNDER THE NOSE.

THE CAMERA IS TUCKED BEHIND THE BLACK FLAT TO AVOID FLARE AND PRODUCE A GOOD SIDE ANGLE.

A BARE-BULB FLASH HEAD IS SHONE THROUGH THE "DOORWAY" AT A FEW INCHES ABOVE EYE LEVEL.

TWO LARGE BLACK FLATS ARE POSITIONED SO THAT THERE IS A "DOORWAY" BETWEEN THEM.

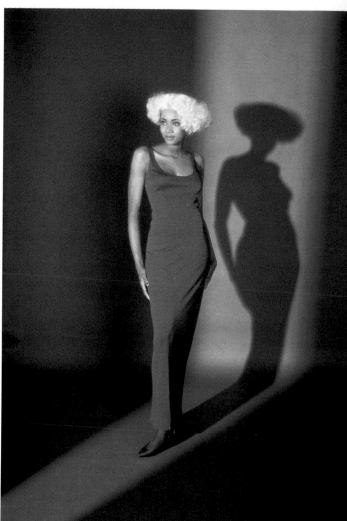

Shadows are one of the major benefits of bare-bulb photography—assuming that you use them to your advantage. Here, two large, black flats created a "doorway" through which the quartz-halogen light source was shone.

Using Light Angles

You can take advantage of the angle you place the light at if you pay close attention to the direction of the shadows, as well as where the model is standing in relation to the background. A bare bulb will cast a large shadow on a distant wall if it is positioned at a low level or eye level, but it will disappear from the wall (and hit the floor instead) if the light is high and pointing down toward the subject. However, if that same high light is used with a nearby wall, the shadow shows up on the wall behind the model.

Obviously, photography is full of choices. In the second image, Bean set up a Novatron flash unit without a reflector close to the model (below). Here, the circle of light created by the flash is aimed at her face and gradually the light fades off. Had Bean asked the model to step away from the wall, the shadow would have fallen lower than the camera view and would not have appeared in the image.

A good exercise is to work with one model and one bare bulb and experiment. Try to create light that mimics sunlight or stage light. Move the bare bulb around to look at the subject as it is illuminated from many different angles. Watch how the shadows change as the lighting unit moves. Then ask the subject to move in relation to the light. You'll see the resulting shadows more clearly if you use a white backdrop for this experiment.

By using a Novatron flash head as a bare bulb, Eric Bean achieved a very hard-edged light. This type of illumination sculpts the face with deep shadows that define the contours.

Imitating Direct Sunlight

If you want to create the feeling of direct sunlight in the studio, you must remember that the sun acts like a bare bulb or pin-light source. A pin-, or tiny, light source creates a shadow with a razor-sharp edge. And although the sun is actually enormous, it is quite small in relation to the subject since it is more than 90 million miles away from earth. On the flip side, a bare bulb is generally considered to be a pin-light source because it is small in relation to the subject. But if you move it so that it is about 2 inches away from a macro subject, this same bulb becomes a broad light source—and, in turn, a soft light source—because it is now huge in relation to the subject.

Bean shot the image of the woman "by the window" in the studio with a bare-bulb hot light (below). He added the crossbars of a window frame with gobos, thereby making the illusion more believable. The same basic setup can take on a whole new flavor with a simple prop change. In another shot, Bean added roses and eliminated the window frame gobo (left). Now the setup suggests a stage spotlight instead of sunlight.

▲ Because the photographer used roses as props and removed the window-frame gobo, this picture suggests the use of a spotlight or stage lighting.

▶ You can simulate sunlight in the studio via a hot light or a bare-bulb flash placed at a high angle. The use of a window-frame gobo adds to the illusion.

CLASSIC GLAMOUR

INGREDIENTS

- 1 Female model
- 1 White or light-colored seamless or white wall
- 1 Large, diffused light source, such as a flash with an umbrella or a large softbox
- 1 Tall, heavy-duty lightstand to hold the main light high above the camera
- 1 White, silver, or gold reflector
- 1 or 2 Short lightstands to hold the reflector just out of camera view, most likely at the model's waist level
- Clamps to secure the reflector to the lightstand
- 1 Background light, optional

I refer to this lighting setup as "Classic Glamour" because it is so widely used. Basically, the resulting illumination is high frontlighting. The light source is at a high angle from behind the camera position or slightly to the left or right.

High frontlighting for women has been in vogue for decades for one simple reason: it makes women look great. The real secret to its flattering effect can be found in the use of the reflector, which kicks back strong fill from the main, high frontlight. Since the fill light bouncing off the reflector comes from a low angle, it effectively reduces the shadows that the main light causes. As such, double chins, deep shadows under the eyes, and long nose shadows become negligible.

The first time you try this setup, compare the effect with different reflectors: pure white, shiny silver, matte silver, shiny gold, and matte gold. A white piece of

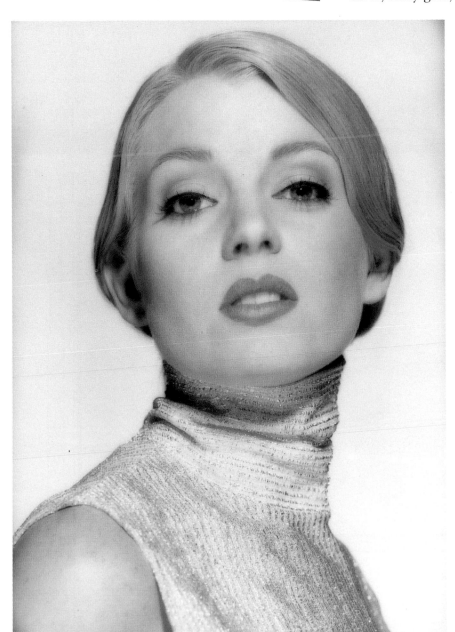

Women always seem to look great with classic glamour lighting. Here, Eric Bean placed a diffused light source far above the camera and then aimed the light down at the model. This high frontlighting was complemented by a shadow-filling reflector tucked in close to the model, just out of camera view.

Fome-Cor or matboard makes a great white reflector. Cover it with unwrinkled aluminum foil, and you have a makeshift silver reflector. Then crumple the tinfoil, cover the card again, and you get a weaker silver reflector. This is because the wrinkles reflect the light in different directions.

Controlling Background Color

In the picture shown on the previous page, photographer Eric Bean made the tan background look white. The addition of a background light that was stronger than the main light caused it to be "overexposed" in relation to the main light. In essence, Bean blew out the background, rendering it completely without detail. If he'd wanted a dark-brown background, he could have reduced the background light in relation to the main light, thereby "underexposing" it.

If Bean had used a black background, he could have switched the white seamless to light-absorbing black velvet. This would have eliminated the background light. You can make a very dark background with almost any color backdrop so long as no extraneous light from the main light or the reflector hits it.

Using Colored Backgrounds

When you work with a non-neutral, colored background or sweep, you need to be careful that a strong background light doesn't accidentally reflect back into the model's face. For example, a red background can turn a subject's face pink. The simplest way to prevent this would be to have the model stand on a neutral-colored floor, and to use the backdrop only as a background, not sweep it out into the studio. The key here is that the floor works as a reflector as well, since the high main light flows down onto it. And the red seamless swept under the model would kick back pink light.

Shooting gets more complicated if you aim a background light onto a colored background, such as red seamless paper. In essence, the background can *become* a reflector, casting pink light back on the set. If the background light is strong in comparison to the main light or if the studio is small, this reflected light could cause a noticeable color cast on the final film.

If this color cast becomes a problem, you can "safeguard" your subject by blocking most of the reflected background light. To do this, put black paper on the floor beneath your subject and then position large cards on either side of the subject, just out of camera view. Then, as long as the background light doesn't catch the reflector, the resulting image will be fine.

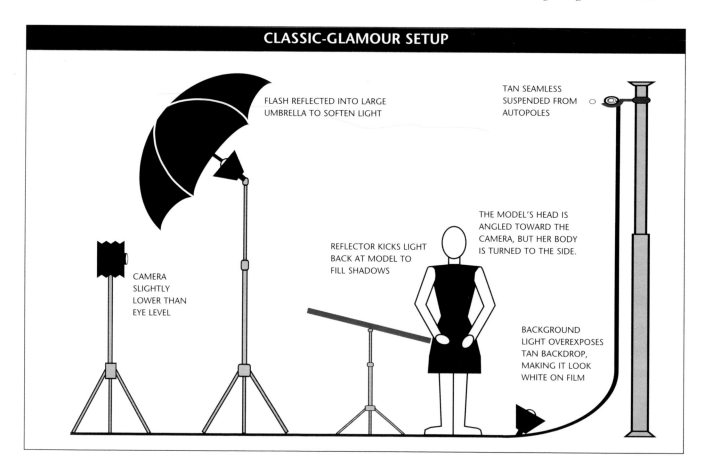

CLASSIC-GLAMOUR SETUP

FLASH REFLECTED INTO LARGE UMBRELLA TO SOFTEN LIGHT

TAN SEAMLESS SUSPENDED FROM AUTOPOLES

THE MODEL'S HEAD IS ANGLED TOWARD THE CAMERA, BUT HER BODY IS TURNED TO THE SIDE.

REFLECTOR KICKS LIGHT BACK AT MODEL TO FILL SHADOWS

CAMERA SLIGHTLY LOWER THAN EYE LEVEL

BACKGROUND LIGHT OVEREXPOSES TAN BACKDROP, MAKING IT LOOK WHITE ON FILM

WHITE TENTING

You want light that has some direction to it, such as high left or right to mimic sky light. But you don't want any harsh shadows since "softness" goes along with the angelic qualities that you're trying to portray. So you need to add a great deal of bounced light in order to infuse the scene with fill light.

White metaphorically means purity, but it also *requires* purity from a photographic standpoint. Any color cast introduced into the studio will have a negative effect on the final image. For example, you can lay down white seamless and see white in your camera's viewfinder, but if the main light or any other lights hit a colored wall, you might introduce ugly color casts.

For centuries, artists have created paintings that evoke an ethereal or angelic feeling by using the color white and bathing the scene in glorious light. So it is no wonder that photographers have adopted white sets and props for their portraits of babies, toddlers, and young families. Mother-and-child (Madonna) shots and bridal portraits also benefit from this technique. The light, airy mood that a white set establishes is an instant hit for this market.

Producing this kind of picture is easy in concept but often difficult to achieve from a logistical standpoint.

Selling Baby Pictures

The best way to sell baby pictures is to show prospective clients examples, whether on a wall, in your store window, or in a portfolio. The holiday themes shown in this section give you a great seasonal hook. Photographer Harvey Branman even donates framed pictures of happy babies and families to a local hospital's maternity ward; in return, the hospital displays his studio information prominently. It is free advertising—and it works.

Shooting a flash through a large umbrella produced directional but very soft light. A bare-bulb flash reflected off a low ceiling created fill light, while the white bed kicked fill light back into the baby's face. The Santa cap added a pleasing bit of color. The only trick was coaching the baby and waiting for the right expression.

Appropriate Subjects

For babies, toddlers, and families, the benefits of this type of illumination are threefold. First, the soft light and white background are cheerful, nursery-like, and appropriately angelic. Second, it is complimentary to the rounded and less angular faces of youngsters.

Third, and just as important, is that this lighting is very forgiving. Toddlers and babies move around a lot. Even when they are in their mothers arms, their heads turn this way and that as they visually explore their new surroundings. With highly directional lighting, this could be disastrous, plunging their faces into darkness or creating deep, ugly shadows.

Tenting works well for brides as well. The forgiving nature of this light is no longer important since as an adult, the bride is more responsive to posing and can move her chin in minute increments, so that the light hits her perfectly. The illumination successfully brings out the soft drapery of her gown and tends to reduce the appearance of skin blemishes or harsh facial lines. In addition, the angelic flavor of the white set and the lighting is particularly appropriate for a bridal portrait. Of course, bridal portraits can also be shot using any number of other portrait-lighting techniques, but the white-on-white approach is always a favorite.

Sexy lingerie shots have become a popular wedding present for women to give to their new husbands. Many wedding photographers offer these shots as an option in their pricing package. Bridal boudoir pictures are almost always done in a white-on-white setting, often with the woman wearing her veil and garter. Some photographers even create a dressing-room setting in the studio. The addition of a diffusion or soft filter adds to the fairy-tale feeling and tends to glamorize the subject.

Selling Bridal Portraits

To sell bridal portraits and bridal-boudoir pictures, try working hand-in-hand with a local bridal shop. Many novice wedding photographers do fashion shoots with the store's merchandise for free, in exchange for the prominent display of these photographs in the store. The photographers' business information is attached, and their brochures are nearby.

Then once you have bookings, encourage the brides to invite their friends to the portrait shoot. They are potential customers as well, and word-of-mouth advertising is still one of the very best types of promotion. For the same reason, make sure your regular portrait customers know that you shoot bridal and wedding portraits as well.

White tenting is often chosen for bridal portraits because it is complimentary to both the bride and the dress. As this image shows, this technique produces an innocent, angelic quality.

Metering Options

This white-on-white situation can be difficult to meter. If you have the option, set up the studio ahead of time and run some test film. If you're photographing a family or children in motion, make sure that the entire "live" area on the set has the same exposure value from edge to edge. If you don't, your exposure will be inconsistent from one side to the other. The easiest metering method is to use an ambient light meter and to take your reading from where you think the models will be.

Suppose, however, that you're using hot lights (no flash) and all you have is the camera's built-in meter. In this situation, you must remember the 18-percent-gray rule, and take your reading off a gray card to avoid drastically underexposed images.

Color Problems

A tough problem to deal with in white-on-white pictures is a color-balance shift. If you're shooting color-negative film, color cast can be corrected in printing. But if you're shooting color-slide film, you are in trouble. The most common cause of color-balance shifts is a tent that isn't pure white. Bouncing light off a pink surface will produce a pink cast. Even some so-called white paints have brighteners that cause blue casts. Underexposure can also result in an overall blue cast. And room lights left on while shooting can cause yellow (tungsten) or green (fluorescent) casts. Daylight seeping through a window can shift the color cast to blue. Finally, heat-damaged film can turn pictures magenta or green. When photographing people, you should err toward warm rather than cool tones.

Can you imagine more unpredictable subjects? Illumination that was even across the whole set helped the photographer concentrate on composition and expression. He didn't have to worry about how the light was affecting the three children, their mother, and their pet rabbit.

FORE AND AFT

- 1 Model
- 1 Main light (hard or soft; it can even be a flat reflecting the background light back at the subject)
- 1 Rim light pointed directly at the model's back from behind (often a bare bulb and from a low angle; this light should be two stops brighter than the main light)
- Cinefoil, a snoot, or a barndoor to aim and limit the rim light
- 1 Light meter to check the balance between the main light and the rim light
- Light modifiers as needed

Fore-and-aft lighting is simple in concept: you have a main light directly in front of your model (fore) and one behind (aft). Because this is an extreme—and somewhat untraditional—setup, it can be a little tricky to pull off. The artistry is in selecting a main light that is appropriate for the subject and the feeling that you're trying to portray. Suppose that you're doing a baby or a glamour shot; the main light will probably be a soft, diffused light from a high front angle. However, any type of light, including a hard, bare-bulb flash or a ringlight, can work if you carefully choose its quality for the model.

Here, Harvey Branman used backlighting in order to achieve a translucent glow in the feathers; this resulted in an angelic look.

Overexposed Aft Light

The aft portion of the lighting is a light hidden behind the subject (either lower than camera view or blocked by the model's body). The purpose of this light is to separate the model from the background by producing a rim, or halo, around the model's back.

A good example of this is the shot of the woman shown below. Photographer Eric Bean created the main light by reflecting a flash head into an umbrella. This soft light complemented the subject's features. However, her skin tone is very close to the color of the backdrop, which could have been disastrous if he'd forgotten the rim light.

To offset his model from the background, Bean fired a bare-bulb flash at her from behind and to the left of the camera. Then he set this flash about two stops higher than the main light, so all the details in this highlight were blown out (assuming the exposure was based on the main light). Bean also took care to prevent any of the rim (aft) light from hitting the camera lens and causing flare.

Photographer Harvey Branman opted for a slight variation of this setup when photographing a little girl (opposite). He used the rim light to illuminate the translucent feathers of his young model. This caused them to glow in an appropriately angelic fashion.

For this shot, photographer Eric Bean pointed a flash head through a soft umbrella from slightly above the camera angle. This produced a flattering, soft light on the model's face. To offset her from a similarly toned background, he fired a bare-bulb flash at her from behind, set at two stops higher exposure to blow out the details. This added a crispness to the final image.

Take a Half Turn

Often photographers get used to standing in one position in their studio and thinking in linear patterns. But outside, with the sun shining, photographers can "alter" the direction of the light in relation to subjects by walking in a circle around them. In the morning, if the photographer faces east, the subject will be backlit. Conversely, if the photographer faces west, the subject will be frontlit. And if the photographer faces southwest, the result is classic 45-degree lighting. Try to keep this in mind when you're shooting in the studio. A simple half turn can make all the difference in your images.

Eric Bean created another variation of this technique by rotating the fore-and-aft lighting 90 degrees (below). After making his initial shot, he likes to walk around his subject and see how the light affects his subject as his camera position changes. Here, the male model is turned sideways, and the rim light comes from the left. In this unusual, side-to-side lighting setup, the main light is simply a large, white flat placed very close to the model on the right side. The reflector is catching the light from a bare bulb that is illuminating the model's back and bouncing light off the flat onto the front of the subject.

Why is the reflector the main light? Because the exposure was based on this light. The reflected light loses about two stops during the reflection process. So the bare-bulb light on the model's back is now comparatively overexposed and records as a burned-out highlight, lacking detail.

If you take fore-and-aft lighting and rotate it 90 degrees, you end up with this effect. Here, Eric Bean used a bare bulb to illuminate the model's back, overexposing it about two stops. This light hit a flat to the right, and reflected back soft light into the subject's face (at the proper exposure).

RINGLIGHTS AND CROSS-PROCESSING

INGREDIENTS

- 1 or more models
- 1 Ringlight for the camera, such as those designed for photomacrography, which fits around the lens
- Fairly high-speed film to compensate for the weakness of the ringlight

- Additional flash heads as the main or background lights, optional
- Slaves to trigger additional flash heads when the ringlight is fired
- An additional quartz or tungsten light to create a blur effect, optional

Ringlights, long the secret of photomacrographers, have their uses in fashion photography as well. Ringlights are circular and literally fit around your lens. Because they surround the lens, they produce flat lighting. If you stand your model near a wall, you'll see an outline shadow around the entire subject.

Photographer Eric Bean used a Sunpak DX12R ringlight to produce two distinct fashion images. In the photograph of the man, the ringlight flash was the main light (left). The barely visible, black-halo shadow on the blue background gives it away, as do the shadows on both his "cheekbones." The third clue is the red-eye effect, caused by the flash being on the same axis as the lens. (Note that Bean could have eliminated the red-eye by either brightening the room lights during the shooting session or turning on the flash's modeling light. He chose not to do this because he liked the odd way the red-eye picked up the vibrant red shirt.)

Both the rim lighting and the glow behind the male model's shoulder was the result of a bare flash head pointed straight at his back. Bean set the flash head at least two stops brighter than the ringlight, which he based the exposure on.

Be aware that you must take care when using a flash unit like the Sunpak DX12R. These units are designed for closeup subjects and, therefore, aren't very powerful. In fact, Bean had to shoot this image at a wide-open aperture ($f/4$) with ISO 100 film. If you need or want to achieve more depth of field, you'll have to switch to a faster film.

The unusual coloration of the photograph was caused by "cross-processing." Bean shot E-6 color-transparency film but processed it in C-41 color-negative materials to produce a negative (see "Cross-Processing" on page 53).

To create this unusual, cross-processed image, Eric Bean combined a ringlight for the main light with a bare bulb behind the model (see diagrams on page 52). Cross-processing of E-6 film in C-41 chemicals (to create a negative) resulted in the vibrant colors of this picture.

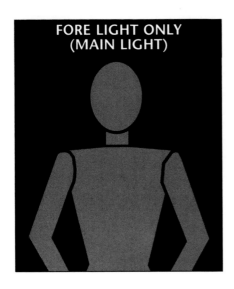

**FORE LIGHT ONLY
(MAIN LIGHT)**

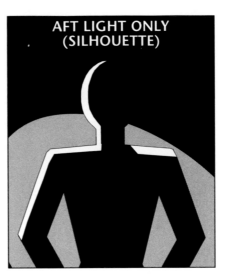

**AFT LIGHT ONLY
(SILHOUETTE)**

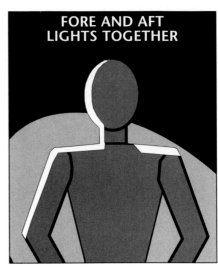

**FORE AND AFT
LIGHTS TOGETHER**

Ringlight as Fill

Like the automatic fill-flash feature found on most point-and-shoot compact cameras and modern autofocus SLR cameras, a ring flash can serve as fill flash instead of as a main light. When photographers use a ringlight this way, they set it to be weaker than the main light. As a result, the ring flash will minimize—but not eliminate—the shadows that the main light creates.

For the female model, Bean used the ringlight as fill. The main light swept across her from a high left angle, casting a distinctive shadow to the right. He fitted the main light with a slave, which fired it at the instant the ringlight fired.

The ringlight, which Bean had set at lesser power than the main light, filled in the shadows from the drapes of the woman's outfit, as well as under her chin and hands. The ringlight opened up the whole picture, leaving no dark shadows visible from the camera (the ringlight fill was on the exact same angle as the camera, actually encircling the lens). A close look at her left arm reveals the telltale outline shadow of a ringlight flash.

Eric Bean used a ringlight as fill for the main light, which swept across the model from a high, left-of-camera position.

Cross-Processing

Many photographers have fun experimenting with cross-processing. But few individuals know that there are two ways to do it. These two techniques yield radically different results.

Shooting Slide Film

Start by shooting E-6 transparency films, but process them in C-41 chemicals. You'll obtain color negatives that appear bluish when you view them on a lightbox. In printed form, the results are vibrant, highly saturated, and somewhat unrealistic colors (see the picture on page 51).

Bean suggests shooting E-6 film normally (he uses Fujichrome 100 film), but push-processing the film by at least a stop. He does this in order to lower the contrast and prevent the loss of highlight details in the cross-processing. Overexposure matched with push-processing lowers the amount of contrast even more, and tends to make the images look exceptionally grainy. Normal exposure mayched with normal processing results in the highest amount of contrast.

Shooting Print Film

Photographer Bobbi Lane prefers to shoot color-negative (C-41) film and process it in E-6 chemicals. This produces a faded look with unusual skin tones (right). The various colors of the base layer of individual types of print film cause these different color casts. Lane usually shoots Fuji NPS negative film at 2 stops overexposed and then push-processes it 2 stops.

Processing and Printing

You'll need to process the film yourself in home chemicals, like those Beseler makes, unless you can find a professional lab that offers cross-processing. If you don't tell the lab staff members what you're trying to do, they are liable to catch your "mistake" and process the film in the "right" chemistry.

Printing is a bit difficult since you have to come up with a whole new color-printing filter pack to get the flesh tones right. You'll want to use a low-contrast paper. Here again, you'll probably have to print the negatives yourself, or find a lab that does custom color printing.

Bobbi Lane shot and processed color-negative film in normal C-41 chemicals (top). Then she cross-processed it (bottom). Notice the different flesh tones and the colors in the painting.

ATHLETES

The trick to successfully photographing athletes in the studio is to show them at the peak of their performance. Whether they are dancers, skaters, golfers, or fencers, they all have trademark moves that show off their skill, fitness, and grace.

Photographer Meleda Wegner generally uses soft lighting to photograph athletes. If she's working with a group of people and/or the action takes up a large amount of space, such as leaping into the air, she selects an extremely broad light source (see page 56). The reason is simple. The light source must cover all the players and all the action, no matter where they take place on the set. This soft lighting also has the benefit of being flattering, and doesn't emphasize sweat or wrinkles in the costume caused by body contortions.

On the flip side, hard lighting can be used to create great drama, to emphasize muscle definition and the glint of sweat. But you'll need to make certain that the model's action is very controlled, so you can predict precisely where the shadows will be on the face, body, and background.

Preparation

The floor of your set is quite important when you photograph athletes, such as dancers, in motion. Seamless paper, even if it is secured with tape, can rip free, slide, or tear, all of which can be dangerous to the models. That is why Wegner places a large piece of Plexiglas, 4 x 9 feet or bigger, on the floor over the seamless paper or backdrop to give the athletes better traction than paper or canvas does (right). She secures the Plexiglas to the wood floor

with tape and sometimes lead set weights, just out of camera view. She keeps a close eye on her lighting throughout the shooting session to ensure that an ugly glare doesn't come off the Plexiglas.

If the seamless is white, Wegner uses white Plexiglas. If it is any other color, she uses clear Plexiglas. Anyone who has ever shot full-body pictures on white or light seamless paper or canvas will also appreciate how easily scuff marks and dirty footprints clean up. Just be certain to use a Plexiglas cleaner because glass cleaners can leave permanent clouding and streaks on the Plexiglas.

Instead of or in addition to a dressing room, you'll need to provide your subject with an open area away from the set where they can stretch and warm up, especially if you're going to ask them to assume athletic stances for the pictures. In the warm-up area, Wegner sets up a huge, 4 x 12-foot mirror, which enables the athletes to perfect these movements before going on set. This helps boost their confidence, too.

Pay attention to your subjects' special needs as well. Suppose, for example, that you plan to photograph a golfer in full swing. Before you shoot,

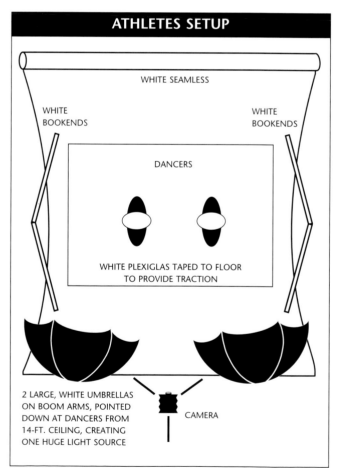

ATHLETES SETUP

WHITE SEAMLESS

WHITE BOOKENDS

WHITE BOOKENDS

DANCERS

WHITE PLEXIGLAS TAPED TO FLOOR TO PROVIDE TRACTION

2 LARGE, WHITE UMBRELLAS ON BOOM ARMS, POINTED DOWN AT DANCERS FROM 14-FT. CEILING, CREATING ONE HUGE LIGHT SOURCE

CAMERA

you must make sure that all your lights and boom arms are high enough to be out of harm's way.

When Wegner photographed professional skater JoJo Starbuck, she discovered that skaters pose a special problem. Since their skating blades are as sharp as knives, they can destroy the photography studio's floor and Plexiglas and canvas backdrops. But photographing Starbuck with safety guards on her skates made her look silly. Wegner came up with a solution that involved painstakingly applying several thin strips of gaffer's tape to the bottom edge of the skate blades. The tape wasn't noticeable on film, provided the skater with more traction, and protected the floor surfaces.

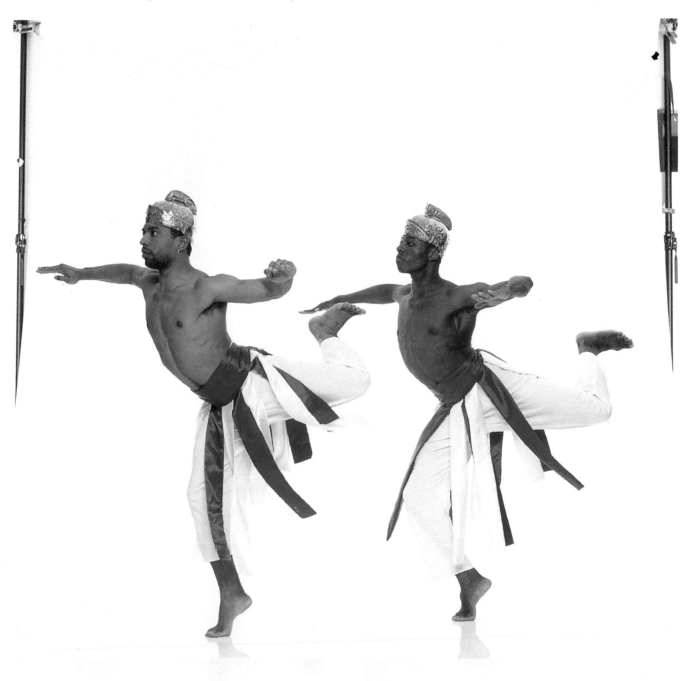

In this uncropped (for educational purposes) shot, a Plexiglas floor was used to give the dancers traction. This surface is a studio photographer's friend because it is easier to clean than seamless paper or canvas backdrops. The large light source was created from two flash units with umbrellas. They're held near the ceiling by two heavy-duty boom arms.

Choosing the Action

Deciding what action to shoot is a large part of whether your picture will be a success or not. If you aren't familiar with the athletes' routines or performances, ask them to demonstrate some of their trademark or favorite movements, or do a short run-through. Since they are performers, they'll probably have a good sense of viewer appeal, and selecting one or two elements from their repertoire shouldn't be difficult. If timing is critical, let the athlete or the leader of the troupe give the "1, 2, 3" count for best results.

For the group of dancers photographed on white, Wegner actually used light reflected into two oversized umbrellas. The umbrellas touched the ceiling and were held high above the camera by two heavy-duty boom arms. They were synched with slaves to fire with the shutter.

It is important to note the reason why the image shown on the previous page is uncropped, with the seamless, the autopoles, and the edge of the Plexiglas clearly visible. Since the final photograph was going to be silhouetted, Wegner gave little thought to the outlying edges of the frame. However, if this hadn't been the case, she would have used a longer lens and backed up in the studio, or simply used a wider backdrop and larger piece of Plexiglas.

A broad light source kept the subjects evenly illuminated, even as they jumped into the air.

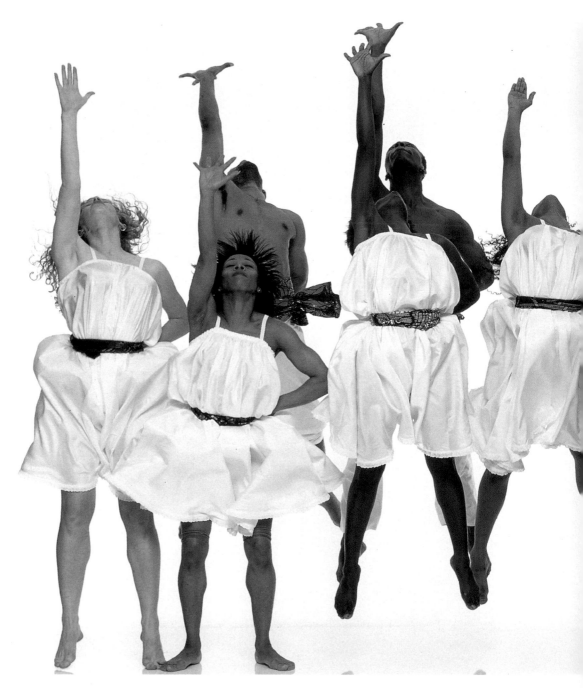

Keep It Simple

When Wegner photographed JoJo Starbuck, the main light source was a softbox to the right of the camera. The photographer then positioned a spotlight with a 10-degree grid behind her on the right side of the camera in order to create a bright edge to her right. The main light produced soft contours, while the spotlight separated Starbuck's torso from her arm and the background.

The finishing touch was a light breeze from a wind machine that added just a hint of bounce to the skater's hair. The beauty of this device is that its air flow is quite targeted, so it can be directed at a small, specific area.

When you shoot a full-body shot of a standing athlete, posing is particularly important. If the pose isn't dynamic, the model won't look athletic. A good start is to make sure that the model's legs and hands have visual separation from the body to avoid a tree-trunk look. Simply asking athletes to shift their weight onto one foot will often start this process by altering their balance. Here, the photographer had Starbuck tilt her torso away from the camera in both pictures (even though she was looking toward the camera); as a result, her pose immediately became stronger.

Good posing doesn't stop here—it continues into fine details. Ever the professional, Starbuck has studied and perfected her body poses, right down to her graceful finger positioning. If her hands had been awkwardly clenched in the first shot, the image would have lost its appeal.

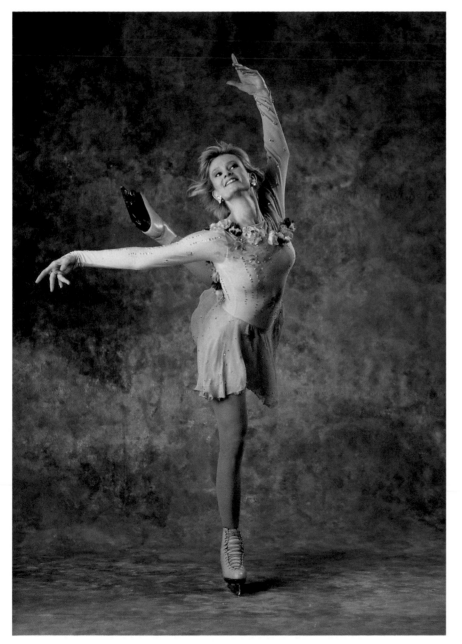

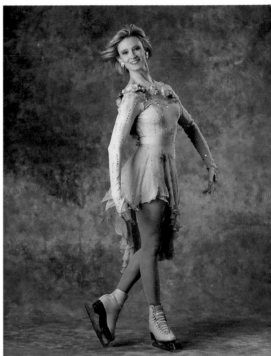

The elegance of professional ice skater JoJo Starbuck's pose begged for simple lighting, which consisted of a softbox and a spotlight. Photographer Meleda Wagner took special care to prevent the skater's super-sharp blades from slicing the canvas. Wegner's solution was to apply several layers of thinly sliced gaffer's tape to the bottom of the blades. Not only did this protect the canvas and the floor, but it gave the skater better traction for her maneuvers. Wegner didn't used Plexiglas on the floor because it was too slick.

MOVING SUBJECTS

INGREDIENTS

- 1 Child or a group of children
- 1 or more parents, optional
- 1 Large, soft light source at least 4 x 4 feet and made from 1 or more softboxes (stacked), or a large, white flat with 2 flash heads bounced off it
- 1 or 2 Fill cards
- 1 Seamless paper or canvas sweep
- A Standing platform, optional
- 1 Middle-range zoom lens, optional
- 1 Flash meter
- Counterweights to secure the lights and equipment

"Stand on the 'X'." "Tilt your head counterclockwise." "Smile subtly." These are typical commands that photographers use to coach the best possible portrait out of adult models. And most models, amateur and professional alike, have little trouble following them.

But when your models are children, these cues and rules break down. Even if your subjects are old enough to understand your requests, the commands will quickly crush all spontaneity, and you'll end up with a stack of boring pictures. What you need is a lighting setup that is forgiving. If the children move off the "X"—the optimal lighting point—turn toward or away from the light, or even stand on their head, you want good results.

Establishing the Good Exposure Zone

Photographer Meleda Wegner utilizes a simple setup that has great latitude, enabling her model to move within a zone (front, back, and side to side) with little or no change in overall exposure or lighting (see the diagram below). She starts with an extra-long, extra-wide backdrop that she sweeps out into the studio from on top of two autopoles.

Next, she positions a large softbox, or two smaller softboxes stacked, to the side of the camera about 4 or 5 feet away from the model. This, in effect, creates a huge light source in relation to the subject. Opposite the softbox on the other side of the model, Wegner arranges a set of 8-foot white bookends, or two large flats, to act as fill and bounce light from the main light back toward the shadow side of the subject. Because the softbox is taller and wider than the child, the model can move back and forth without moving out of the main circle of light. If the child does go out of

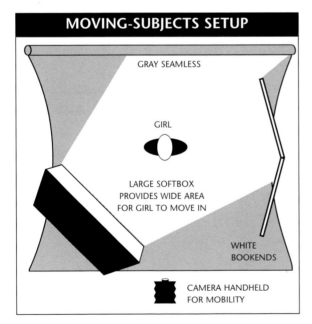

MOVING-SUBJECTS SETUP

GRAY SEAMLESS

GIRL

LARGE SOFTBOX PROVIDES WIDE AREA FOR GIRL TO MOVE IN

WHITE BOOKENDS

CAMERA HANDHELD FOR MOBILITY

Photographer Meleda Wegner had her hands full with her young subject, who was having a wonderful time dancing all over the set to her favorite CD. The setup prevented the girl's energy from being a problem.

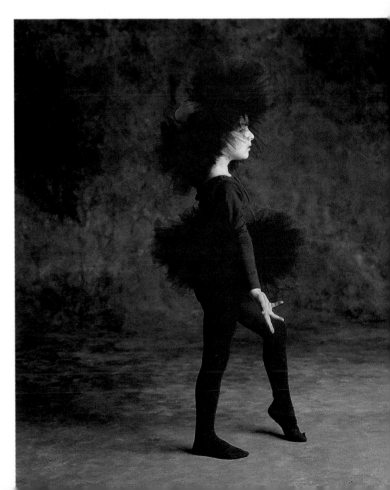

this area, which is called the "zone of good exposure," Wegner can quickly close or open the aperture by 1/3-stops accordingly.

When photographing children on the go, you might want to abandon your tripod and hold the camera in your hands. Keep in mind that you need to be able to recompose quickly as the models move. If you're working with a 35mm camera, consider a zoom lens. Another option is to shoot with a wider-than-normal lens and plan to crop the end result.

Plan Ahead

For most children, being photographed is fun and novel for only a limited period of time. So you should complete all of your preparation, lighting, metering, Polaroid test prints, and other "boring" tasks before your young subjects arrive at the studio. Remember to check the lighting and metering from a child's height, rather than your own—even if this means having your assistant or a friend stand on his or her knees. Then do everything else that you can think of before the children walk in the door. Set up the backdrop, tape any loose wires to the floor, load the film, and lay out or identify potential props and clothing. Once the children arrive and get on set, all you'll possibly need to do is tweak the lights.

When working with children, you must be especially careful about your equipment because they are curious and can hurt themselves. As a precaution against tripping and bumping, start by taping down all wires to the floor with removable gaffer's tape. Next,

counterbalance the weight of your lightstands to prevent them from falling over if the children bump into them. Commercial set weights, sandbags, or milk jugs filled with water will do the trick.

During the session, you'll be busy shooting and concentrating on photographic matters, so try to recruit an assistant to act as a "child wrangler." This person's jobs are to interact with the children to keep them comfortable and enthused, and to make sure that they're having fun—especially when you're taking care of dull stuff, such as rewinding film, switching lenses, or evaluating a Polaroid test print.

The child wrangler can also be responsible for keeping your young subjects from knocking over lightstands or touching flash powerpacks. Usually, the children's parents aren't the best choices for child wranglers. In fact, many photographers try to get the parents off the set and out of sight as soon as possible. Children are often more self-conscious and poorly behaved in front of their mother and/or father.

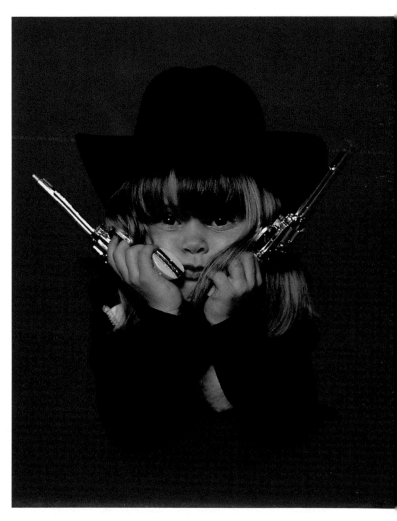

By keeping her camera off a tripod, the photographer was able to quickly move closer when her subject sat down for a rest. The result: a tightly cropped portrait of a little cowgirl.

Quick Hint

Use props. When photography becomes a game of "dress-up," many youngsters become enthusiastic models, especially when they choose the clothes themselves. Hats are an ideal prop for both boys and girls.

59

Making Children Comfortable

Playing music during the shoot is a great way to get young models enthused and relaxed, especially if they've picked out and brought their own selections. Ask the parents to pack their children's favorite tapes or CDs when you plan the session.

Advise the parents to bring a variety of clothes as well, even if they have their heart set on a photograph with a particular outfit. If the outfit gets dirty or the child doesn't feel comfortable in it, a quick change is needed. And if you plan to photograph children often, you should stockpile fun toys, teddy bears, hats, and costumes that will be new to and delight your young models. These items serve three purposes: making the children feel comfortable in strange surroundings; entertaining them during downtime, such as waiting for a sibling to be photographed; and providing creative props for the pictures themselves.

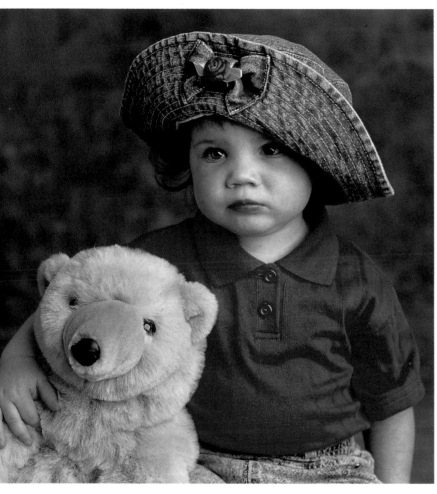

This toddler wasn't enjoying the modeling process at all, even after she befriended the photographer's teddy bear. But once she took a short break to play with toys in another room, she was able to start fresh. It is the photographer's job to make the studio as unintimidating as possible.

Finding a Market

As long as there are proud parents, there will be a market for photographs of children. Some parents want serious portraits, while others want fun pictures that show off their children's unique personalities. And still other parents have professional aspirations for their youngsters and want photographs for modeling portfolios.

Aspiring models are a terrific market. Agencies and clients always want to see recent photographs of children since they change so quickly as they grow. Once you have a happy client, chances are good that you'll get steady work. In addition, these particularly photogenic subjects will help you produce exceptional sample prints that you can use as sales tools for getting other clients.

Through the imaginative use of props, you can create seasonal marketing opportunities that make portraiture a timely, top-of-mind event. Christmas (Santa hats, presents, and religious scenes), Hanukkah (menorahs, candles), Easter (rabbits, bonnets, and baskets), and even Halloween (pumpkins, candy, costumes) photographs are terrific. Try photographer Harvey Branman's method of offering free seasonal exhibits (with his address attached) to hospitals or community centers where parents are likely to see them.

CHARACTER PORTRAITS

INGREDIENTS

- Model or character actor**
- Props or costumes appropriate for the subject
- 1 Single light source, hard or soft, probably from an angle that is more extreme than usual
- 1 Background light, if desired
- 1 Fill light, if necessary

 ** Plan to spend some time interviewing your subjects before the session in order to learn about the character, gesture, or overall feeling they hope to portray in the photograph.

In general, character portraits aren't designed to be glamorized portraits, like those you can find in the "Classic Glamour" and other sections of this book. They're intended to show actors in a role. Think of these shots more as caricatures that show off an actor's expressions and body language.

One of the most successful techniques when shooting character portraits is using a single light. This is often a hard light or a light at a dramatic angle, or both. Hard edges and dramatic angles tend to emphasize or even exaggerate facial (character) lines, which in turn reveal an individual's uniqueness.

Set Goals

Before beginning the shooting sessions, carefully discuss the models' goals. What are they trying to portray: an emotion, a role, a gesture? How do they want their characters to be perceived? For example, do they want to come off as motherly or fatherly? Do they want to appear wild and reckless? Do they want to instill a feeling of trustworthiness and integrity, like a respected corporate executive, or are they the quintessential sleazy salesperson? Do they want to show off their range of emotions, from ecstatic to sorrowful, or to act innocent or guilty? Also, how much characterization do they want to put into it? Do they want their portrait to look comic or serious? Realistic or outrageous?

Once you've established your clients' goals, work with them on gestures, costuming, and props. A cigarette might be a great prop for the sleazy salesperson, but it is inappropriate for the motherly or

fatherly characterization. For example, a simple hand gesture can help create a realistic depiction of a person in a deep depression, while a slight variation toward exaggeration of the hand gesture creates a comic cartoon of sorrow that looks like a still image from a silent film. Similarly, for the picture of the baker, photographer Alan Farkas came up with the idea of using the flour (below). This element added a touch of comedy. To create this portrait, Farkas positioned a large softbox at a 90-degree angle to the camera directly from the side at the model. Next, he placed a large, white flat at a distance to the left, to give just a little bit of fill light. A weak background light helped to separate the baker from the the dark background.

Character portraits can almost be caricatures or cartoons, with props and expressions playing a big role. For this reason, dramatic sidelighting works because it brings out and emphasizes facial expressions.

Play with the Lights

Once you and your clients have firmly established goals, you can set up the lighting equipment. Start with a hard light source, either a flash or a hot light, and pick a direction. You might actually need to try a number of angles, from high front to straight from the side. Optimally, you should stand at camera angle and have an assistant move the lights around so that you can see what effect the different arrangements have on the subject.

If the shadows are too deep, you can start adding fill by placing a white flat to the shadow side, just out of camera view. Conversely, if the shadow lines are too harsh, begin diffusing the light source with scrims, umbrellas, or even a softbox. For character portraits, it is probably best to start with hard lighting and to modify, or soften, it as needed. The hard light helps you quickly identify the facial features you want to emphasize.

In the "Hollywood starlet" image, Farkas used one spotlight to illuminate the outdoor scene, which is no secret because it is visible in the picture (below). Here, the light actually becomes a prop, as well as acts as a light source. Notice how the hard light clearly defines and even overemphasizes the woman's cheekbones. And the stage-spotlight feel goes well with her "Taa-Daa!" body posture.

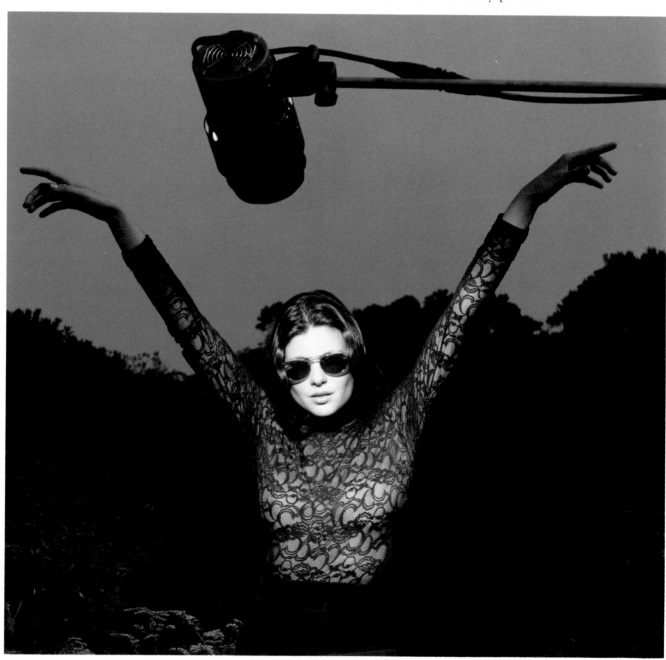

A spotlight became a prop in this "Hollywood starlet" character portrait.

PORTABLE PORTRAIT STUDIO

INGREDIENTS

- Battery-powered flash units, or monolights or powerpack flash units with plenty of extension cords
- Collapsible light modifiers, such as umbrellas and portable softboxes
- Lightstands and weights to counterbalance lightstands
- Backup gear, including an extra camera, sync cords, and a meter
- Collapsible reflectors
- Foldable backdrops, autopoles, and clamps to secure the backdrop
- Gaffer's tape
- Assorted clothes to improve the composition
- A makeup kit for nonprofessional models

The portable portrait studio can include just about everything listed in Part One of this book. Of course, you would need a power generator, a moving van, and 20 assistants to haul the gear. The trick is to scale down and still be able to produce studio-quality images on location.

The most mobile you can get involves powerful, battery-powered flash units, like the popular Norman series. These units enable you to shoot in the great outdoors without having to worry about electrical outlets. If you're working indoors or at extension-cord distance from electrical outlets, you can use ordinary studio flash units with powerpacks. Check with the homeowner or building superintendent to make certain that your electricity-hungry equipment won't cause a fire hazard or overload the circuits.

Keep in mind that you should always take along more extension cords than you can imagine using. Bring outdoor models if you plan to venture there. And unless you are all alone, you need to tape the cords to the ground so you don't trip any passersby.

Light modifiers, such as softboxes and reflectors, come in portable versions as well. If you don't own collapsible or foldable softboxes, reflectors, and backdrops, you can rent them for the occasional location shoot. They are worth the expense involved. And umbrellas are quite popular for location portraiture because they are so quick and easy to both set up and take down. Similarly, the Flexfill-style collapsible reflectors that twist and fold into 1/3 their extended size are also helpful on location.

Shooting Techniques

Bobbi Lane took a decidedly portable approach while working outside her studio (below). For this portrait of a woman in white in her living room, Lane opted for monolights. You can plug these lights directly into a wall outlet without a powerpack. This feature makes them an ideal choice for shooting at a remote, indoor location. Here, the main light was one strong flash shot through a white umbrella. The fill light was natural light coming from the window and bouncing off the white ceiling and walls. A white card was used to aim more of the fill light directly back at the model. Since the sunlight was weak in comparison to the monolight, Lane needed to keep the shutter open for 1/8 sec. at *f*/8 to make it look balanced.

Photographer Alan Farkas made a shot of a young baseball player in the late afternoon for Cancer Action (see page 64). In order to illuminate his subject,

The photographer achieved simple location lighting by combining one monolight and natural sunlight. The main light was diffused through an umbrella; the fill light was bounced off the white ceiling and walls and a white card next to the model.

Farkas used a battery-powered flash unit with a medium softbox attached. Then to create the unusual, dreamy quality of the photograph, he threw everything except the boy's face out of focus via the swings and tilts on a 4 x 5 view camera (see "Swings and Tilts Focusing Effects" below).

Packing a Bag of Tricks

Once you leave your studio for the location, you need to be completely self-sufficient. Be sure to pack plenty of gaffer's tape, both black and white; assorted clamps; lens tissue; baby wipes for cleaning just about anything; extra sync cords and a PC repair kit; a spare camera body; model releases; and plenty of business cards and promotional materials.

If you're working with nonprofessional models, bring along a full makeup kit with fresh lipsticks and mascaras. And remember, men can benefit from matte powder to eliminate perspiration shine from their foreheads, too. (Of course, you might have to explain to some male models that you're applying the makeup for technical not cosmetic reasons.) A bag of different colored shirts and a blazer or two can save the day if your subject's clothes don't fit the mood or are the wrong color.

A single softbox and a battery-powered flash illuminated this outdoor scene. The unusual focusing effect in this picture was produced via the use of the swing and tilt controls on a 4 x 5 viewfinder. This altered the plane of sharp focus from straight up and down to diagonal.

Swings and Tilts Focusing Effects

The unusual focusing effects found in Farkas's picture of the young baseball player weren't caused by diffusion or spot-mist filters. If you look closely at the image, you'll notice that the boy's face is in focus and that the rest of his body is out of focus. This effect isn't possible with most 35mm cameras since the plane of sharp focus is designed to be parallel to the film plane. Therefore, if you were to photograph this boy with a 35mm camera pointed straight at him (not tilted up or down) while he stood upright, the whole plane of his body would be in relatively sharp focus.

View cameras (and a few specialized 35mm lenses and medium-format cameras) offer swing and tilt controls. These enable you to swing the angle of the lens or the film plane to either side, or to tilt it back and forth. As a result, by manipulating the film plane in this manner, you can alter the shape of the image. And you can alter the plane of sharp focus, which is usually straight up and down, by manipulating either the lensboard or the film plane.

In terms of both product photography and working with minimal depth of field, being able to change the plane of sharp focus from straight up and down to diagonal, for example, can permit you to get the whole scene in focus. Alternately, you can utilize the plane of sharp focus as Farkas did in his shot of the young boy. The photographer used it to throw the rest of his subject's body radically out of focus.

Simulate a Studio on Location

Just because you're shooting on location doesn't mean that your images have to look like it. When you go to where your subject is, you might not always be lucky enough to find an exquisite background with terrific lighting. For this reason, you're sometimes obligated to "create" a controllable studio setting at a remote location. The set can look like an actual setting using a realistic backdrop and props, or it can look like a studio with a traditional, dappled portraiture backdrop. I've even seen photographers shoot traditional studio portraits on street corners with a painted backdrop hung from the side of their vans and the lights powered by a generator hooked to the vans' motors.

Photographer Meleda Wegner chose to recreate a studio feeling on location when photographing guests at a wedding (below). In a side room of the reception hall, she set up two autopoles with a crossbar, draped a canvas backdrop over it, secured the cloth with clamps, and then "swept" the backdrop into the room. Next, she placed a handsome posing couch and floral arrangement on the set. Wegner illuminated the scene with studio flash equipment via powerpacks and a large, portable softbox. She then asked guests to step out of the reception hall and into her portable studio to be photographed.

Safety First

From a safety standpoint, anytime you are on location you have to worry about the safety of passersby and onlookers. Some photographers put fluorescent-orange or yellow hazard tape on the tips of their tripod and lightstand legs. This helps call attention to them, even if the onlooker is starstruck by the model. (It also has the added benefit of making pieces of equipment quite noticeable in the viewfinder if they creep into the live picture area.)

Furthermore, the lightstands and tripod need to be heavily counterbalanced with weights in order to stabilize them if they're bumped into or the wind picks up. Rather than carry heavy, lead set weights, you can bring along several collapsible gallon water jugs designed for camping. Simply fill them with water (from a fountain) or with sand (on the beach), and then tie them low on the stand.

And always remember the hazards of working with high-powered electrical equipment near water—and *never do it*. This includes the ocean, swimming pools, puddles, and even rain.

A studio setting was recreated at an actual wedding reception for this shot of guests, complete with flowers and a loveseat as props.

THEATRICAL PORTRAITS

INGREDIENTS

- Models or performers
- 1 or 2 Flash units
- 1 or 2 Tall, heavy-duty lightstands
- Grid-spot attachments to help direct the light in a spotlight-type fashion
- 1 Black studio, or a studio made to seem black with a black seamless backdrop and large, black flats
- 1 Fog machine or can of fogging spray
- Colored gels for impact, optional

Theatrical and stage-style lighting of musicians, theater troupes, and other performers can, of course, be shot in a photojournalistic fashion at the real performance. But then you're restricted to the lighting set up by the lighting crew, which is geared toward audience reaction, not photographers' needs. You're also limited in terms of your shooting angles, and you can't stop the show to pose your subjects. Instead, many photographers prefer to reenact the action in the controlled setting of their studio, or even in the theater itself on a "dark" night.

A Nighttime Illusion

The typical Broadway-style show takes great care in its production values. The lighting designers add to the drama of the scenes by using strategically placed spotlights. The designers will bathe a scene with a bank of overhead lights, and then in the next moment plunge it into darkness and use a single spotlight to emphasize one character. They'll momentarily blind the audience by sweeping a spotlight into the crowd, knowing that the viewers' eyes will automatically follow it. And to suggest a foggy night or a smoky lounge, designers rely on a fog machine or dry ice to churn out "fog."

To get the feeling of a stage production in your photographs, you can utilize these theatrical techniques, as photographer Bobbi Lane did for her client, the Boy Scouts of America (opposite, top). Her goal was a nighttime illusion, reminiscent of a Charles Dickens novel. Drawing upon her knowledge of stage productions, she started with costuming, selecting clothing with a vintage flair for both the adult and child models. Next, she rented a Rosco fog machine from a props-and-special-effects house.

Lane then decided she needed to shoot either in a large black studio or outdoors at night; she didn't want to worry about light bouncing off white walls. She wanted to be able to circle around the model, with any of the four black walls (or the unlit black void of the great outdoors) available as a black backdrop. She ended up working outdoors. Either way, she would have been able to shoot the two very different photographs shown here. She made both with the same exact lighting; the only difference was that the photographer moved in relation to the lights.

Lane's lighting setup was simple. The main light was a strong flash unit that she'd placed on a tall lightstand to mimic a streetlight. A grid spot attachment aimed the light in a spotlight fashion. Finally, she positioned a second flash unit at a low level, about 5 feet off the ground, and put a blue Rosco filter on it. Keep in mind that Rosco and other cinematography filters are designed specifically to cover lights, as opposed to the delicate gels used over camera lenses. The prominent feature of lighting gels is that they are heat resistant, whereas camera filters are optically clear and extremely precise in coloration.

Once the set was ready and the models were in place, it was time to create the "fog." The beauty of a fog machine is that it produces very thick fog that clings for a remarkably long time precisely where you paint it. Next, Lane carefully painted fog in between the models and the lights, and then quickly began shooting. (Had she been in a studio, Lane would have closed all the windows and doors before applying the fog to prevent an internal wind current that would pull the fog into places she didn't want it to be.)

In one photograph, the main streetlight illuminates the right side of the models (opposite, bottom). The second lower light, which you can actually see in the background, backlights the fog, thereby enabling the two figures to stand out as silhouettes. Lane utilized the exact same lighting for the second Boy Scout photograph, which she shot just a few moments later. Here, Lane circled around the set so that she was to the left of the low light. In this shot, this light skims across the boy's face to reveal three-quarter lighting across his face, while the streetlight illuminates both his hand and the coin.

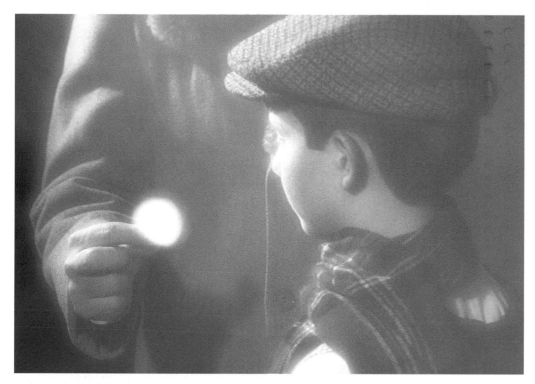

Photographer Bobbi Lane used the exact same lighting but different camera angles for these two images. By shooting in outdoors, she was able to circle around her subject to produce two distinct images. She could have achieved the same results in a large, black studio.

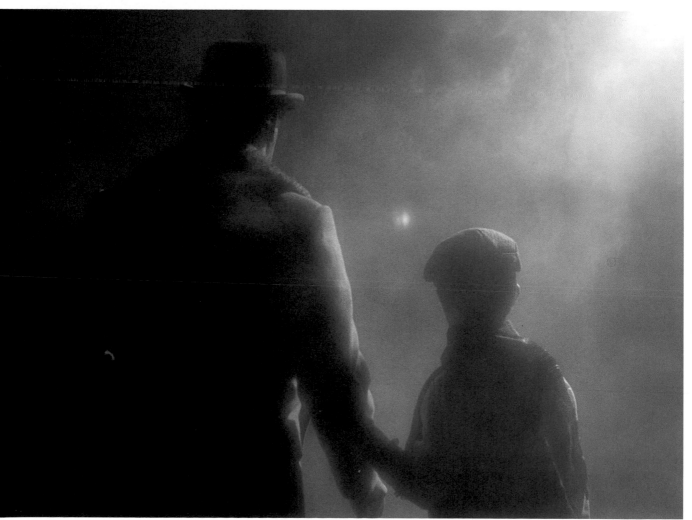

Lighting Wizardry

The Merlin photographs, which Lane created for a multimedia presentation for a new product launch, required a similar technique. In the full shot, a spotlight overhead creates a hair light on Merlin (below). The table and the front of the wizard are illuminated by a main light to the left of the camera. A light on the far right, which the photographer gelled with a green Rosco filter, introduced both theatrical color and a weak fill light. Also, the far-right light catches in the fog, turning it green.

If you look closely, you'll see that the crystal ball in the image tells the whole story of the lighting design (opposite, bottom). This detail, enlarged from the original photograph, clearly reveals all three light sources reflected. Talk about wizardry! The top highlight is sharp and specular, indicating that the rim light was a hard light, such as a spotlight. The main light, which is apparent on the bottom right of the crystal ball, is more diffuse, and thus has diffusion material over the head to produce softer shadows. The third highlight, which is green, is large because the fog is diffusing it.

In the second set of photographs, which contain the hands and the crystal ball, you can see the effects of two very different types of lighting and how fog reacts to them. The green image shows backlit fog and a backlit crystal ball (opposite, top). The effect is an ethereal, glowing fog. Lane shot the white scene with an ungelled softbox from a high left angle. Here, the hands, gold ring, and skull are well lit, but the fog seems less mystical.

A main light, a hair light, and a fill light take on a whole different appearance when you add fog and gels.

Backlighting with a gelled spotlight (top) renders both the magician's hands and the fog differently than high left lighting with a softbox does (bottom).

Part Three
CORPORATE AND INDUSTRIAL SHOTS

7HE ROLE OF CORPORATE AND INDUSTRIAL photographers is hard to identify because they solve the photographic needs of the diversified business world. In addition, they often serve as jacks of all trades, doing everything from corporate portraiture to product shots. For the sake of simplicity, however, the recipes in this section are limited to producing images that you might commonly find in annual reports and corporate brochures.

Annual-report photographers usually need to photograph important executives, as well as workers in action. Some companies and annual-report designers prefer the classic executive portrait, in which the individual is posed in what appears to be an executive office. Others ask photographers for more natural and photojournalistic-looking pictures that show the executives and other workers in real-life situations. But as you'll see in the following recipes, "real-life" doesn't mean "as you find it" or "existing light"; it means "make the lighting so good that it looks real." That is the true key to success in this photographic specialty.

CLASSIC EXECUTIVE PORTRAITS

INGREDIENTS

- Flash units for the main, fill, and background lights (if necessary)
- Umbrellas or easy-to-set-up softboxes
- Plenty of extension cords
- Portable reflectors
- Extra PC cords

- 1 Spare camera (in case of equipment failure)
- An assistant to stand in for the executive while you set up the lights
- Matte makeup to eliminate the subject's sweat glean (if necessary)

Dealing with Time Constraints

Like most people in the general populace, the executive probably thinks that photography is a quick, point-and-shoot activity and doesn't understand the time and know-how it takes to light something or somebody well. And to make matters worse, executives are usually highly paid individuals who believe that time means money. As a result, you're generally given very little time to set up your shot and even less time to shoot it. This is especially true when you're shooting in an executive's office and, therefore, disrupting business even while you're just setting up. So, when booking the shoot, try to ask for a certain amount of time to be set aside, such as 20 or 40 minutes. This way, the executive will have a realistic view of what is expected.

Unless you know that you've been scheduled for a specific block of time, however, be prepared for the worst. I've heard many stories about photographers who set up their lights and shot off just one or two quick frames before they were informed that their time was up and the shoot was over. Obviously, simplicity is the name of the game. It is better to have a quick, fail-safe method rehearsed and ready than to experiment and fuss with the lights on site—and risk losing out on actual shooting time.

A photographer I spoke with took this philosophy to an extreme. He once had the opportunity to photograph the President of the United States, but was told that he could have only two minutes of the President's time. Rather than rely on a photojournalistic approach involving either fast films and ambient light or an on-camera flash, he hired four assistants and created a precision drill team. Two of the assistants served as human lightstands and held the lights in place with the battery packs strapped to their belts. The other two assistants held up a backdrop behind the President to create an instant studio. The task was easily performed with style and within the time limit.

Photographer Bobbi Lane's method is far more practical—and affordable—on a regular basis. Her first choice calls for a single flash unit, preferably a

Executive portraiture can be simple if it is appropriate to bring the executive to your studio. Then you can have full control of the situation and use almost any of the lighting techniques introduced in Part two. But most high-level corporate executives rarely have a lot of free time, and leaving the office to travel to your studio often isn't an option. Furthermore, many of the most successful corporate portraits show the individuals in their "power" offices, on the factory floor, or in their work environment. So, a great deal of executive portraiture involves location photography.

With this kind of work, you often can't scout your shooting location ahead of time since many private businesses (and executives' private offices) are off-limits to everyone except employees. If possible, when booking a job like this, try to arrange a scouting trip ahead of time with an office assistant. Take careful notes when scouting, and plan shots in your mind's-eye. This previsualization will help you plan what equipment to bring and should speed up your setup time. For example, you'll know whether you have to deal with a picture window that has no shade, ugly fluorescent lighting, cramped quarters, low ceilings, or colored walls that might cause an unappealing color to be reflected into the photograph.

monolight that plugs directly into the wall. Onto this she mounts a large umbrella with a white interior. She also brings a large, white reflector, either the collapsible-disc type or a piece of Fome-Cor. Next is her camera bag packed with a main camera, a backup body, and several lenses. Just in case, Lane carries two monolights for background, fill, or backup lights. She carefully packs them to fit onto one industrial-strength travel cart, and slings her camera bag over her shoulder.

Upon your arrival at or admittance to the shooting area, one of your first tasks is to determine where to shoot. If the executive is waiting, be sure to tell the individual to feel free to keep working while you set up. If you're shooting in an office, look for an area within it that is uncluttered but that is still identifiable as a business setting. Ask permission to move chairs, lamps, and furniture (within reason), or to straighten up a cluttered desk in order to simplify the scene. (Make certain that you move everything back to its original place afterward.)

If at all possible, use an assistant (someone you brought with you or the executive's assistant) to sit in while you set up the lights and shoot test Polaroids. This way, you can get fairly close to the right lighting before the executive arrives on set, as well as quickly finalize the lighting at that point.

In an executive portrait shown here, Lane illuminated the executive with a strong flash reflected into a jumbo umbrella at a 45-degree angle to the right of the camera (below). On the opposite side of the camera, she placed a fill card. Next, she read the light coming through the window. Although her sync speed could have been as fast as 1/250 sec. with the camera she was using, she bracketed the shutter speeds between 1/4 sec. and 1/30 sec. and asked the man to stay very still. These long exposure times resulted in a mixture of flash exposure (on the executive) with natural light from the window and a warm (tungsten) glow from the lamp. All in all, from arrival until finished shot, Lane was given less than 15 minutes to shoot.

From the moment of her arrival to the final picture, photographer Bobbi Lane had less than 15 minutes to set up the lights and shoot.

ENVIRONMENTAL PORTRAITS

Environmental portraiture varies from executive portraiture in that photographers pay much more attention to the environment. When you shoot executive portraits, you want to create a sense of place and, therefore, include some of the icons of a "power" office. However, these icons should just be symbols that let a viewer know that this is a picture of an important executive; they shouldn't otherwise be emphasized.

Environmental portraits, on the other hand, use the setting to convey information about the individual to the viewer. In general, this means pulling the camera back a bit to reveal more of the location. For example, photographer Alan Farkas decided to photograph a master organist in a recital hall rather than in his small office or in a studio (opposite). Then Farkas posed the master's protégé in the background for both symbolic and graphic purposes. And because Farkas traveled into the musicians' environment, this is unquestionably location photography. Although this kind of photography calls for portable gear, it doesn't necessarily mean less gear. In fact, Farkas needed five flash units to make this shot.

Orchestrating the Shot

In a relatively large, handsome setting and with more than 15 minutes to set up, Farkas created this portrait of the Master Organist at the Eastman School of Music in Rochester, New York. Using his assistant as a stand-in, Farkas prepared the lighting for the master. He posed his subject in a profile stance in the foreground and illuminated him from the side with a medium softbox, just out of camera view. Next, Farkas's assistant posed at the organ while the photographer set up the lights for this area. He chose a high-skimming spotlight to light the master organist. He then used a second spotlight to send a blaze of highlights onto the wall to the right of the organ player. Farkas pointed two flash heads at the light-colored wall behind the camera, giving the organ pipes an appealing glint.

Once all five lights were in position, he took the necessary meter readings. Finally, he asked the organist and the student to take their places. After a few small lighting adjustments, he made the shot.

Utilizing Portable Gear

Photographer Bobbi Lane's portrait of a yellow-clad artist is a good example of an environmental portrait executed with portable lighting equipment (see page 76). Her subject is in the business of creating Hollywood parties on a grand scale, complete with table decorations, such as the large cartoon of a newscaster's face, and 40-foot custom-made murals, of which the Hollywood sign is an integral part.

Lane began by setting up a battery-powered Norman 200B flash with a small umbrella. These compact, lightweight, yet powerful units are great except for one fact: they have no modeling light, so you must shoot in the dark. Only plenty of experience working with off-camera flash (or an interchangeable Polaroid back on your camera and a pack of instant film to check your results) will help you place the lights with predictable results.

Here, Lane was able to confidently position the umbrella to reflect light on the subject from a high angle, 45 degrees to the right of the camera. Because the umbrella had a wide light spread, it also illuminated the large cartoon on the closest table. A large, white card, placed on the opposite side of the subject, reflected fill light back into him.

The artist's room decorations also included a set of roving, tungsten swivel lights that swept across the 40-foot Hollywood mural like searchlights. Based on her experience, Lane estimated that she would need a 1/15 sec. exposure in order to properly record the searchlights and dark background on film. (If she were less confident, she could have taken an ambient-light reading.) She mounted her camera on a tripod to keep it steady during the long exposure. The hardest part was getting the timing right so that the subject's facial expression and body language were good, and at the same time firing the camera and flash when the roving

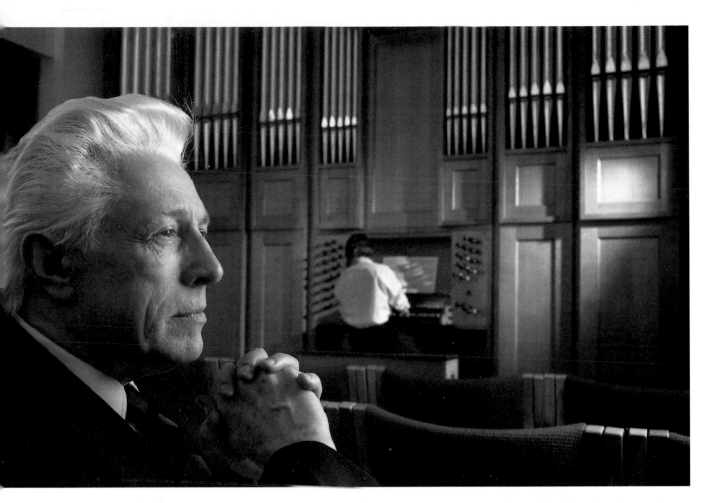

ENVIRONMENTAL-PORTRAIT SETUP

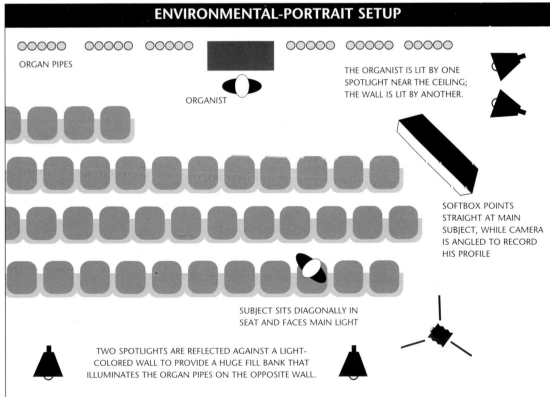

ORGAN PIPES

ORGANIST

THE ORGANIST IS LIT BY ONE SPOTLIGHT NEAR THE CEILING; THE WALL IS LIT BY ANOTHER.

SOFTBOX POINTS STRAIGHT AT MAIN SUBJECT, WHILE CAMERA IS ANGLED TO RECORD HIS PROFILE

SUBJECT SITS DIAGONALLY IN SEAT AND FACES MAIN LIGHT

TWO SPOTLIGHTS ARE REFLECTED AGAINST A LIGHT-COLORED WALL TO PROVIDE A HUGE FILL BANK THAT ILLUMINATES THE ORGAN PIPES ON THE OPPOSITE WALL.

For this narrative portrait of a master organist, Alan Farkas included the musician's protégé in the background.

lights hit the Hollywood sign portion of the mural. During this long exposure, the tungsten lights on the ceiling illuminated other portions of the room with a warm glow as well.

Photographer Meleda Wegner faced a much simpler situation when she visited the studio of a sculptor who worked in stone (below left). To light him, she used a single umbrella at a 45-degree angle. Wanting to show off and emphasize the contours of the sculpture and graphically compare them to the contours of the artist's face, she chose not to use a fill light or reflector to lighten the shadows that the main light created.

▶ Without modeling lights, photographer Bobbi Lane had to guess at the positioning of her lights. Good timing enabled her to catch a roving spotlight as it traveled across a 40-foot Hollywood mural.

▼ On location, using only one light, photographer Meleda Wegner brought out the lines and contours of both the sculpture and the sculptor's face.

"On Location" in the Studio

In a pinch, you can shoot "environmental" portraits in the studio. For the cover of *GSB* magazine, which is a trade publication for professional gift buyers, Wegner needed to quickly create a home environment (below). She used a few homey props in order to quickly transform an empty studio into a "living-room"; these included flowers, a cozy couch, and curtains. The main light was a softbox, and a card on the other side of the model provided fill. Background lights illuminated the rest of the studio with sunny "window" light.

Photographers are allowed to "lie" and create a home environment out of an empty studio. This studio was propped to look like a living room.

COMPUTER SCREENS

INGREDIENTS

- 1 or more models
- 1 or more computer screens with an interesting graphic or document showing (and the screensaver function turned off!)
- 1 Main light, either flash or a hot light
- 1 Flash meter to read the flash
- 1 Incident- or reflected-light meter to read the room lights
- 1 Reflected-light meter to read the computer screen
- Gobos and black cards to eliminate flare by blocking unwanted light from the computer screen
- Blackout material to cover the computer screen, if necessary

Today, it is hard to come across an office or business that doesn't have a computer. And since computers play such a big role in the business world, it isn't surprising that corporate and industrial clients want pictures that include them.

And once you learn how to take beautiful product shots of computers, you need to learn how to successfully include the computer operator in your photographs as well. By simply photographing the computer operator with flash, you might end up with an effectively illuminated portrait, but the computer screen will record either as black or as a big glare. To prevent this from happening, you must finesse the situation and view it as two separate photographs on one piece of film.

Exposing for the Screen

Determining the exposure for a computer screen is the tricky part since no one monitor is the norm. The optimal exposure for the standard television screen is approximately 1/30 sec.; this is the *refresh cycle rate* during which the moving lines of electrons complete a whole still picture. A phenomenon called *persistence of vision* enables you to fuse the blanks between these still images and perceive them as continuous motion.

A shutter speed faster than 1/30 sec. will record only some of these lines of electrons, giving you an incomplete picture. A slower shutter speed will record more than one of these still images, thereby causing a blurred photograph unless the scene on the television is nonmoving, such as a station identification.

Generally speaking, a photographer then uses aperture selection, film speed, or ND filters to achieve a shutter speed of 1/30 sec. for a television set.

Unfortunately, most computer monitors aren't nearly as bright as a television set. (Can you imagine watching a bright television from a distance of 18 inches all day?) In many cases, the computer screen will look normal on ISO 100 film with an exposure in the 2 sec. to 4 sec. range. So it is important to select a nonmoving image for the computer screen to prevent the image from blurring during this long exposure.

Your next concern about the screen is to select an image that looks good. Watch out for screensavers that send flying toasters or other graphics across the monitor. Ask the operator to turn off any screensaver functions; you don't want the computer to suddenly switch to the default screen. If this happens, you might find pictures of flying toasters or the Simpsons when you get your film back. Also, make sure that the chosen screen doesn't have any proprietary or confidential information on it. The company logo in full color is often a good choice.

Finally, since computer monitors tend to reproduce very contrasty on film, you need to adjust the contrast controls on the monitor (if it has them) to their lowest setting. Lane usually meters computer monitors by placing a reflective meter directly on the screen. Polaroid test prints are also a great way to estimate exposures. Keep in mind, though, that you must remember to adjust your exposure for the difference between the Polaroid film's ISO and that of the conventional film you're using.

Sometimes assignments require photographers to shoot complicated combination-lighting designs. For one client, Lane made a combination corporate portrait, environmental portrait, and computer-screen shot (opposite). A main light illuminates the executive from the far left, as well as the side of the computer. She used six background spotlights with slaves, each aimed at the storage carousels on the wall. This produced a striking, graphic, arch effect. In addition, the lights in the storage carousels were fluorescent, so she placed magenta gels inside of their casings to better balance them with the flash. Next, Lane asked her subject to remain very still after the flash fired, so no ghosting would occur during the simultaneous, long, ambient-light exposure (see "Slow Flash Sync" on page 140).

If flare on the computer screen becomes a problem, you might find it difficult to fix. If you've simply forgotten to turn off the overhead lights, you might have found your problem. First, identify which light is

causing it by having an assistant turn different lights on and off while you look through the viewfinder at the monitor glare until you identify the culprit. Then use strategically placed gobos and cards to block the offending light. These can be hidden behind objects or just out of camera view. Alternately, you can creatively shape a snoot out of Cinefoil to direction stray light away from the screen.

Another option is to strategically hide gobos and cards behind objects or to place them outside the live picture area. Both of these solutions will block some

of the stray light. You can also form a creatively shaped snoot out of Cinefoil to direct the light away from the scene.

If screen flare continues to be a concern, you have four choices: 1) reposition the model and the lights to eliminate the problem; 2) spray the screen with water-soluble dulling spray; 3) cover the screen with black cardboard during the first exposure, then remove the board and double-expose the image with no other lights than the computer screen; or 4) ignore the flare, and have the film digitally retouched later.

This photograph successfully combines a corporate portrait, an environmental portrait, and a computer-screen shot. A main light illuminated the man, and six background lights spotlighted the storage carousels. The fluorescent lights were gelled with magenta. A slow shutter speed enabled the computer screen to register on film.

Multiple Screens

Forget just one computer screen—how about shooting a room full of them? Now you have to keep stray light from hitting all of the monitors and causing flare. You must also make sure that the screens have approximately the same intensity of light output to ensure proper exposure on all of them. When Lane faced this situation, she handled the challenge by attacking each portion of the scene separately (right). For the closest computer operator, she placed the light out of camera view, so that it poured over the back of the computer and lit the front of the man.

For the distant computer operator, Lane used a spotlight from nearly straight above, held by a tall boom arm out of camera view. Then she positioned other lights high to provide fill light for the keyboards and the rest of the scene. She carefully positioned cards around these lights to prevent them from directly hitting the computer screens. Lane fired all of these lights with the modeling lamps off. She left the shutter open for an extra 1/2 sec. to enable the computer screens to record on film as well. (After the flash went off, the only lighting in the room came from the computers and the emergency-exit signs.)

To solve the problem of shooting a room full of computer screens, Bobbi Lane attacked each portion of the scene separately.

Lightbox Lighting

This kind of illumination doesn't require an actual lightbox, like the one you edit your slides and negatives on. Here, the lightbox is used in the photograph as a prop in portrait photography. You can treat a lightbox like a computer screen, although it is much brighter. When photographer Bobbi Lane took a picture of Mario, a photo retoucher with A&I labs, she used a 6-foot-long lightbox. Using a color-temperature meter, she read the light coming off the lightbox, with the room lights out. She found that she needed to filter the light in order to make it look neutral on the film she was shooting. By opening the back of the lightbox with a screwdriver, she was able to insert the right gels to correct the illumination.

Next, Lane covered the left-hand side of the lightbox with 8 x 10 transparencies. Then she covered the entire portion of the lightbox that was outside the live picture area with black cards, so that it wouldn't light the subject. She then lit Mario with a small softbox to the right of the camera, which she positioned to make it look as if it were the light from the lightbox. She also gelled the softbox with a warming filter. A grid spot behind the subject serves as both a room light and a hair light.

A lightbox can be treated like a computer screen, even though it is typically much brighter. This photograph is far more complicated than it looks. The lightbox had to be filtered internally and carefully carded. The man's face was lit with a separate softbox.

Paint the Picture

Styling is critical in any photograph. And you certainly should remember to pay attention to this all-important element when you do computer shots. Never hesitate to rearrange a businessperson's cluttered, messy desk if you can create a better picture by doing so. For example, substitute a "ratty" mouse with a new, clean one from a colleague's desk. Remove notes and other distracting bric-a-brac unless their presence adds to the image. You might want to carry a can of furniture polish in order to spruce up a wood desk, as well as computer cleaning pads to remove fingerprints and pen marks. Just be sure to return the desk to its original state after you're done shooting.

Lane carefully considered the styling when she took a picture of a young man's bedroom (right). The boy's room didn't look this way when she first walked in. She moved posters, hid unwanted clutter, and then added "clutter" that was more visually interesting and fit the feeling she was aiming for.

To light the boy and the room, Lane decided to imitate window light. She moved the desk away from the wall and placed a flash unit with a large softbox between the wall and the desk. This had the effect of making the desk look like it was positioned next to a window. A large, white card reflected light back at the side of the boy.

Keeping an eye on propping and colors is also essential to successful location portraiture. All location photographers' bags of tricks should include several spare T-shirts, blouses, and blazers in different colors in case the subject's clothing doesn't work or they need a splash of color. Photographers also need to be bold when they work on location. Sometimes they have to take control of the situation and move furniture, clean up desks, and/or borrow plants from another office. In other words, don't hesitate to do a little housekeeping if it will improve your picture. If you explain your intentions, your subjects will rarely object. In the shots shown here, the photographer added flowers to make an otherwise sterile office space human. And as you can see, shirts in different colors give clients more visual options when selecting photographs for their catalog or annual report.

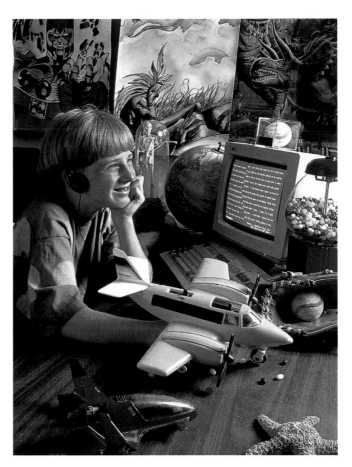

This young man's room didn't look this way when the photographer walked in. Bobbi Lane moved posters, pulled the desk away from the wall, hid unwanted clutter, and then added clutter that was more visually interesting and fit the feeling she was striving for.

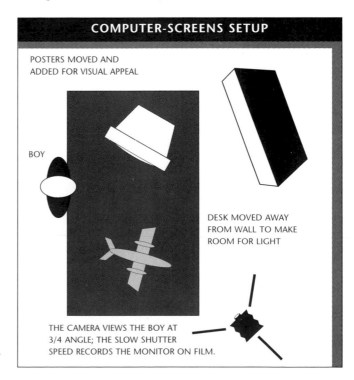

COMPUTER-SCREENS SETUP

POSTERS MOVED AND
ADDED FOR VISUAL APPEAL

BOY

DESK MOVED AWAY
FROM WALL TO MAKE
ROOM FOR LIGHT

THE CAMERA VIEWS THE BOY AT
3/4 ANGLE; THE SLOW SHUTTER
SPEED RECORDS THE MONITOR ON FILM.

SCIENTIFIC PRODUCTS

INGREDIENTS

On Location:

- Softboxes and fill lights, for both indoor and outdoor shots
- Large, white fill cards
- Permission from your client to redecorate the location or to move if the background isn't suitable

In the Studio:

- 1 "Boatload of lights," including hard and soft lights
- White cards in different sizes for fill light
- An appropriate model and/or props

You can shoot scientific products for inclusion in brochures, catalogs, and annual reports using classic still-life, glassware, and other techniques. But for industrial or corporate purposes, it is often far more desirable to photograph such products "in action" in laboratory settings. This is because annual reports sell the expertise of the company (that of the people) and the technology (state-of-the-art research-and-development labs or factory lines). For example, a microscope becomes much more interesting and visually appealing when it is shown being used by an attractive scientist.

In the Studio

Like a classic still life, you can create the product-in-use shot in the studio. In fact, if realistic "laboratory" propping isn't necessary or desired, you can have a relatively easy time shooting this kind of picture in the studio. This is because you have greater control over the environment than you do when shooting on location, and all your equipment is on hand.

When working with a scientist looking into a microscope, photographer Alan Farkas used what he calls a "boatload of light" (left). To successfully shoot a high-contrast picture like this, you need to have an extremely controlled set, preferably in a studio. To photograph this setup, Farkas started with a medium soft light way off in the distance, to the right of the camera. This lit up the scientist's face and the top edge of the microscope. A hard light down low and behind the scientist lit up the bottom of his chin and the edge of his hand, providing an appealing rim-light effect. A background light brought out the mottled paint of the canvas and separated the microscope tray. Finally, Farkas added white fill cards (to the bottom of the scene just out of camera view on top and to both sides).

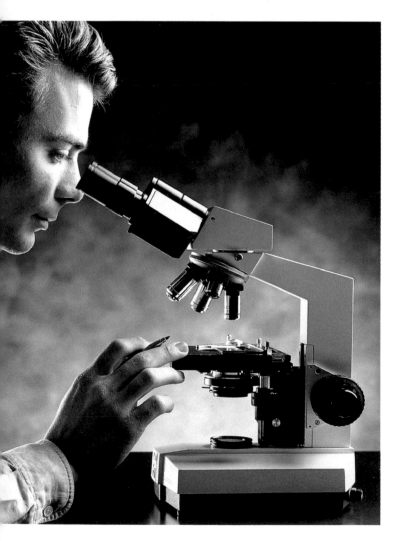

Contrasty setups require controlled lighting and a high number of lights. As such, to make this as easy as possible, this type of picture should be shot in a studio.

On Location

Photographers don't often have the luxury of bringing products and models into their studios where they can have full control over the set. But working on location doesn't mean that you can't control your environment. It simply means that you have to use a lot more ingenuity to make the best of the situation.

While working on location, Farkas photographed two college students in a chemistry lab (below). He started to set up in the lab, but he realized that it had seen too many students: the cabinets and counters were badly marred and unphotogenic. A trip down the hall revealed a similar lab but in much better condition. So Farkas and his assistant removed all the equipment from the cabinets and counters and replaced the chemistry-lab items with them.

Next, he lit the people with a medium softbox off to the right and positioned a fill card opposite it to the left. You can clearly see these two lights in the reflections in the bottles on the right. The only exception is the brown bottle, in which the woman blocks the fill card. Farkas lit the cabinetry with a bare bulb directly overhead, which he'd gelled with a warm, yellow filter to give the room a cozier, friendlier feel.

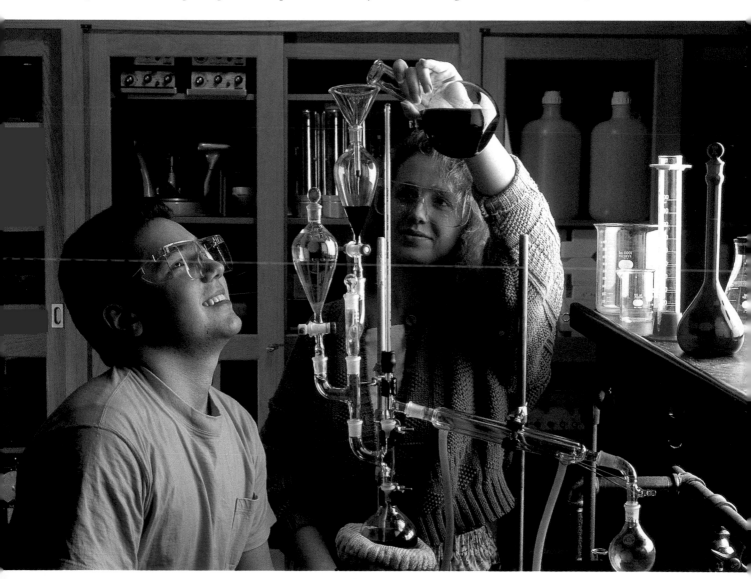

The college chemistry lab was quite grungy and unsuitable for a shot. So photographer Alan Farkas improvised and moved the lighting setup, bottles, and everything in the cabinets into another lab.

Scientist and Product

Interesting objects, such as a computer screen, help add information and visual appeal to the standard corporate portrait. The photographer's challenge is deciding what the true subject of the picture is: the product in the scientist's hand or the scientist? Taking this a step further, is the real goal of the photograph to suggest "advanced technology" or "serious research" rather than to simply be a picture of a product or a person?

The most successful photographers answer this question before they start shooting, and then gear their composition towards that end. Compare for example, two shots photographer Bobbi Lane made of the same subject, a chemist at a vitamin company checking the status of a chemical. Using a narrow depth of field (the effect of a wide-open aperture, such as $f/3.5$), she first focused on the bottle, letting the man fall out of focus. For the next exposure, she focused on the man, letting the bottle fall out of focus.

The result is two similar photographs with two different editorial feelings. When the scientist is the focal point, the picture tells a story about the quality of the people who do the research and create the company's vitamins (top). But when the scientist is secondary to the product, the story is about the quality of the product (bottom).

To illuminate this scene, Lane positioned a strong flash outside the building, shining it into the window of the lab. She then placed a second, smaller light inside the room and bounced it off the ceiling. This light provided fill at about 1½ stops less exposure than the main light. Finally, she wanted to add emphasis to the hand and the bottle, so she used a shiny silver card (which was almost as reflective as a mirror) to bounce the fill light back up onto the bottom of the scientist's hand.

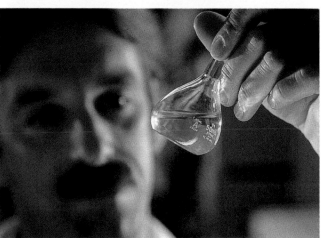

One version of this scene tells the story of a company's qualified research staff (top). With just a change of focal point, the story now becomes about the quality of the products (bottom).

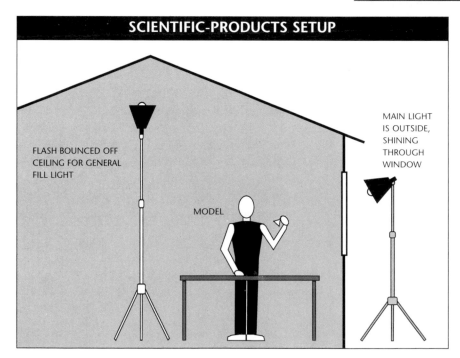

SCIENTIFIC-PRODUCTS SETUP

FLASH BOUNCED OFF CEILING FOR GENERAL FILL LIGHT

MODEL

MAIN LIGHT IS OUTSIDE, SHINING THROUGH WINDOW

WORKERS ON LOCATION

INGREDIENTS

- A worker, or your assistant dressed as a worker
- Portable flash or quartz lighting, such as battery-powered flash units for outdoors and monolights for indoor work
- Umbrellas, collapsible lightboxes, snoots, and grid spots
- Large, white reflectors for fill lights
- 1 Heavy-duty tripod to secure the camera if long exposures are necessary to record low-powered available light
- A selection of lenses from wide angle to telephoto if you are unfamiliar with the environment
- Backup gear, including an extra camera, sync cords, and meter

Taking annual-report-type pictures of people on location might seem similar to shooting environmental portraits. Keep in mind, however, the major difference between these two kinds of shots: environment portraits are *portraits*. The main subject is, unquestionably, the person—even though the environment reveals more about the individual.

But when you photograph workers on location, the primary subject is the location, whether it is a winery, a factory, or a construction site. The person in the picture simply helps to tell the story of the location, and is sometimes included merely to serve as a graphic element or to add a sense of scale. As such, this type of photograph is far more closely related to pictures of architectural interiors (see page 128) than to portraiture.

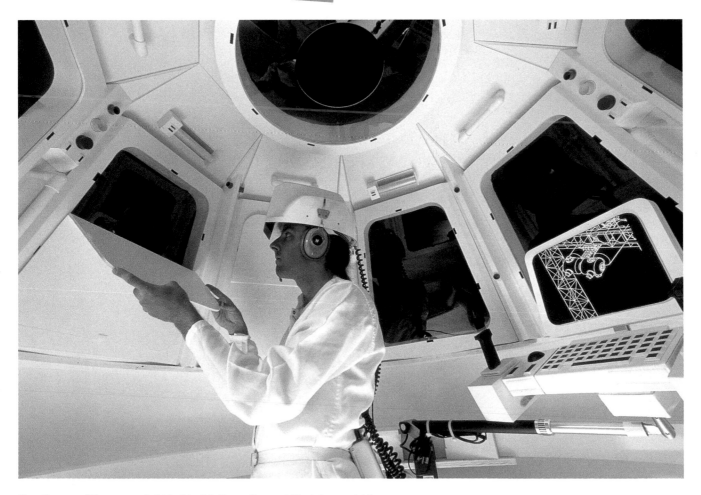

Shooting conditions were tight inside this Fome-Cor and Plexiglas model for a space-station room. Bobbi Lane's assistant Kenny donned a science uniform and posed in this shot.

Small Versus Vast Spaces

Research facilities are sometimes small and cramped, or filled with so much equipment that photographers have little room to maneuver in. Light placement is limited, and they're often forced to use wider-angle lenses than they might otherwise choose. In such situations, the only solution is to do the best you can. Some of the most difficult industrial shots involve a subject that is actually a small, enclosed space, such as the interior of a car or a tiny room.

When photographer Bobbi Lane saw the 5-foot model room for the proposed NASA space station, she reacted by marveling at what you can make out of Fome-Cor (see previous page). Her task was to photograph the room, which was made of little else than Fome-Cor, Plexiglas, and a few plastic switches. The problems she faced were enormous. First, the room's small size made maneuvering difficult and left little room for hidden lights. Second, the Fome-Cor walls weren't strong enough to attach lights to or even against. Third, the multiple Plexiglas windows acted like mirrors, casting unwanted reflections everywhere.

Lane's first decision was that human scale was an absolute necessity in this image. So she secured a science uniform, helmet, and headset for her assistant, whose role quickly changed to model. Next, she selected an 18mm ultrawide-angle lens for her 35mm camera, mounted the camera on a tripod, and composed the image. For most of the remaining five or six hours it took to make this shot, Lane fiddled with the lights. Her final lighting solution involved putting shiny white Fome-Cor on the ground to create a sturdy, reflective floor. She then propped flash units on the Fome-Cor, so that they reflected off the now white ground.

The lighting required overcoming two obstacles. The first involved avoiding the reflections in the windows. She succeeded everywhere except the top panel (if you look closely, you can see the cords and the Fome-Cor reflector). The other problem was that because of the confined space, the lights were close to their subjects, making light falloff (from the floor to the ceiling) a real problem. In her first attempt at a shot, the bottom of the frame was much hotter (higher exposed) than the top. Slight readjustments of the lights, followed by light readings, followed by more readjustments, was the pattern she used until no one area was getting too much light.

Photographer Alan Farkas faced a different kind of problem when shooting at a winery (opposite). Instead of a small, white room, he had an enormous, dark atrium to light. Vast spaces can also lead to logistical challenges for photographers. The ceilings and walls are often too far away to work as effective bounce cards for fill light. As a result, photographers have to bring in additional lights. And certain objects that are unfamiliar to viewers, such as huge chemical vats, can be misinterpreted as small barrels. To prevent this problem, you must add something for scale, such as a person or forklift. Like Lane, Farkas realized that human scale and human interest were needed to make this shot interesting, so he rummaged around for an appropriate costume for his assistant.

Here, an assistant came to the rescue. The human element adds interest and scale to this winery shot.

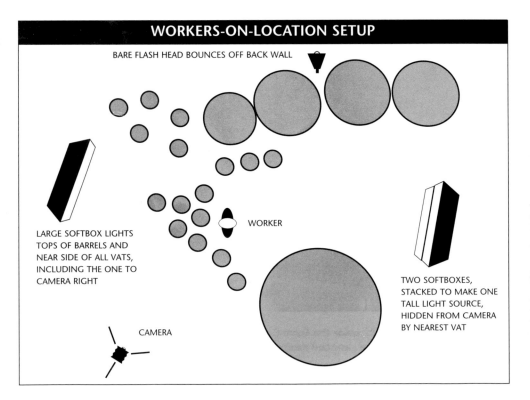

WORKERS-ON-LOCATION SETUP

BARE FLASH HEAD BOUNCES OFF BACK WALL

WORKER

LARGE SOFTBOX LIGHTS TOPS OF BARRELS AND NEAR SIDE OF ALL VATS, INCLUDING THE ONE TO CAMERA RIGHT

TWO SOFTBOXES, STACKED TO MAKE ONE TALL LIGHT SOURCE, HIDDEN FROM CAMERA BY NEAREST VAT

CAMERA

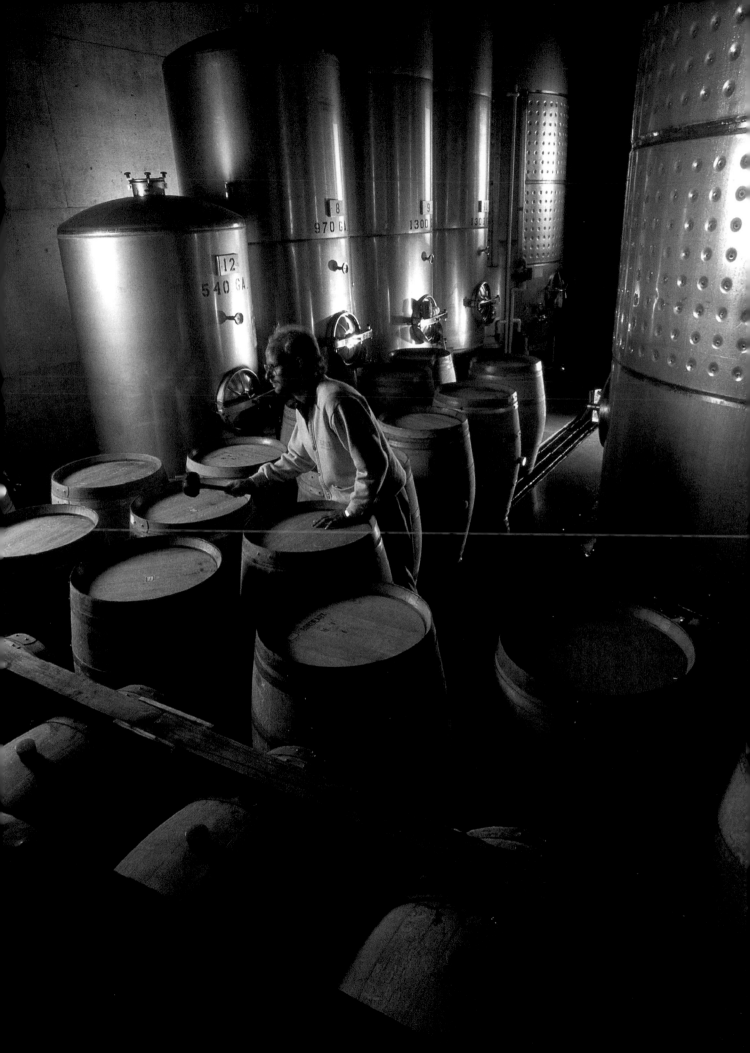

Farkas began the lighting setup on the left side of the camera. He used a large softbox to light the front of his assistant, the tops of the barrels, and the left-hand side of the giant vats. Hidden behind the vat on the far right were two more softboxes, stacked on top of each other to create one very tall lightbox. This produced appealing highlights on the right side of the distant vats, bringing out their rounded shapes. It also gave an edge light to the assistant's back, separating him from the dark background. Next, he bounced a bare-bulb flash against the back wall, hidden behind the large vats.

The brown color of the barrels and walls established the overall warm tones. Farkas chose not to correct this to neutral with a filter over the lens because the warm feeling seemed appropriate for a winery and made the setting appear to be less industrial than it actually was.

Closer Versus Distant Views

One way around having to shoot in an enormous room is to analyze your subject and look for a closer viewpoint. Do you really need to show, for example, the whole room or the whole piece of machinery? If not, simply find a portion of the subject that tells the entire story. Conversely, you might have to shoot a subject for which the whole story can't be told by showing only a worker and some equipment.

Working Alongside a Videographer

For many corporate shooting situations, a still photographer might be asked to take pictures during a video production. In the clients' minds, this is "two-for-one" shopping. They can get both a video and still photographs with only one disturbance in the workday and one set of models.

But problems usually arise because video cameras are electronic and have automatic white balance, which film doesn't. Moving from daylight, to fluorescent lighting, to quartz-halogen lighting and back isn't a problem for the videographer since good video cameras can automatically remove unwanted color balances. Even if there is a mix of color temperatures, such as quartz and daylight, the difference appears significantly less on video than on conventional film. In addition, you can't generally use flash unless the video camera has been turned off because the flash will appear on the videotape.

All of this leaves photographers scrambling with different filters and films to make the light look neutral on film. This type of photography starts to suggest a photojournalistic approach more than anything else—unless you're given time before or after the video shoot to reposition lights or turn some off and others on. A color-temperature meter is indispensable for reading the precise color of the lights, as well as for telling you which filters to use to correct them for either daylight- or tungsten-balanced films.

Photographer Bobbi Lane made a portrait of a chemist at a vitamin company during a video shoot, which posed its own special set of problems. Her assignment was to shoot pictures alongside the videographer, before and after each take. She wasn't allowed to change the lighting, but had to work with what the videographers had set up.

In this case, the videographers had used a powerful HMI as the main light, coming from the right side of the camera. This produced strong, 5500K, daylight-balanced illumination. The videographers had several 1000W quartz lights (1Ks) bounce light off the wall behind the person for fill. They illuminated the front jars and cabinets with Keno Flowtubes, which look like a long bank of fluorescent lights but are actually quartz-halogen tubes. Since both the Keno Flowtubes and the 1Ks are 3200K tungsten-balanced lights, Lane was able to gel them with conversion filtration. This balanced them to the same color temperature as the HMI light.

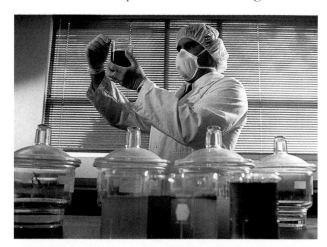

Working during a video shoot is difficult because you must deal with the videographer's lights. Luckily, Bobbi Lane was able to gel the quartz fill lights to match the main, daylight-balanced HMI.

Information about where the equipment is used is paramount. For example, who would buy an expensive underwater camera if the advertisements depicted it being used on only dry land? In such situations, you must shoot from a distance.

For a closeup shot of a worker inspecting some industrial pumps, Farkas decided against a completely literal approach (below). Shooting with a 35mm camera instead of his standard 4 x 5 or other medium-format camera, he opted for a wide-open aperture to throw the pumps out of focus. He lit the worker with a strip-shaped softbox, up close and behind the pumps. Although you can clearly see this light in the subject's eyeglasses, the tilt of his head prevented his eye from being obliterated by the highlight. Next, he aimed the light from another softbox in a similar direction. Here, however, the soft-box was in front of the pumps and lit the foreground (while appearing to come from the same light source).

A small bare bulb put a touch of separation light onto some of the internal workings of the pump.

The next part of this assignment called for Farkas to photograph a surveyor (bottom). By stepping back and taking a distant view of the surveyor, Farkas was able to tell the story of this worker on location. Taking advantage of an inset corner design at a building under construction, he shot this portrait from the opposite corner, one flight up. Using daylight- and flash-balanced film at dusk, he combined a long exposure to capture the blue evening light with one flash unit. Farkas put a warm gel on the flash and directed it straight at the surveyor from a low angle and without a reflector. This created extremely long and hard-edged shadows. (If Farkas had decided to use hot lights and tungsten-balanced film, the daylight would have appeared even bluer because of the mixed-lighting situation; see "Architectural Interiors" on page 128.)

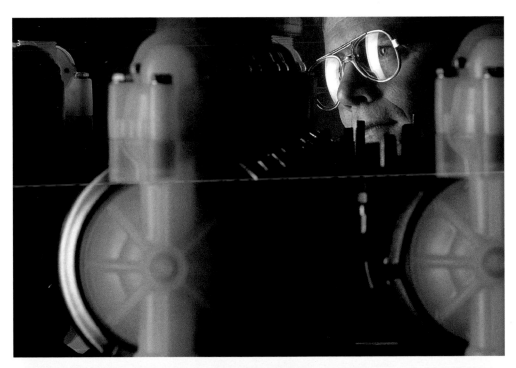

Positioning a softbox on either side of the pumps created the illusion of one light source. Photographer Alan Farkas carefully positioned the man's head in such a way that the softbox's reflection doesn't obliterate his eye.

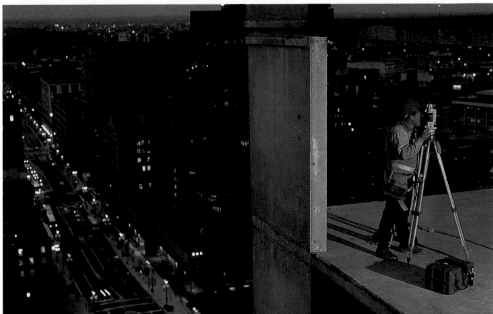

For the second part of the assignment, Farkas shot from one floor up. He combined a bare-bulb flash with a twilight exposure.

STORYTELLING PHOTOGRAPHS

The real art of photography for promotional and annual-report brochures comes from storytelling. This is the ability to make photographic images that convey the meaning, goals, integrity, and soul of a company. There is no one lighting setup for storytelling photographs. Instead, photographers must utilize their technical experience and artistic abilities to solve visual problems in new, creative ways.

Photojournalistic Storytelling

To create a brochure for the Xerox Corporation, photographer Alan Farkas drew upon his background in studio photography to light the scene, and his photojournalism training to capture the frantic pace of a business office and the chaos of a last-minute project. He is a master of storytelling technique and employs

Knowing a lot of photographic techniques can be critical when you need to come up with storytelling concept pictures. To make this image for a Xerox brochure, the photographer used flash, hot lights, fluorescent lights, and a camera on a video pan-head.

The Creative Process: Concept Through Fruition

Part of successful brochure and annual-report photography is the ability to tell a story. For a Xerox Corporation brochure, photographer Alan Farkas's assignment was to demonstrate the chaos and panic that a good office-management system can prevent. The best way to come up with ideas on how to illustrate such a concept is the same technique writers might use. Close your eyes, and think about what it feels like to be in that situation. Here, imagine that the job is late, the boss is yelling, and the clients are in the reception area. Words that come to mind are *panic, rush, anxiety, sweat,* and *stress.*

At this point, you should be well on your way to envisioning a photographic solution, if not more than one. You might have considered a comic approach or a montage of images. In the end, Farkas and the art director settled on a photographic solution that involved panning blur to help illustrate the frantic pace of last-minute preparations.

Notice that the designer of the advertisement decided to flip the image for graphic effect. An interesting side note: in magazine and book production, the general rule is to lay out photographs in such a way that the subjects are looking or are pointed into the center of the magazine or book rather than off the page. This orientation appears more natural and helps keep the viewer's attention inside the book. Here, the designer purposely broke this rule and flopped the photograph in order to complement the unsettled feeling that the image produces.

very different methods to obtain results. His technique involved mixed flash, hot lights, and the overhead, fluorescent lights in the office (see "Slow Flash Sync" on page 140). High and to the left of the camera, Farkas placed a high-powered flash unit with a small reflector. This produced a strong frontlight with a hard edge. He then strategically placed hot lights to illuminate the man's back and the office behind him.

When Farkas was ready to shoot the picture, he had the model run at full speed past him while he panned the camera during a 1/8 sec. exposure. He set the camera on rear shutter sync, thereby causing the flash to fire at the end of the exposure. This, in turn, resulted in the movement blur from the long exposure to appear to be behind the subject, rather than in front of him, which would have looked unnatural. Since there were so many variables involved with the running model, the handheld panning, and the timing of the shot, Farkas made at least 50 exposures to be sure he'd captured it on film.

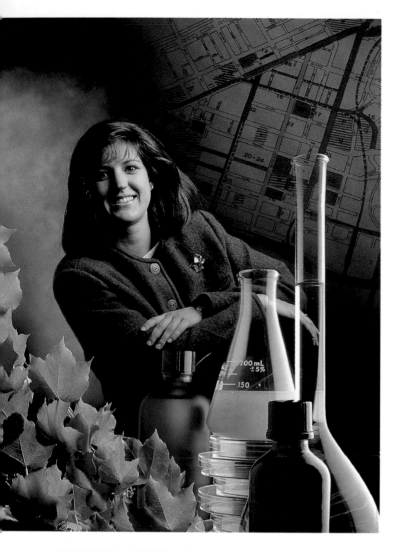

Multiple-Image Photographs

Another storytelling technique Farkas relies on involves in-camera masking and four-camera sets. Creating a successful multiple-image photograph requires careful planning. First, you need the ideas for the right imagery. Second, you need to sketch their placement. Third, you have to light them harmoniously. And fourth, you need the technical know-how to pull it off.

Multiple-camera sets are best done with view cameras because you can shoot one image at a time simply by removing the single-sheet film holder from the back of the first camera and walking it over to the next camera in line. In addition, the large "viewfinder" on a 4 x 5 camera (the 4 x 5 groundglass), enables Farkas to literally tape a 4 x 5 acetate sketch of his desired end result onto the back of the camera. Then, while composing the image, he can match the real view to the acetate sketch.

Farkas used this approach to produce an image for Cornell University (left). Here, he matched a model who looked like a typical student with icons of the school's programs (city planning and science) and its Ivy League status. Before shooting a single frame, he

The recipe for this photograph required a lot of planning and preparation, as well as four camera sets, four exposures, and one sheet of film.

In-Camera Masking

Photographer Alan Farkas creates his unusual, multiple-image, storytelling photographs via in-camera masking techniques. His system takes advantage of the fact that view cameras have film backs that can be removed and placed in a different camera. So if Farkas has four images to combine, he creates four sets with four cameras and just walks the film holder with its single sheet of film from one camera to the next. This enables him to process a sheet of test film, review it, change an aspect of one or more of the sets, and rephotograph it with precise repeatability.

The key to masking is blocking off extraneous light from the unwanted areas of the film. Masking can be done at the film plane, in front of the lens, or on the set. Usually Farkas relies on extremely accurate masking in front of the lens and backs this

up with rough masking at the film plane. He uses black tape about 3/4 inch away from the film plane to create a hard edge to the mask. To mask in front of the camera lens, he uses black cards. The closer the card is to the lens, the softer the line; the farther away from the lens, the harder the masking line.

In order to soften this line even more, Farkas tapes thin strips of neutral-density (ND) filter material to the edge of the card, such as 1/4 inch of 1/3 stop (0.10ND) or of 1 stop (0.30ND) of neutral density. And once you start getting up to the 2-stop (0.60ND) range, you see almost the same effect as the black card. Be aware that masking on the set requires painstaking attention to stray light. Blackout material or light-absorbing black velvet must fill the frame everywhere except the "live"-image area of that set.

roughly sketched out his idea on paper to help him plan the various elements. He began by photographing the model on black-and-white film with simple but dramatic lighting. The only difference between this and "Fail-Safe Portraiture" lighting is that Farkas left out fill light, thereby enabling the shadows to turn black. This created an effective checkerboard pattern between the hands (light), suit (dark), face (light), hair (dark), and lit background (light).

Farkas then printed this picture on 11 x 14 paper and taped it onto the wall. He set up his 4 x 5 camera and composed the image according to his sketch. With a spirit level, he checked that the film back of his view camera was perfectly parallel to the wall, so that no image distortion would occur. Next, he placed lights at 45-degree angles on either side of the photograph to provide even, "copystand" lighting. He then readjusted the lights minutely until the light readings from all four corners and the center of the print were exactly the same.

Farkas placed flocked blackout material around the portions of the image on which he planned to superimpose the other three images. As a safeguard, he also made a tape mask inside the camera's bellows, about half an inch in front of the film plane. He then rephotographed the image.

Leaving the camera, lights, and print in place, he removed the film holder and moved on to a new camera to shoot the chemistry-lab objects on the second set. First, to make a black tent (which is the exact opposite of a white tent), he combined black flats and large, black cards; he made the background out of light-absorbing blackout material. The purpose of it was to block out all reflections except those he'd designed.

The main light on the chemical bottles came from a softbox to the right of the camera. It created the bright-band reflection on the right side of the back bottles and petri dishes. A large, white card on the left side of the camera produced an even softer highlight on the left side of the other bottles. Farkas used a small, black card to keep the nearest brown bottle dark on its right side and to block the reflection from the fill card. And to add the warm glow to the rear brown bottle, he positioned a shiny silver card directly behind it. Next, he masked the lens along with the film plane (see "In-Camera Masking" opposite). Then he photographed the scene on the same piece of film that he used for the first exposure in the first camera.

The third set contained the ivy. Farkas illuminated it from behind and slightly to one side. The backlighting accentuated the leaves' translucent quality, bringing out their vibrant green color. To get the leaves to hang

Masking with Only One Camera

You can utilize photographer Alan Farkas's masking technique for a four-set picture if you have only one camera, so long as it is capable of multiple exposures. However, working with one camera is much more difficult, incredibly time-consuming, and less accurate than working with multiple cameras. You still need to create four sets. The difference is that you must move the camera from set to set, keeping careful notes on focusing information and aperture settings. Setting up four tripods make this process easier because you won't have to fiddle with camera position as much. With only one tripod, you can get reasonably repeatable results by placing tape on the floor to mark where the tripod legs go, and then measuring the camera height.

the way he wanted, he had to shoot with his camera upside down.

Farkas shot the fourth image, the map, in a similar fashion to the way he made the black-and-white print in the first set. This time, however, he used a quartz hotlight instead of flash. The different color temperature of this light caused it to appear warm toned on film. (If he'd wanted to record the light's actual white color, he could have either shot it with flash, or used the hot light and filtered the camera lens with an 80A conversion filter.)

Farkas then took this piece of film (which now had four separate exposures on it) to the lab for processing. After reviewing the transparency, he adjusted exposures, tweaked the masks, and made small corrections in the sets before exposing the final film. If he'd worked with only one camera and moved it from set to set, he would have lost the ability to fine-tune each segment.

Note how the superimposition works in the finished piece. Any area that was black or masked in one exposure and "live" in another, appears normal. For example, take a look at the spot where the woman's hand crosses over the dark portion of the bottles. When two exposures have medium tones at the the same point, you get a blending, or melding, of the colors, as in the ivy leaves and the gold bottle. And when two exposures have light tones, they completely burn out to a detail-less (overexposed) highlight.

Part Four
PRODUCT SHOTS AND STILL LIFES

STILL-LIFE AND PRODUCT photography is a huge category of photography that has many different branches. Photographers often build their entire career out of just one small fraction of the whole, such as shooting food, beverages, or jewelry. This is because, when taken to the extreme of quality, these types of photography can be quite complex, and the technical nuances of the field can take years of practice to master. If you have your heart set on specializing in one aspect of professional still-life photography, you should study it at a university and/or work as an assistant to a top photographer.

But on a more basic level, anyone with a little technical know-how and a great deal of common sense can produce good, general still-life photography. The recipes that follow are designed to get you started on a wide variety of still-life applications, from glassware and textiles to creative, multiple-exposure product shots. Proficiency in general still-life and product photography will enable you to meet the diverse needs of clients you now have or hope to work for.

Most people think of still-life photography as complex sets involving multiple lights; large-format view cameras; and an assortment of gobos, reflectors, and other light modifiers. While it is true that many still-life situations end up requiring a lot of equipment and accessories, it doesn't always have to be this complicated. In this section, you'll even learn how to shoot good product shots with just one light source and nothing more!

SINGLE LIGHT STILL LIFES

INGREDIENTS

For hard lighting:

- 1 Single spotlight (flash or hot light)
- 1 Snoot, commercial or homemade from Cinefoil
- Black cards to create falloff where desired
- Gobos, such as tree branches, to add interesting patterns to the main light

- Fill cards (if necessary)

For soft lighting:

- 1 Single softbox and flash unit
- Seamless paper background
- White fill cards (if necessary)

This recipe covers two distinct, one-light solutions to still-life photography. One approach uses a diffused light source; the other, a hard spotlight. The final images have very different feelings. The shot of the beans on the plate is dramatic and looks like it was taken outdoors; in the other picture, the gilded fruits are gently contoured and were clearly shot in a studio. It is important to remember that each result is appropriate to its end use.

Hard Lighting

This kind of illumination gets its name from the deep, hard-edged shadows it creates. A pinlight or small light source, such as a bare bulb or the sun, creates a hard edge. (The sun is considered a small light source because it is so far away that it becomes relatively small when compared to the subject.) Generally, hard-edged objects are the best subjects for hard light since it emphasizes their already dramatic form. Examples include buildings, boxes, and any studio setup where you want to mimic direct sunlight.

Photographer Alan Farkas produced a catalog image of summer dishes using a hard-edged light (below). Because this shot wasn't part of a magazine article, it needed to have a sense of place and convey a feeling appropriate to the product that was for sale. So in order to convey an appropriate outdoor and summer flavor, Farkas used one light, one light modifier, and one prop.

For the background, he chose a large piece of dark-gray slate, which provided both texture and an outdoor feel. He took special care setting up the plates, with each one held to a different height and angle by underlying pillars made from wax, 4 x 5 film boxes, or children's wood blocks. And for the only prop, he selected "perfect" beans from a 2-pound bag.

Farkas used a single spotlight with a snoot to illuminate the whole scene. He positioned it at a low, skimming angle to create strong shadows that emphasized the texture of the slate table and the shapes of the beans. It also added to the authentic flavor of late-afternoon sunlight. Farkas strategically placed black cards out of camera view to cause the light to fall off in the lower left portion of the scene. Finally, he used a branch with leaves as a gobo to cast interesting "outdoors" shadows.

A single spotlight, a tree-branch gobo, and a few black cards made up the entire lighting design for this shot.

Soft Lighting

Soft lighting gets its name from the soft edges of the shadows it creates. This kind of lighting gently shows off the curves of an object through soft contours. In general, soft lighting is good for rounded subjects, including apples, pears, and the human face. Big, broad light sources, such as a softbox or a flash with an umbrella, create soft illumination.

Photographer Meleda Wegner's assignment was to produce a simple, straightforward shot of gilded, artificial fruits for use in a magazine article on decorating (below, right). The editors didn't want to show the product in use, such as in a table center-piece. Instead, the pictures were going to be used in a silhouetted form, with text wrapping around them. So the photographer needed to shoot the fruit on a white background and to keep the outline simple.

Wegner's first task was to carefully lay out the fruit to show their best sides and create a grouping that was graphically interesting and not "gappy" with white spaces. By placing a softbox above the fruit, she was able to bring out the contours and gilding of the fruits.

In addition to making the silhouetting process easier, the white seamless also worked as a fill light to soften the shadows on the underside of the fruits. The top lighting had the advantage of producing small but definite shadows beneath the fruits. Then once the pictures were silhouetted, these shadows would serve to graphically anchor the fruit to the magazine page; they wouldn't appear to be floating (below, left).

In a similar setup, Wegner shot a handmade coffee table for a catalog. Here, the light was angled more to the side. Since this furniture wasn't going to be silhou-etted, she chose a dark background instead of white. Note how the gray produces less fill light, thereby enabling the underside to go dark. A cooperative cat provided scale and "humanized" the picture.

▲ This simple lighting setup consisted of only a single softbox and a white seamless background.

◄ When the photographer used a similar softbox setup and switched to a dark gray background, the image contained considerably less fill light.

FORE AND AFT STILL LIFES

Fore and aft lighting, a popular technique with glamour shots and portraiture, is also well suited for still-life photography. Positioning a frontlight directly next to or above the subject and matching it with a backlight from directly behind the subject can work well for still-life photography, too.

Move the Camera

In a variation of fore and aft lighting, the product and lights remain stationary; the photographer simply does a quarter turn around the subject. So now there are sidelights. The lights are still at 180-degree angles to each other, and they haven't moved in relation to the subject. Nevertheless, the result looks radically different because of the new camera angle.

In photographer Alan Farkas's shot of an old saw blade, the fore light is a snooted spotlight on the right side of the camera (below). It produced a circular patch of light on the center of the blade, bringing out its texture. A low-skimming flash (here, the aft light) on the opposite side of the camera added a bright (overexposed) highlight to the very edges of the saw's teeth. And backlighting a sheet of brown craft paper created a textured, visually harmonious background.

If you use fore-and-aft lighting and simply change your camera position, you can get a final result that looks like this.

Creating a Silhouette

In photographer Alan Farkas's picture of a bird of paradise, a Hawaiian flower, you can see that the subject is both front- and backlit (silhouetted). The best way to describe how Farkas made this picture is to start with the background light, which is the aft light. He aimed a bare-bulb flash at the background in order to create a halo of light. Then to soften this light, he placed a diffuser in front of it. He also used a warm, amber lighting filter to give it a bit of color. The result of this background light alone is to turn the flower into a black, backlit silhouette on film.

Next, Farkas added a carefully snooted spotlight from a high, front, slightly left (fore) position. This light was narrow enough to hit just the top portion of the flower, thereby bringing it out of the silhouette. The final touch, a spotlight from low right that hit the flower on the far left, added a pleasant compositional element. Farkas made certain that the output of this light was less than that of the main light because he didn't want the flower to be more visually dominant than the main subject. He also let the flower fall outside of the plane of sharp focus. He relied on a wide-open aperture and depth of field to render it out of focus.

The creativity of this picture comes from the intermixing of the silhouette and the lit portions of the subject. Farkas had several variations to consider. He could have included a rim light for the aft light by shining the light directly at the flower from behind, rather than reflecting it off the background. This would have produced more of a halo effect rather than a simple silhouette.

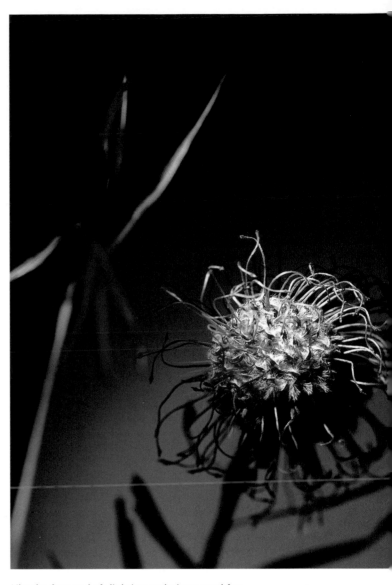

Like the fore-and-aft-lighting technique used for portraiture, this method uses two lights at 180-degree positions in relation to each other.

FORE LIGHT ONLY (MAIN LIGHT)

AFT LIGHT ONLY (SILHOUETTE)

FORE AND AFT LIGHTS TOGETHER

CLASSIC PRODUCT STILL LIFES

INGREDIENTS

- A product, carefully styled and placed on the set
- A backdrop, real or fantasy, for the product
- Props that are appropriate for the product
- Multiple lights (flash or hot lights)
- Light modifiers, including softboxes, grids, and snoots
- Reflectors, mirrors, and white cards to strategically add light to the scene
- Gobos, scrims, and black cards to strategically block light to certain parts of the set
- Gels and filters to creatively color the lights or to correct color casts

Don't confuse classic product still-life photography with simple still-life photography. It is anything but simple since it involves multiple lights, reflectors, gobos, and more. But the real trick is to make the final shot look simple, no matter how complex the set is. You can achieve classic product photography via a myriad of techniques, but this usually involves separate light sources for the product, the background, and the other props. Often, the product itself is lit with one light and edged or rimmed with another.

Classic product shots come in two forms, realistic and fantasy. In the realistic setting, the lighting must look simple and natural, regardless of how complicated it actually is. Photographers carefully position black cards near lights to send unimportant portions of the live picture area into darkness. And photographers rely on small, silver or white reflectors to add important highlights that make a specific picture element prominent or help to separate it from a dark background.

Achieving a Natural Look

At first glance, photographer Alan Farkas's photograph of a portable printer looks easy to shoot (opposite). However, as you can see in the diagram, a great deal is involved. For realistic product shots like this one, which suggest that the product was photographed in its working environment, the set must be carefully put together and propped. Regardless of how many lights and how many hours it takes to prepare the shot, it should never look like a set-up picture. Believability is critical.

Here, two separate lights illuminated the printer and paper. For the first, Farkas snooted a spotlight to illuminate only the sheet of paper. The second light was a softbox that illuminated the printer itself. To better aim the softbox, as well as to avoid any spillover of light onto other parts of the set, he "cut down" the softbox with black cards. "Cutting down" merely involves blocking off portions of the softbox with cards, thereby enabling you to create a new shape, such as a soft triangle.

Continuing the lighting design, Farkas further established the "real-life" feeling by simulating morning window light. In order to achieve this effect, he aimed a warm-gelled spotlight through a Venetian-blind gobo. The spotlight produced specular highlights on the coffee cup, and the warm-colored light added to the morning feel.

Next came the distant cityscape. Farkas placed a piece of Rosco diffusion material behind the set and then projected a slide of a city onto the glass from behind. After arranging this rear-projection setup, he threw the slide out of focus to make it look more distant.

The final touch was matching the flash synchronization with a slow shutter speed. This long exposure achieved only one thing: after the flash went off on the dark set, the computer monitor had enough time to burn into the film and look as if it were on. (At the flash sync speed of 1/250 sec., the screen would have barely recorded on film.)

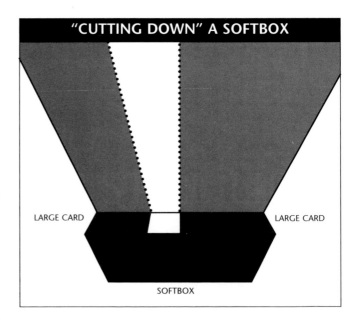

"CUTTING DOWN" A SOFTBOX

LARGE CARD LARGE CARD

SOFTBOX

Classic product shots come in two forms, reality and fantasy. In a
realistic setting, the lighting must look simple and natural,
regardless of how complicated it actually is.

The Fantasy Set

Some shots aren't designed to show the product in a "real-life," working setting. Instead, photographers go for pure impact and fantasy, using lighting, color, textures, or geometrical props to create a visually appealing composition. Farkas's two computer images belong to this category. The choice of colors and props depends on the feeling that the photographer wants to portray, such as elegance, modern flair, high tech, and action.

In this type of shot, you have a great deal of leeway. When photographers work with a monotone product, they often employ colored gels to introduce color into the overall picture. This is especially true if the picture is going to be used on a billboard, magazine page, or catalog page, where it must visually compete with other design elements.

For computer photographs, Alan Farkas likes to go for impact through the use of dramatic colors. Note how your eye is drawn to the vibrant green colors of the computer photograph (below). Flying and off-kilter

products and props, such as the computer disks that Farkas suspended from invisible wire, also lend to the feeling that this is an active product that energizes, metaphorically.

Here, the main light is the white spotlight that skims across the front of the keyboard and the mouse. These objects are then framed by lights from a green-gelled flash unit that illuminates the background and the top of the computer. (A second green-gelled spotlight the tips of the left edges of the keyboard green.)

Blind Supports

Regardless of whether you decide on a realistic or unrealistic set, keep in mind that you must do a lot of hidden work: tilting, stacking, or propping up objects with blind supports. Notice how the keyboard in the second image isn't actually flat on the ground, as well as how the mouse is floating. Favorite techniques include tucking objects, such as wooden children's blocks, empty 4 x 5 film boxes, Silly Putty, and oil-based (nondrying) clays, under the boxes.

Pure impact is the goal of fantasy product shots. Here, colored gels and "flying" props help grab the viewers' attention.

FUZZY GELS AND MULTIPLE EXPOSURES

Photographer Alan Farkas uses an effective technique to add attention-grabbing color that emphasizes rather than overpowers the main subject. He works with colored gels during multiple exposures and fog-filter overlays. In essence, first he shoots a sharp picture, then adds one or more fogged picture elements on top of it in the form of multiple exposures on the same piece of film. The result is a picture that strategically mixes sharpness and softness.

Portrait Success

Farkas created an interesting portrait of two business executives for *Success* magazine by showing them on video-monitor screens (see page 104). He began by taking the men's pictures, having them digitized, and bringing them up on the monitors. Then in the studio, he completed the process with a triple exposure.

The arrangement of the main lights was pretty straightforward by product-photography standards. Two flash spotlights from a high angle to the right side of the camera lit the front of the monitors, whose screens had been covered with light-absorbing blackout material. A blue-gelled light then came in from the right to bathe the left side of the first monitor. These two lights made up the first exposure.

Next, Farkas took the blackout material off the screens (which had protected them from reflections during the first exposure) and turned on the monitors. Since monitors tend to look very contrasty on film, he

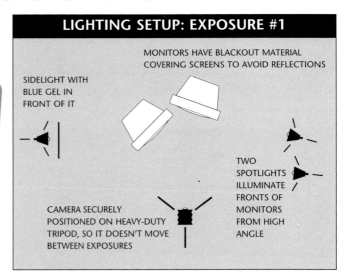

LIGHTING SETUP: EXPOSURE #1

MONITORS HAVE BLACKOUT MATERIAL COVERING SCREENS TO AVOID REFLECTIONS

SIDELIGHT WITH BLUE GEL IN FRONT OF IT

TWO SPOTLIGHTS ILLUMINATE FRONTS OF MONITORS FROM HIGH ANGLE

CAMERA SECURELY POSITIONED ON HEAVY-DUTY TRIPOD, SO IT DOESN'T MOVE BETWEEN EXPOSURES

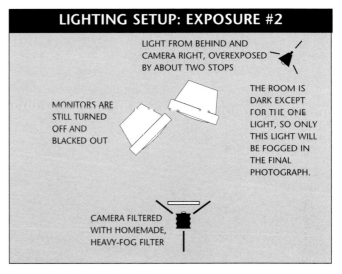

LIGHTING SETUP: EXPOSURE #2

LIGHT FROM BEHIND AND CAMERA RIGHT, OVEREXPOSED BY ABOUT TWO STOPS

MONITORS ARE STILL TURNED OFF AND BLACKED OUT

THE ROOM IS DARK EXCEPT FOR THE ONE LIGHT, SO ONLY THIS LIGHT WILL BE FOGGED IN THE FINAL PHOTOGRAPH.

CAMERA FILTERED WITH HOMEMADE, HEAVY-FOG FILTER

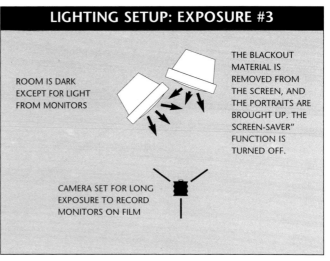

LIGHTING SETUP: EXPOSURE #3

ROOM IS DARK EXCEPT FOR LIGHT FROM MONITORS

THE BLACKOUT MATERIAL IS REMOVED FROM THE SCREEN, AND THE PORTRAITS ARE BROUGHT UP. THE SCREEN-SAVER" FUNCTION IS TURNED OFF.

CAMERA SET FOR LONG EXPOSURE TO RECORD MONITORS ON FILM

used the screen adjustments to set them to low contrast. Then he turned out all the lights in the studio except these monitors, and made a time exposure until they were properly exposed on film, about 1/8 sec. If Farkas had taken the photograph with just the main light and the blue-gelled light, the monitors would have been set off from the background by a hard edge. However, the fuzzy, fog-like feeling required an additional step.

The third exposure was for the glowing background light, which was gelled with filters. The unique part is that Farkas shot the background exposure while filtering the camera with a homemade fog filter. To make this filter, he covered a 6 x 6-inch piece of glass with a thick coating of dulling spray. This caused the bright background lights to record so foggy that they seeped over the edges of the monitors. And since the monitors and monitor screens were recorded separately with an unfiltered camera, they appear sharp, thereby creating an effective interaction between the sharp and foggy portions of the image.

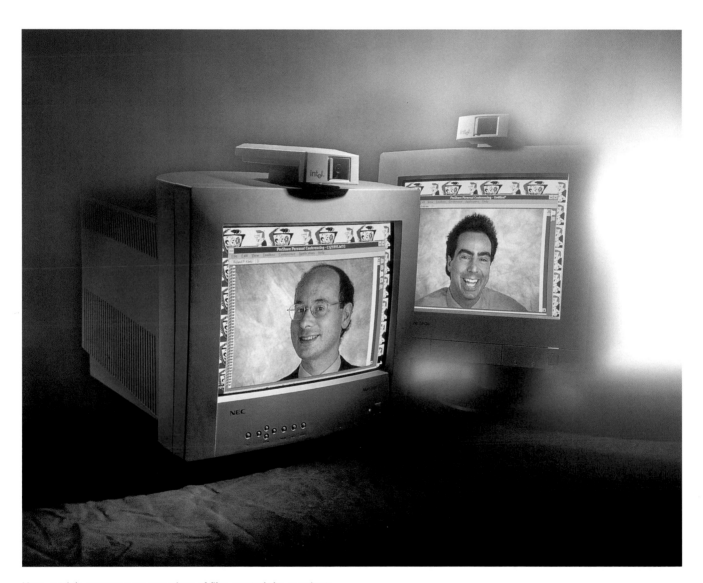

Here, a triple exposure on one piece of film created the monitors, the images on the screen, and the ethereal background lights.

Improvise to Make the Subject Look Real

Sometimes an object might look correct to the human eye, but it doesn't record that way on film. In such situations, photographers must improvise and rig the set or product so that it will respond to the physical shortcomings of the film, thereby creating a picture that "looks right." A common problem that photographers often have to overcome is the difficulty involved in accurately recording a product's colored lights—whether it is the "ready" light on an answering machine or an intricately lit control panel.

Farkas was faced with just such a problem when he had to photograph a railroad signal for its manufacturer (below, left). Obviously, the color and clarity of the lights were important. Now that you are familiar with other techniques, you might guess that he combined the flash synchronization with a slow shutter speed to record the three warning lights on the signal. But in this specialized situation, that technique didn't work, so he had to improvise.

Since railroad signals are locked into place, and the train can come down the track only one way, the glass over the warning lights is made of Fresnel lens material so that the light is focused in one precise direction. As a result, the light can be quite weak in comparison to an unfocused light and still appear equally bright to

train conductors. Because of this, the 12-volt lamps recorded too dull on film to be useful to Farkas.

To solve this problem, he put a small softbox behind the signal, with a flash head behind each light. Through experimentation, he learned that the green glass on the signal didn't react well to the photographic process, looking different and unrealistic on film. To compensate, he removed the green glass and replaced it with a gel that was optically closer to what the signal light "should" look like on film. He then illuminated the front of the signal with a medium softbox that he'd gelled yellow.

Farkas then created the background colors by using four lights, each one gelled with either a magenta, orange, yellow, or blue light filter. He carefully placed cards around each light in order to prevent the overlap in the colors; the blending of some of the colors didn't work well in this situation.

Next, the photographer shot the background lights in a separate exposure. For this shot, he filtered his camera with his very strong fog filter. This caused the bright background lights to record foggy, which is especially evident where the illumination seeps over the edges of the signal. By using the same fogging technique and background colors on the company's other signal products, Farkas was able to create a colorful and cohesive collection of photographs of otherwise boring-looking machines for a brochure.

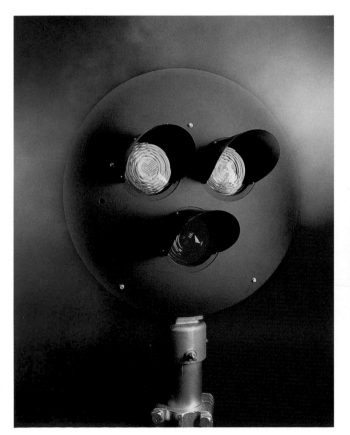

▲ By using the same basic technique and "fuzzy" colored gels, Farkas was able to create a family of product shots that had a cohesive feel for a catalog.

◀ For photographer Alan Farkas, the hardest part of creating this picture was making the actual signal lights look correct on film.

Warm/Cool Gels

Utilizing the fog-filter/fuzzy-gel/multiple-exposure lighting technique, Farkas focused the viewers' attention on the all-important corporate logo in the tread on a pair of Nike athletic shoes (below). In this shot, a pedestal quite literally raises the subject into the category of sculpture. He filtered the camera with a heavy fog filter and used opposing colored gels, cool blue and warm amber, to create an interesting interaction, and unconsciously makes viewers think of the indoor/outdoor (warm/cool) relationship.

Once again, the main light was a simple overhead spotlight in one exposure. It served to focus the viewers' attention to the logo. Next, Farkas turned off this light and double-exposed the same sheet of film with three different lights.

Farkas decided to have a weak fill light bring out some of the details on the bottom side of the decorative pedestal. Because he filtered the light with a full-half CTB blue light filter, the underside took on a slightly blue cast. The second light illuminated the white wall, but a CTO orange filter turned it warm yellow. Next, the photographer used a CTO orange-filtered spotlight to produce the bright streak across the background. The result of the two exposures, the warm and cool light filtration, and the on-camera fog filtration is an elegant rendition of what could have been a mundane product shot.

This recipe calls for a double exposure, CTO orange and CTB blue filters, and a homemade camera filter.

LIGHTBOX LIGHTING

Creating a Makeshift Softbox

While shooting an assignment for a company called Netware, photographer Bobbi Lane created a giant softbox by making a table out of two sawhorses and a large, thick sheet of frosted, white Plexiglas. Underneath the Plexiglas, she positioned a large softbox pointing straight up.

Next, Lane carefully placed the Netware boxes and contents on the Plexiglas, propping them into precise position via such blind supports as clay, tape, wax, and small boxes and pieces of cardboard. Above the set, directly opposite the upside-down softbox, she placed a large, overhead softbox. Then she closed up the set on either side with large, white flats for fill.

Shooting Jewelry

The makeshift-softbox setup also works well with jewelry that contains a mixture of translucent gems and hard metals. The gems will be effectively backlit; the metal will be illuminated by a blanket of soft light, creating attractive, broad reflections over its surface.

When you shoot shiny objects, such as jewelry and metal, the trick to remember is that they reflect a perfect image of the light source itself. (Think of metallic sunglasses, and you'll know what I mean.) So the type of lighting you choose is important. Creating a set in which all sides are covered with white to establish a light tent is an effective technique.

INGREDIENTS

For the lightbox:

- 2 Sawhorses with a piece of frosted, white Plexiglas across them
- 1 Large, white softbox positioned underneath the Plexiglas and pointed straight up at it
- Gels to color the light from the softbox, optional
- 1 Grid or a textural prop on top of the Plexiglas

For the toplighting:

- 1 Softbox or some other light positioned above the product
- White, silver, or gold cards for fill
- Gobos and black cards to block lights to portions of the set

This great lighting technique comes in handy for certain types of products. It is a natural for translucent objects, which tend to glow when a diffused light source is placed beneath them. But you can also use it to shoot opaque products for which the novelty of glowing light from below tends to suggest the ethereal imagery of painters of miracles and nativity scenes. When shooting an opaque object with this type of lighting, you'll need additional lights from above or the side to prevent a silhouette.

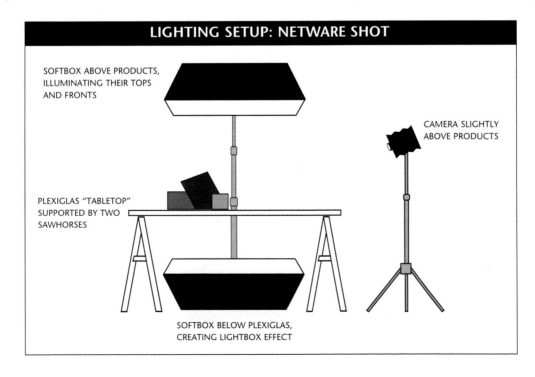

LIGHTING SETUP: NETWARE SHOT

SOFTBOX ABOVE PRODUCTS, ILLUMINATING THEIR TOPS AND FRONTS

CAMERA SLIGHTLY ABOVE PRODUCTS

PLEXIGLAS "TABLETOP" SUPPORTED BY TWO SAWHORSES

SOFTBOX BELOW PLEXIGLAS, CREATING LIGHTBOX EFFECT

Visual Variations

All the recipes in this book are designed as starting points for photographers. True artistry begins with taking the techniques that you learn here and modifying or altering them to match your creative visions. You can, for example, easily modify standard lightbox lighting by adding colored gels, interesting props, or different types of fill light. Another possibility is the fog-filter/double-exposure effect discussed earlier.

Lane created a particularly interesting variation of lightbox lighting when photographing an 8-inch satellite tweeter. Instead of a softbox as a toplight, she used a snooted spotlight, pointing it straight down at the tweeter. Also, she placed a plastic, silver grid, like those found in some industrial lighting panels, on top of the Plexiglas softbox for visual interest. Then to cast tones into the tweeter, she positioned three different light gels directly on the softbox.

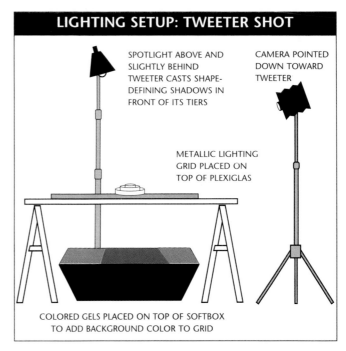

LIGHTING SETUP: TWEETER SHOT

SPOTLIGHT ABOVE AND SLIGHTLY BEHIND TWEETER CASTS SHAPE-DEFINING SHADOWS IN FRONT OF ITS TIERS

CAMERA POINTED DOWN TOWARD TWEETER

METALLIC LIGHTING GRID PLACED ON TOP OF PLEXIGLAS

COLORED GELS PLACED ON TOP OF SOFTBOX TO ADD BACKGROUND COLOR TO GRID

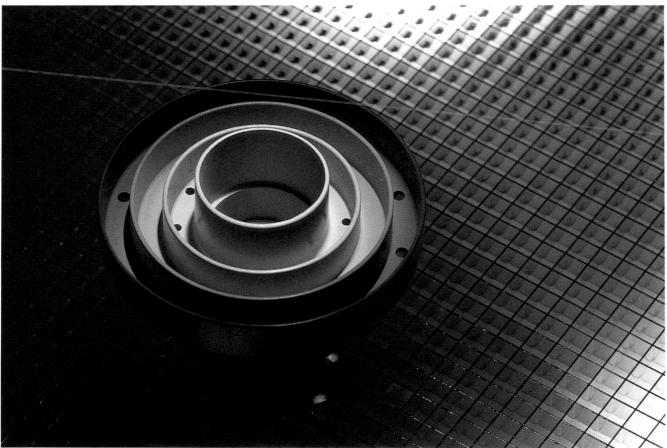

◀ The combination of a softbox above the product and a softbox below the Plexiglas table resulted in this interesting effect.

▲ This shot differs in that the lightbox was dressed up with color gels, a grid was placed over the Plexiglas, and the overhead light was changed from a softbox to a snooted spotlight.

PRODUCT IN HAND

Product-in-hand shoots are quite common, and are natural offshoots of still-life photography. The human hand (especially if it belongs to a perfectly manicured hand model) adds not only scale but also elegance to product shots. In the most complex situations, where the lighting on the product and the exact angle it is held at are critical, the product is blind-supported on the set. Here, the more variable human hand is simply brought in to hold the product, which otherwise appears to be frozen in air. However, when this is less critical, repeatability can be roughly estimated.

Foot and Leg Products

It isn't hard to make the leap from product-in-hand to product-on-leg shots. The basic principles of portraiture remain the same. Soft light gently sculpts the contours of the leg (or hand) and is generally more pleasant, while hard light conveys drama and brute strength.

Photographer Alan Farkas shot a variation of the product-in-hand technique (left). For this product-on-leg picture, he utilized a spotlight from the left, but no fill. Instead, a 2K quartz hot light mottled with a gobo made from old Christmas-tree branches casts interesting shadows on the background. This light also effectively separates the dark backs of the model's legs from the background.

Keep in mind that when you work with foot and leg models (male or female), having them lie on their backs with their feet in the air or resting against a wall before a shoot is a common way to reduce any swelling that might make their feet or ankles look unattractive. This is especially important in the summer or if you can't schedule the shoot for the morning. Similarly, hand models should keep their hands raised in the air for a few minutes prior to the shoot.

Half-Hour Setups

In their simplest form, product-in-hand shots can mimic the simplest portraits, which rely on nothing more than a large, soft light source and a fill card. All you need is half an hour. In that short amount of time, you can produce a photograph like the one Lane made of Nexxus hair conditioner being poured into a hand (opposite, top). She established simple, clean lines by placing a large softbox overhead and a fill card beneath. The most time-consuming part of the shoot involved the assistant practicing to get the "perfect pour" of conditioner out of a beaker. (Of course, the model needed some time between exposures to clean her hands.)

This jumping shot was taken with the model on her back with her legs in the air. Since the photographer used a 4 x 5 view camera, previsualizing what the final image would look like was easy.

Note the difference in the lighting between this image and Lane's closeup shot of a man's hand holding fiber-optic cables (bottom). Here, she decided to work with a harder-edged light, which is more appropriate for the product. This shoot also took less than 30 minutes from start to finish because of its simplicity. The main light was cast by a spotlight with a 10-degree grid spot placed over it. This aimed the light directly toward the subject from an angle that was slightly back and left. Then, in order to produce strong fill light on the right side of the image, Lane opted for a mirror-like, shiny-silver card.

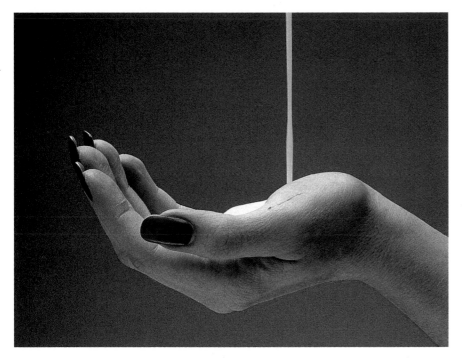

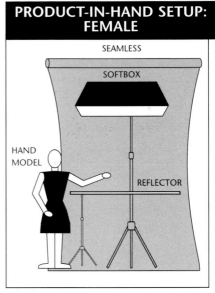

Lighting for female hands tends to be soft and diffused, such as the softbox and reflector used for this photograph of Nexxus hair conditioner.

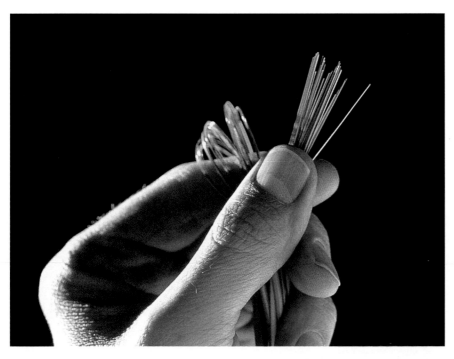

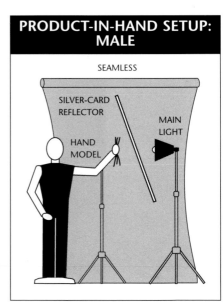

In general, photographing male hands with a hard, directional light is usually considered appropriate.

NORTHLIGHT WINDOWS

If daylight could remain unchanged for hours at a time, still-life photographers would all have natural-light studios with dozens of windows. But the sun appears to move across the sky, change its color along with its altitude, and alter its course with the seasons. So photographers hole themselves up in the dark, covering their windows with layers of blackout materials to prevent light from getting in. It is simply easier, more predictable, and certainly less frantic to be able to create "window" light from scratch in a dark studio.

The most popular lighting is northlight, which has been the favorite of painters and artists for centuries because of the soft way this light wraps around still-life and human subjects. Without direct sunlight through the windows, the northern sky sends light through glass windows in almost the same fashion as a large, diffused softbox. You can imitate the glow of a northlight window many ways, but the easiest and most popular method is to create it with a large softbox.

Establish a Country Feeling

For photographer Bobbi Lane's country-heart shot, she recreated the feeling of a table near a window. Light streams in from a window on the right side, as well as behind the box of chocolates. But if you look at the step-back photograph or the diagram of the overhead setup, you'll realize that this is a far cry from a cozy kitchen table (opposite).

To create the northlight from the "window" to the right, Lane positioned a medium-size softbox at a high,

Here, photographer Bobbi Lane created this country-kitchen still life from scratch.

10 A.M. angle. It shone onto a table made from two sawhorses and some plywood, which she'd carefully made up with a crocheted tablecloth and other country-oriented items. She also painstakingly placed and propped up the candy box and other objects to look casual, but perfect. Next, on the left side of the camera, she clamped a white card to a lightstand to provide fill light.

Lane didn't need curtain rods. She hung the curtain from two lightstands with a boom arm and clamps. The part that isn't visible in the step-back photograph is the window treatment. To simulate daylight, Lane placed a sheet of white paper with a light shining into it 2 feet behind the curtain. The final touches were lighting the candles and combining a 1/15 to 1/30-sec. exposure to the flash synchronization.

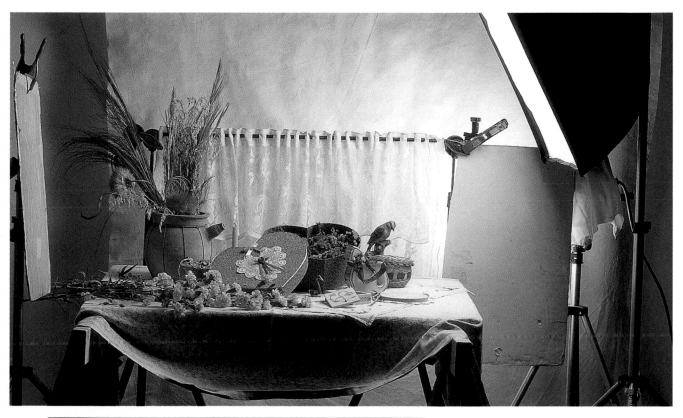

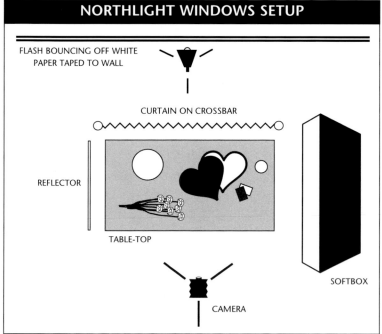

NORTHLIGHT WINDOWS SETUP

FLASH BOUNCING OFF WHITE PAPER TAPED TO WALL

CURTAIN ON CROSSBAR

REFLECTOR

TABLE-TOP

SOFTBOX

CAMERA

Here, Lane recreated reality in a studio, with "northlight" shining from a medium softbox.

HISTORIC STILL LIFES

Nothing gives a picture a historic feeling better than the glow of a candle or lantern. Not only do people feel warm when they see warm colors, such as orange and amber, but they instantly associate these lighting sources with antiques. In addition, photographers can learn from the masters: photographs that echo centuries-old paintings automatically gain believability in terms of depicting historic subjects.

The Art of Propping

This image, made for the Tehon Cattle Ranch, could have been achieved via hot lights or flash. But either way, the believability factor came from the 1/4-sec. exposure (opposite). The slow shutter speed that photographer Bobbi Lane used enabled the lantern to cast a warm glow across the map. This, in turn, added to the cozy, old-time flavor of the shot. Other than the lantern, the only light source was a flash unit sent through a small lightbox. Lane then cast some of this light back into the picture as fill by using a large, white flat on the opposite side of the set.

The difficult part of this shoot wasn't the light, but the propping. The whole shoot, from setup to breakdown, took about three hours, with at least two of those hours spent designing the set and placing the props. And that doesn't include the time that the art director, who had designed and drawn the map the night before the shoot using antiqued paper, spent on this project. And Lane devoted a great deal of time on the telephone lining up props.

Since the client was a cattle ranch, it seemed appropriate that the other props used in the shot were leather-making tools. Lane had called a leathermaker and asked him to bring over an assortment of tools and pieces of leather. From these, she and the art director selected appropriate pieces and orchestrated their placement. And even after she found an antique-style lamp, Lane had to dirty the glass with oil and dulling spray, to make it look older and less perfect than today's glass.

A large part of still-life photography is the believability factor. If your lighting doesn't look natural, the image fails. If your props aren't credible, the image fails. If the lamps or candles aren't glowing, the image fails.

If you are lucky enough to live in a major photography center like New York, Los Angeles, or Chicago, you'll find dozens of prop houses that rent authentic and replica furniture, gadgets, and clothes for photographs. Just name the period—Edwardian, Colonial, 1970s—and the store will deliver the props (at an enormous rental fee, of course). Even ordinary antique, furniture, and thrift businesses in the photo districts of New York and Los Angeles have signs in their windows that read "We Rent to Photographers."

If you don't have the client budget for rentals and/or you live in a small city or town, all you need is some creativity and resourcefulness. Thrift stores can yield treasures. And modern furniture and props can now be "antiquated" with special paints and products sold in chic, home-decorating stores. Another option is to use my uncle's childhood ploy of dipping new cowbells in acid, burying them in a wet marsh, and digging them up a few weeks later as "antiques."

Aging Techniques

In addition to propping, you can sometimes employ other techniques to make a picture look older. For example, you might want to shoot the image in black and white and then print it with a sepia tone. Handcoloring black-and-white images or printing them on watercolor paper also produces a retro look. Many people enjoy doing Polaroid transfers for the same reason; through this technique, a Polaroid image is transferred to watercolor paper. (For complete information on this technique, call Polaroid—see the List of Suppliers on page 143). For the flashback look, people shoot through vignetted fog filters. Be aware, however, that this can look quite dated if you aren't careful.

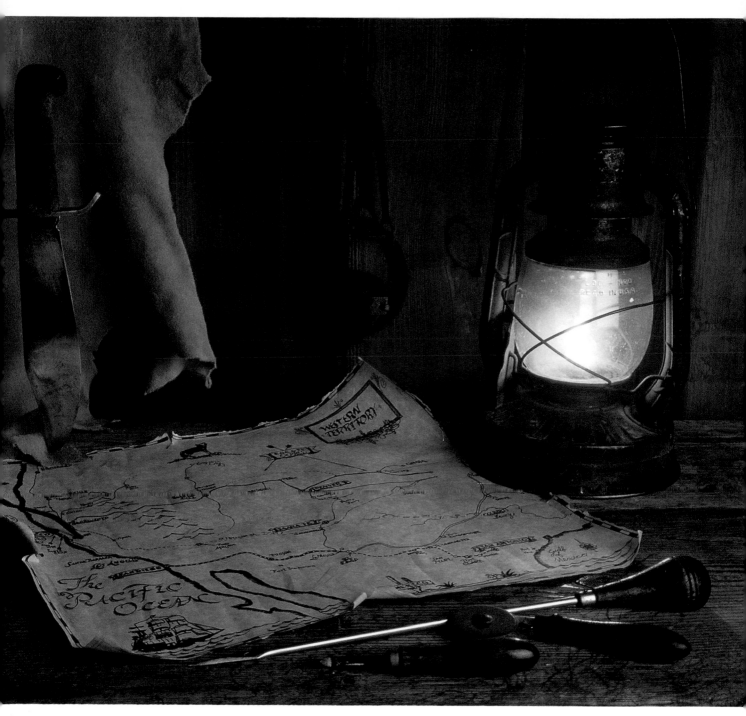

A hand-drawn map, a glowing lantern, and leathermaker tools united to make a believable still-life photograph for the Tehon Cattle Ranch.

GLASSWARE

INGREDIENTS

- A large sheet of white Plexiglas (either thin to curve into a sweep or thick to use as a table-top)
- 2 Sawhorses to act as table legs
- 1 Large softbox beneath the Plexiglas, pointed up at the ceiling
- 1 Boom arm to hold the softbox in this position
- Heavy counterweights for the boom arm
- 1 Softbox above the set, optional
- A white background and white cards on the sides
- Canned air, camel's-hair brushes, air blowers, and glass cleaner to keep the set and props free of dust, hairs, and debris

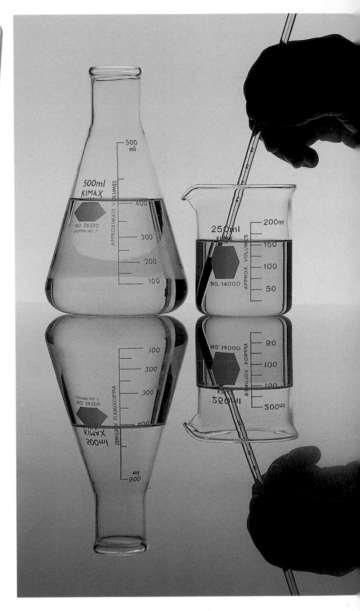

The trick here was hiding the join line where the Plexiglas table ended on the horizon.

Glassware is difficult to shoot because it is transparent and highly reflective. When glassware is backlit, you get black edges. When it is lit with broad light sources, you get stripes of light (although you can use black cards in order to produce black, or reflectionless, stripes). When it is lit with small light sources, you get specular highlights.

The Simple Setup

In photographer Bobbi Lane's beaker-stirring shots, the props are sitting on a table that she made with two sawhorses and a piece of thick, white Plexiglas that is shiny on top and frosted on the bottom (right). This type of Plexiglas works best because the frosted bottom edge catches and disperses the light, while the top still maintains its beautiful, shiny surface. The back edge of the Plexiglas was about 12 inches from a white wall. A light beneath the table pointed straight at the wall.

It is important to realize that the Plexiglas is separated from the wall. Also, the light is perpendicular to the wall, and doesn't point up toward the Plexiglas. This, arrangement, combined with minimal depth of field and a wide-open aperture, helped to almost completely eliminate the horizon line that the edge of the Plexiglas caused.

The single light served to silhouette the hand and backlight the glasses for a black edge, while simultaneously lighting the bottom of the hand with soft, reflected light that shines through the frosted underside of the Plexiglas. When Lane was ready to make the exposure, the assistant/model carefully reached over the Plexiglas to stir the beaker.

For this shot, the exposure choice was a highly aesthetic decision. This dark (underexposed) version has a different feel that also works.

The Complicated Setup

Faceted crystal can often be a nightmare to illuminate because of the difference in the way you perceive crystal and the way it actually looks at any one moment. When you admire a crystal glass, you usually roll it in your fingers in order to watch how the light sparkles as it hits the various facets. You remember the way this looks in your mind's eye, but it is extremely hard to communicate it in a two-dimensional picture that captures just one instant of that finger roll. Often, when cut crystal is lit to show off *all* its facets, the photograph ends up being quite confusing. Instead, it is often best to select one aspect of the design and emphasize it through lighting and composition, while downplaying the rest in the opposite fashion.

For a far more complicated shot than the beaker picture, Lane's task was to photograph a crystal sailboat for a client (see pages 118–119). The client's mind was set on showing off the intriguing facets in the boat's sails, even though Lane advised that the better solution would be to show simple lines. Adhering to the all-important business rule, "the client is always right," she worked for seven or eight hours to produce an image that showed the facets.

Lane started with a huge piece of white Plexiglas that was thin enough to bend into a gradual curve. Next, she secured the bottom to two sawhorses, like a table. She swept the back upward to attach to a crossbar on two autopoles. She positioned a softbox directly underneath the table in order to create a lightbox effect.

From three positions high above and behind the set, Lane then aimed lights at the sail, two with snoots and one with a 10-degree grid spot, to create specular highlights in the complicated internal facets. Her assistant adjusted the lights while she watched through the viewfinder until the optimal internal reflections had been achieved.

The client loved the resulting Polaroid test prints. But Lane was still convinced that this wasn't the best solution, even though the client was pleased. So, on her own time, she spent another few hours changing the lights to rephotograph it her way (opposite). Although the facets in the sails were beautiful in real life, she didn't think that they communicated well on film. So she decided to streamline the sculpture's look by carefully eliminating the internal refractions.

Lane started with the same basic setup of the first image, with the curved Plexiglas and the softbox beneath it, but eliminated the three spotlights completely. Lane added blue to the scene by laying colored gels directly onto the top of the softbox and moving them until the desired effect was evident. Variations of pink and other colors called for a simple switching of gels. Before the shot and at periodic intervals, she carefully checked the Plexiglas and crystal for fingerprints, smudges, and dust.

When Lane delivered the final film of both setups, the client went with the simpler version. The client thought that it was more elegant and more beautiful. Because Lane delivered what was asked for, and more, she earned the client's trust, as well as future work and referrals.

Photographer Bobbi Lane worked for seven hours to give the client the image that was wanted (above) before convincing her client to let her do it her way and try a different method.

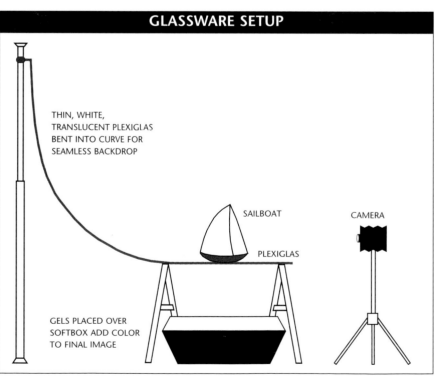

GLASSWARE SETUP

THIN, WHITE, TRANSLUCENT PLEXIGLAS BENT INTO CURVE FOR SEAMLESS BACKDROP

SAILBOAT

CAMERA

PLEXIGLAS

GELS PLACED OVER SOFTBOX ADD COLOR TO FINAL IMAGE

The resultant image (left) was much simpler and far more elegant than the client's original concept. A simple change of gels turned the glass boat from blue to pink (above).

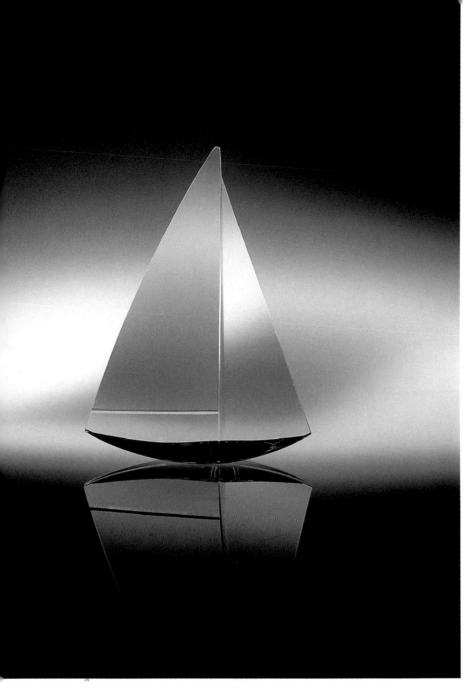

Dealing with Clients

Many times clients have a vision in their mind's-eye of what they want the final photograph to look like. As a general rule, it is your job to give them what they ask for. You can suggest another, better solution, but let go of your idea for the time being if they like theirs more. Remember, "the client is always right."

The best photographers, however, also work a little longer to give clients what they *didn't* ask for as well. This is your chance to show them the better version, done your way. Often clients end up using the "extra" version, which you included with the first shot. Furthermore, the alternate might lead to your securing both the client's trust and future business.

TEXTILES

You can communicate a great deal of information about a fabric if you know its texture, so one goal of textile photographers is to accurately portray a fabric's tactile qualities. Both photography instructors and how-to books often suggest working with hard, skimming lights to bring out a subject's texture. But using a hard light in this way only works if you want to emphasize or exaggerate that texture. For example, you might want to show off the coarseness of stiff burlap. Common sense rules that you should use the quality of light that best matches the tactile qualities of the textile. Soft light obviously complements the smoothness of silk better than a spotlight.

Arranging the Fabric

The basis of photographer Meleda Wegner's lighting setup for textiles is a low light that rakes the subject to bring out its texture. To avoid hard-line shadows, she filters this light through a softbox in order to diffuse it. She uses white cards to further reduce the shadows, just to the point that there is detail in the shadows and depth is perceived, but the harsh contrast is removed.

If a fabric is designed to be hung, such as a window dressing, Wegner usually hangs it to shoot it. But she prefers to set most other textiles up on the floor or a low table. This way, she doesn't have to

Textile photography must meet several criteria. First, it must show how the fabric feels. Is it soft? Coarse? Textured? Second, it must reproduce colors with critical accuracy because textile buyers are concerned with even slight differences in color casts. And third, since this type of photography is generally used in catalogs to sell the textiles, the photographs must be visually appealing and not just look like two-dimensional swatches of cloth.

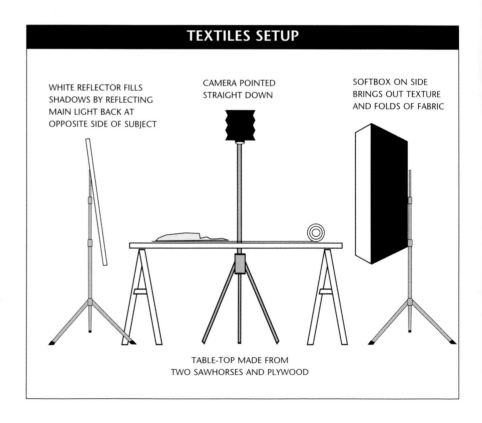

TEXTILES SETUP

WHITE REFLECTOR FILLS SHADOWS BY REFLECTING MAIN LIGHT BACK AT OPPOSITE SIDE OF SUBJECT

CAMERA POINTED STRAIGHT DOWN

SOFTBOX ON SIDE BRINGS OUT TEXTURE AND FOLDS OF FABRIC

TABLE-TOP MADE FROM TWO SAWHORSES AND PLYWOOD

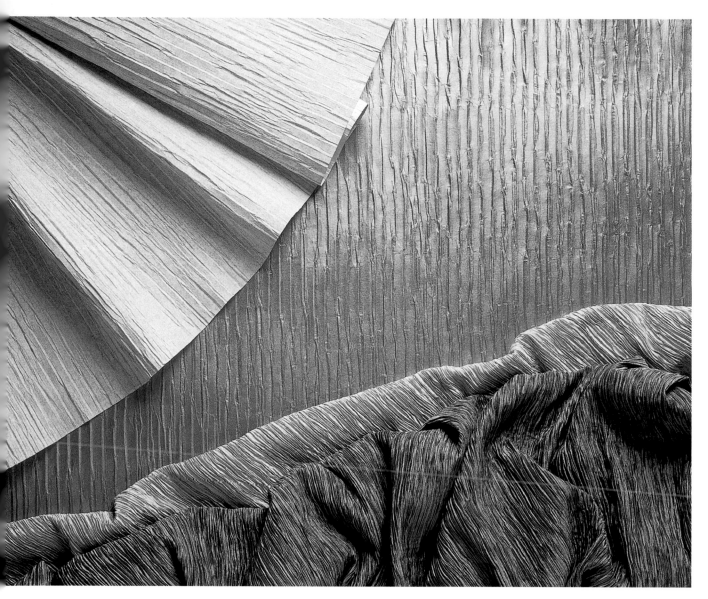

The draping of these fabrics might look natural, but a lot of time is spent creating the perfect folds. This includes placing items underneath the fabric and invisibly pinning it in place.

fight gravity and can design the folds and drapes that she wants.

To get the fabrics to take and keep the forms she decides on, Wegner uses quilt padding underneath it; this padding material is about 1/4-inch thick and is available at most fabric stores. Other times, she uses cardboard tubing and handcut styrofoam pieces. She then places these items underneath the fabric to force it to drape and fold exactly how she wants it to. When she achieves the ideal composition and a natural look, she secures the fabric invisibly into place with headless pins.

Wegner then shoots straight down or nearly straight down at her subject. This keeps the film plane of her camera roughly parallel to the fabric, thereby eliminating any image distortion of the pattern. (When she hangs the fabric, she shoots from a typical standing position, making her film plane parallel to the fabric and thereby eliminating distortion as well.) By keeping her set on the ground or a low table, she avoids having to climb a ladder to see into the camera and can eyeball the scene while setting up.

A large part of Wegner's job is propping and the artistic draping of the fabrics. One shot involved two complementary sheets of handmade papers (above). At other times, she uses fresh flowers or theme props, such as a bridal tiara for wedding-gown lace or a silver rattle for silk wallpaper for a nursery.

Color Correction

As mentioned earlier, color accuracy is paramount in most textile-photography applications. To achieve perfect color, start by setting up the lights, arranging the fabric, and running a test sheet or test roll of film. Next, compare the processed film on a color-correct lightbox to a swatch of the original fabric. Almost invariably, the film won't match the exact color of the cloth. Determine which color you need to add or subtract in order to make them match, and then begin adding the appropriate color compensating (CC) filters in order to correct it (see "Color-Compensating Filters" below). Make sure that the color shift isn't the blue shift caused by underexposure.

Color can be thrown off for several reasons. First, your light source might not be precisely matched to the film; the solution is to determine how far off the light is, and correct it by filtering your camera with CC filters or replacing your bulbs or flash tubes. Another possible reason is that non-neutral light is reflecting off the walls or other parts of the studio film. Here, the solution is either to paint these items white, or to "tent" your subject by blocking the walls with white flats or fabric.

Perhaps the whole photograph has shifted strongly toward blue. To correct this problem, make sure that you aren't underexposing the film. Also check that you're using flash with daylight-balanced film.

Another potential reason for inaccurate color is that the film is "bad" or from a different emulsion batch than you're used to. If this is a simple and minor color-cast problem, you can filter your camera to correct it. If it is a major problem or uncorrectable, throw out the film and start over.

You might also come across a processing lab that doesn't produce consistent results from one run to the next. This causes minute color-balance changes in your film. The only solution here is to switch labs.

Finally, the fabric might contain fluorescent or metallic dyes that don't record accurately on film regardless of filtration. The solution to this, the worst color-correction problem you'll encounter, is to get as close as you can to the right color and then use digital enhancement.

The color shift between these two otherwise identical pictures is subtle but potentially disastrous. One shot is unfiltered and doesn't accurately represent the rich fabric's true colors (right). The other image was filtered with color-compensating filters (far right).

Color-Compensating Filters

If your film has a weak, green cast, you can correct it by using a weak, magenta filter on the camera, such as a CC05M or CC10M. The higher CC number indicates the stronger filtration, so, for example, the CC10M filter is twice as strong as the CC05M filter. The most common CC filters are optical gels, which are designed to be used in front of or behind the camera lens.

If you've noticed that magenta and green are on opposite sides of the color wheel from each other, you've found the secret to color correction. Colors that are on opposite sides of the color wheel are called "complementary." So the opposite of green is magenta, the opposite of blue is yellow, and the opposite of red is cyan. In color photography, to correct a blue cast, use the complementary color, yellow. And to correct a yellow cast, use blue.

Determining exactly how much correction is necessary is something you can learn only with experimentation and practice. Suppose that you want to eliminate a weak cyan cast. You can try bracketing your CC filters and do a string of photographs, starting with CC05R and continuing to CC25R.

LIGHT PAINTING

INGREDIENTS

- Still-life props
- 1 Camera secured on a heavy-duty tripod or studio stand
- An inexpensive flashlight from a hardware store
- Cinefoil to make a snoot for the flashlight
- Flash, optional
- Blue gels for the flash unit
- A white card or white ceiling to bounce light off
- 1 Polaroid camera back and Polaroid film for instant test prints

Painting with light isn't a new technique. Before the availability of high-powered flash units and the slaves that linked them, this technique was the standard for lighting a large, interior scene, such as a dark-domed ballroom. The photographer would set up the camera, lock open the shutter, and, in the dark, carry a light around and literally paint the scene with broad strokes, guessing at the exposure. Depending on the size of the room and the strength of the light, exposures could take half an hour or longer.

If the photographers dressed in black and moved quickly around the room, they wouldn't record on film—unless they accidentally shone the light on themselves or silhouetted themselves against the light. The event was also a failure if the photographers accidentally pointed the lamp toward the camera since the bare bulb would record instantly and possibly cause flare.

Several years ago, studio photographers rediscovered the method and reduced it to a small scale for interesting effects. By using small, handheld lights, the photographers were able to move around a still life and light it from different angles for unusual, strangely appealing effects.

Light-Painting Devices

Painting with light was made popular in studio photography by Aaron Jones, who sells a great item called the Hosemaster. This expensive, fiber-optic lighting system makes painting with light easy because of its flexible hose, adjustable output, and light-modifying nozzles—but it isn't a necessity. In fact,

photographer Alan Farkas often employs the technique with inexpensive flashlights from a hardware store. He then snoots them with Cinefoil in order to create the shape he desires.

When using any light-painting device, you need to remember that the key to success is experimentation and testing. You can get some idea of the results by using Polaroid test prints on a camera with a Polaroid back. But reciprocity-law failure will affect your results. This is because the relationship between the shutter speed and the aperture to proper exposure starts changing when you get into long exposures; this, in turn, results in underexposed photographs if you follow your meter readings. So only real film testing and a good sense of timing will ensure success.

Alan Farkas used an inexpensive flashlight to "paint" this image with light, along with illumination from a flash unit.

Adding Flash

Farkas has modified the traditional painting-with-light system to combine it with flash. In essence, he makes two photographs on one sheet of film—if you view the flash illumination as one and the painting with light as the other. He also uses a simple, inexpensive flashlight as his painting source, rather than a Hosemaster or other fancy equipment.

For example, his still life of a tin can mixed three flash units with light from a flashlight in what was effectively a combination of three exposures (opposite). The first exposure combined a small softbox placed high over the scene and a skimming backlight that caught the edge of the can on the right. The second exposure was the illuminated background shot with a heavy diffusion filter over the camera and no other lights; as a result, only what the background light illuminated was diffused. While Farkas painted the scene with light, he made the third exposure, which was long. Using a $2 flashlight snooted with black Cinefoil to create a very small circle of light, he painted the inside of the cans on the left and the sides of the main can.

In another example, Farkas created a still life out of two flowers and the gear and spring from an old clothes ringer (below). Once again, he combined flash illumination with a flashlight. He gave the flowers and slate exposure from a flash unit pointed at a white ceiling and gelled blue. Then he added another flash to increase the light on the bottom right. To paint with light, Farkas used a flashlight snooted with Cinefoil. The resulting warm-yellow light is visible on the flowers. He also used the flashlight from a low position in order to skim the slate and bring out its texture.

Here, Farkas mixed the warm-toned light from a flashlight with a blue-gelled flash.

Rephotographing Polaroid Negatives

For a shot of a fork, Farkas's interesting method utilized a double exposure on one sheet of film. Via a masking technique, he first photographed the fork in a high-key (white on white) manner against a white background with Polaroid Type 55 Positive/Negative film. He tossed the instant print and processed the negative. Next, he placed the fork negative on a lightbox to illuminate it from behind, and rephotographed it with a 4 x 5 view camera.

Farkas created a second setup with four rusty, old railroad spikes (below). To overlap where the fork image would be on the double exposure, he placed a rectangle of blackout material in the middle of the setup. He lit the spikes with a flash and a flashlight that had been modified with a snoot made from Cinefoil. Since the film was carefully masked during the two exposures, the final image appears seamless.

Alternately, Farkas could have put together this image on a computer. However, as of this writing, the quality of a film original and the money saved by avoiding computer imaging time still makes in-camera masking and multiple camera shoots quite cost effective and a desired photographic specialty.

Polaroid Techniques

Several Polaroid manipulations have become the vogue in recent years. The first was Polaroid transfers, in which the developing chemical dye pack is carefully transferred onto wet watercolor paper. The result is a print that evokes the feeling of a watercolor painting. And since the result is on watercolor paper, many photographers add watercolor paints, acrylics, colored pencils, or even gold leafing to further manipulate the image. The most recent trend involves emulsion transfers. Here, you slide the emulsion on the Polaroid print off the instant paper and onto other surfaces, such as watercolor papers or cloth. In the process, you can stretch, distort, or wrinkle it.

(Since you can use these techniques with any lighting, I don't cover them in detail here. For full, how-to instructions, contact the Polaroid Corporation and request its instructional booklets—see page 143.)

This image was made with a two-camera setup and careful masking. The center image is actually a Polaroid negative of a fork, rephotographed on a lightbox. The outer image was taken by illuminating rusty railroad spikes with a flashlight.

Part Five
SPECIALIZED TECHNIQUES

7HE LIGHTING METHODS that follow constitute a variety of techniques. They involve specific setups for specific ends. For example, designing lighting setups for architectural interiors could stand as a whole chapter (or book) in its own right; however, the information presented here provides you with a solid grounding in this interesting career choice. Similarly, animal photography can be either a career specialty by itself or an adjunct to a thriving portraiture-, editorial-, or advertising-photography career.

Micro lighting is used to photograph miniature worlds, whether you're shooting a "portrait" of a doll or using realistic outdoor lighting for an architectural model. And painterly still lifes and slow flash sync are general techniques that you can employ with equal success in portrait, glamour, corporate, and still-life photography.

ARCHITECTURAL INTERIORS

Shooting architectural interiors is one of the most specialized types of photography. It requires a combination of photographic technical knowledge and a sense of interior decoration and lighting flair. You also need to have a willingness to work strange hours. First, you must often photograph an architect or interior designer's work when the building is empty, which is often in the middle of the night. This arrangement enables you to hide lights around the room, rearrange furniture, and take the several hours you need to set up and shoot without being disturbed. Second, if the room has a lot of windows, you can start fresh and light the room yourself, rather than waiting for the sun to do it for you. And if the room has banks of ugly, fluorescent lights, you can switch them off and set up the lights you want.

INGREDIENTS

- 1 4 x 5 View camera or lens with swings and tilts
- Flash units and/or quartz lights
- 50-watt quartz light bulbs and flat-base lightstands
- Household bulbs in different wattages to replace lamp bulbs
- An assortment of light-stands (at least 5) and clamps (at least 10)
- Gels to color the lights creatively
- A color-temperature meter to determine film type and filtration
- Filters to balance the lighting to the film in use
- Scrims and diffusers
- Gaffer's tape to hold down and hide wires
- A room with or without windows

The unusual part of this shot was the outdoor lighting. Robert Thien created this by shining a red-gelled quartz light through the thick glass wall. Three other quartz lights illuminated the interior. Two small spotlights illuminated the speakers above the television. Finally, Thien changed the bulbs in the two lamps to 40-watt tungsten bulbs, and left the lamps on during the exposure. He shot this room, which was designed by Stevens & Wilkinson, on tungsten film.

The View-Camera Setup

Architectural photographers invariably rely on view cameras because of the swing, tilt, and shift options they offer. A few 35mm and medium-format cameras and lenses provide limited swing, tilt, and shift actions that you can use in a pinch, but for full capability, nothing beats a 4 x 5 or 8 x 10 view camera.

The swing and tilt capabilities of a view camera permit you to move the lens in relation to the film plane, and vice versa. By utilizing them, you can change the plane of focus, alter the actual shape of the image, and determine whether the lines of the subject will or won't converge. Swings and tilts come in handy in architectural photography because you're often shooting in tiny rooms, with the wide-angle lenses on your camera pointing up or down. Using swings and tilts helps you eliminate the telltale wide-angle convergence of lines, thereby making the scene look "normal" or larger than it actually is.

Shift movements further help out architectural photographers because they "move" the image on the film without your having to tilt the camera up or down, which causes distortion. For example, to include the top of a building with a conventional camera, you need to point it upward; this causes the lines to converge. But with a view camera, you simply shift the lens in relation to the filmback, and the top of the building will appear on the film.

For this shot of a dinner-party setting, the photographer used just two quartz lights. One provides the backlighting on the lamp and crystal; the other provides fill. Shot on tungsten film, the outside world appears even bluer than normal because the picture was made on a rainy, winter day at dusk. Susan Steinberg supplied the catering.

Color Temperature

Technical wizardry comes into play through an understanding of color temperature. Different types of lights have different color temperatures, which result in their appearing as different colors on film. For example, in relation to each other, fluorescent lights look green, tungsten and quartz lights look yellow, and flash and daylight look blue. To further complicate this, different manufacturers' bulbs often have different color temperatures. And as the bulbs age, their color changes even more.

Tungsten-balanced films make quartz lights appear fairly normal on film, although photographer Robert Thien still places a 10B Wratten gel filter on his camera lens in such situations. (Careful testing led him to realize that the combination of his lights, his lens, the lab he uses, and his preferred film yields results that are generally slightly yellow, which he corrects with the 10B filter.) Daylight-balanced films make flash and midday sunlight appear normal. Thien, however, uses a 5M filter when shooting with his Broncolor Impact monolight flash units.

Complications arise when you have several different light sources in one interior setting. Simply selecting a film type (tungsten or daylight) will get you started for either the tungsten and quartz combination, or the flash and daylight pairing. But what if the scene contains additional types of lighting? Here, you'll have to start filtering the lights, changing bulbs, rewiring the lamps for flash, or shooting double exposures.

Be aware, though, that nothing truly eliminates the ugly, green cast of fluorescent lights, except turning them off. Filtering this light with a pink fluorescent filter or a 30M filter helps reduce it, but it isn't perfect because of the physical characteristics, or *spiking*, of the light output. If Thien needs the fluorescent lights in the picture, he makes a double exposure. First, he turns off the other lights and the fluorescents; for the second exposure, he uses only the fluorescents and a 20M filter.

When windows are involved, architectural photography can become a waiting game. You have to wait until the outside light is the color, brightness, and direction you desire in comparison to the interior lighting you've set up.

For this shot of a store interior, the photographer made a double exposure on tungsten film, the first for the fluorescent lighting, and the second for the six quartz lights he added and the existing neon lights. The Greenwood Design Group designed the room.

Shooting an interesting assignment for *Atlanta Homes* magazine, photographer Robert Thien worked with four interior designers to decorate an empty room. Designer Franya Waide, A.S.I.D., created this living room with $50,000. For each of the photographs, Thien imitated window light coming from an unseen window to the right. One monolight flash with a 40-degree grid spot lit the furniture. A second monolight flash with a 30-degree grid spot illuminated the fireplace.

The Tungsten Method

Thien has a favorite method for shooting architectural interiors that is both simple and inexpensive. It utilizes tungsten films and ordinary household light bulbs. The beauty of tungsten-balanced film is it makes standard quartz lights appear relatively correct on film, while daylight from windows turns a deep, vibrant blue. This phenomenon results in a cozy feeling. The room is warm toned, and the outdoors is cold and blue.

Taking this approach to extremes, Thien often waits to shoot until the magic hour just before dawn or after sunset when the light turns an exceptional shade of blue. This color is especially striking when it is recorded on tungsten-balanced film. If the photographer decides that he doesn't want a blue exterior, he simply covers the outside of the windows with huge sheets of orange conversion-filter material. This technique, which was developed by Hollywood studios, filters the light coming through the window, so that the film no longer sees it as blue, but rather it looks neutral and more natural—as if you shot the scene with daylight-balanced film.

With the tungsten-film method, Thien first turns off all fluorescent lights in the scene. Then he decides which lamps, sconces, or chandelier lights he wants on, and makes sure that they are tungsten sources. If he isn't certain of their color balance, he checks them with a color meter or switches them with bulbs that he has brought along. If a lamp has a dimmer, he puts the lamp on low or switches to 40-watt bulbs. This prevents the lights from overpowering the scene; they merely give off a pleasing glow.

Next, Thien decides where the main light should go. This is usually a 500-watt quartz broad light with barndoors. For fill, he often uses another of these lights with a scrim or diffuser in order to cut the output by one or two stops. Sometimes he uses a weaker, 50-watt quartz bulb, which costs about $7, for fill. Around the room, as needed, he then hides small quartz lights on flat-base, up-light stand fixtures, which cost about $15. Finally, before shooting, Thien checks that all his wires, stands, and fixtures are hidden from the camera's view. Using gaffer's tape and clamps, he tucks the wires under rugs or attaches them to the back of the furniture.

Here, the photographer wanted to utilize the apartment's track-lighting setup. So he merely slid the lights along the tracks to redesign the lighting for the photograph including aiming the lights at the flower at left, the sculpture at right, the bookcases and plates, the television cove, and the table in the foreground. Then he added one quartz broad light to illuminate the couches and the main interior. Then he turned on the television, dimmed its output, and switched to a blank channel. He used tungsten film. Brito Design created this room.

Daylight Films and Flash

The only major difference between using the tungsten method and working with flash is how Thien treats daylight and lamps. With daylight film, the light from the flash appears normal, as does sunlight. If a window is involved, he must make the window light equal to or half a stop brighter than the flash illumination.

In order to do this, he can vary the power of the flash units, vary the aperture, or wait for the daylight to become brighter or darker.

Lamps, chandeliers, and candles appear exceptionally yellow, or warm toned, on daylight film. This is usually beneficial because it adds a warm, cozy feeling to pictures. But when Thien doesn't want this effect, he can switch the bulbs to 5500K daylight-balanced bulbs, rewire the fixture for flash, or make a double exposure. For the double exposure, he illuminates one exposure with only these lamps and fits the camera with a conversion filter.

The fish-tank image was quite unusual (left). Thien started by placing a monolight flash at a high angle above the tank. This light illuminated the fish and the rock. Next, he created a tent out of black plastic. This completely encased him, the camera, and the front and two sides of the tank, thereby eliminating extraneous reflections off the glass.

From previous experiences, Thien knew that glass isn't really clear, but has a green and cyan tint. So to reduce the color cast from the tank on the film, he filtered the camera with a 10R filter (to compensate for the cyan) and 5M (to compensate for the green) filter.

Next, to enable the distant office scene to record on film, he chose a slow, 1/2 sec. shutter speed instead of the flash sync speed. This shutter speed is also apparent in the slight blurring of the fish. The rocks, however, look sharp because neither they nor the tripod-mounted camera moved during the exposure. The next step, which was in some ways the most difficult, was waiting for the fish to get used to the black tent and swim into the center of the tank.

▲ For this shot of a fish tank, the photographer, the camera, and the front and two sides of the tank were covered in a huge, black-plastic "tent" to prevent reflections.

▶ Two flash monolights illuminate the interior of this Atlanta Symphony Decorator Showhouse. Shooting daylight film, the photographer used a 1/2 sec. exposure to let the daylight shine through the windows at about half a stop over-exposed. The chandelier was on a dim power setting.

MICRO LIGHTING

If you are interested in creating only a straightforward product shot of a toy, architectural model, or some other miniature subject, you can utilize the product-shot techniques discussed earlier. If you want to make these miniaturizations look real and not like toys or tiny models, you need to get small, both figuratively and literally. Your first task is to decide which lighting you would use on your tiny subject if it were, in fact, life-size. For example, an architectural model would obviously be illuminated by sunlight. But a doll could be lit any way—sunlight, classic-glamour lighting, stage lighting, whatever.

Dolls

Once you've decided on the type of lighting, you need to scale it down to the size of your model. A Barbie doll, for instance, is about 1/6th life-size. Therefore, a realistic stage spotlight for this kind of miniature subject couldn't be actual stage lighting (unless you were able to move it six times farther away than you would use on a life-size Barbie). Since the size of the light source in comparison to the subject affects the quality of light, you must effectively shrink the lights to doll size in order to identically mimic real-life lighting.

For this reason, photographer Bobbi Lane decided to use micro lights to photograph a set of dolls in real-life situations (below). Micro (and macro) lights come in a variety of types and can often be rented from professional camera stores. Some are small quartz lights that look like miniature stage lights. Others, such as the Novoflex MAKL 150, use fiber optics to guide flash illumination through small, focusing lenses. This system even has modeling lights for previewing the scene, a choice of three lens attachments, and six colored filters. The flexible fiber-optic cords enable you to position the lights around the subject in a way that isn't much different from that used for full-size sets. Glamour was the key to the Barbie shoot, so Lane mimicked stage lighting via miniature spotlights. A stage backdrop was painted and then placed behind the toy figures.

Micro lights are the key to "real-world" photographs of dolls and architectural models because the lights are to scale.

Architectural Models

Some architectural models and railroad train sets are large enough to take up a conference-room table. But compared to the actual buildings and/or landscape they represent, they are indeed tiny. The easiest way to shoot these subjects is to imitate a slightly overcast day. This type of light creates shadows with soft edges, just enough both to define shapes and provide scale, but not so hard that they take away from the lines of the building.

Since an overcast sky is basically a huge, diffused softbox, you need to create the same effect over the model. If you own a large softbox, you are in luck. Another alternative is to stack several small lightboxes next to each other to create one large light source.

Another option is to string up white tenting or diffusion material like a canopy, and then shine a light through it. Less perfect options include bouncing the light off the ceiling. But if the ceiling isn't perfectly white, you'll need to filter your camera to avoid an unwanted color cast on the final film. Where necessary, you can use large and small, white cards to add fill light.

Regardless of which of these systems you use, the final result should look like only one light source, since there is only one sun. And if the modelmaker has included working model streetlights, interior building lights, or train headlights, you can use a long exposure—even if you're using flash—to allow these lights to record on film.

To achieve the best possible results, studio photographers should light architectural models and railroad train sets with one light that imitates the sun, whether or not a cloudy-day effect is desired.

PAINTERLY STILL LIFES

Photographer Alan Farkas loves to experiment with new techniques, many of which are covered in this book. He developed this still-life method by drawing on past darkroom experiences when he used texture masks to add a painterly feel to photographs. Instead of adding this texture in the printing stage, he decided to incorporate it directly into his black-and-white negative film by masking his camera. He then added to the painterly feel by printing the negatives on color paper, and adjusting the color to produce a pleasant sepia tone.

The Basic Approach

The method is simple. First, Farkas makes a blank film sheet by processing a piece of unexposed 4 x 5 black-and-white film. The result is a clear sheet that is thicker than most acetate. Next, he makes the mask by spraying the cleared film with a drizzle of spray paint. During his experimentation, he tried heavy coats and light coats. The best result looked like a random dot, evenly spread across the film.

To achieve this, Farkas had to lay out a wide swatch of newspaper, with the film in the center. Then, from a distance, he covered the newspaper with paint using broad, light, even strokes. Since the smoothest part of his stroke was in the center, he made sure to place the film there.

Although Farkas chose to create his own masks, commercial masks are available from professional camera stores. These masks are designed to be used either near the film plane on view cameras, or in front of the lens on all types of cameras.

While the paint was drying, he set up the lighting for the photograph of the calculator paper. He partially unrolled the paper and taped it onto boom arms to keep it in place. The lighting was a single spot overhead. The paper created its own fill light.

Before shooting any film, Farkas placed the painted film mask inside the back of his 4 x 5 camera, attaching it about half an inch in front of the film plane with black tape. Next, he shot the image on black-and-white negative film. To achieve the warm color, he printed the black-and-white negative on color paper with a sepia-tone filter dialed in. The grainy, painterly texture was a direct result of the mask.

Calculator paper illuminated by an overhead spotlight is an elegant-looking subject. The paper serves as its own reflector to create fill light.

Variations

Using the same masking technique, Farkas created an image that transformed the calculator paper into party streamers (right). To achieve this look, Farkas pulled the camera back from the set and added a sculptural creamer that he lit with an overhead snooted spot. Light from the spot also hit a small, silver reflector, which threw hard light back onto the creamer from the camera's left side. He then let the calculator paper go fairly black, illuminating it with only the fill reflecting off the creamer and the seamless.

This painterly technique is also appropriate for human subjects, as well as still lifes and nature images—so long as the composition is strong. Nude subjects seem well suited for this artistic rendition, as Farkas proves in his nude study (below). Wanting to work with simple lighting, he used only a medium softbox on the left side of the camera. He also placed a small light on the background to separate the dark side of the model's body (on the right) and the background.

In this shot, the photographer lit the sculptured creamer from above. A small silver reflector throws fill light back at the left side. The calculator paper provides visual balance to the overall composition.

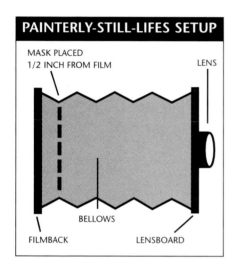

PAINTERLY-STILL-LIFES SETUP

MASK PLACED 1/2 INCH FROM FILM

LENS

BELLOWS

FILMBACK

LENSBOARD

To create this image, Alan Farkas placed a mask half an inch in front of the film plane on a 4 x 5 camera. The photographer made the mask by spraying paint on a clear piece of film.

PETS AND OTHER ANIMALS

Like people, pets can be lit countless different ways, depending on your desired end result. However, the method discussed here is a proven winner that produces great results in a variety of situations.

Setting Up

A good technique is to place a platform for the pet on a backdrop (opposite). The platform must be comfortable for and appealing to the animal. For example, the decorative stone column was cold and therefore attractive to a cat in the summertime.

For a puppy, a better platform might be a blanket or a large, beanbag-style dog pillow. And for an iguana, it would be its hot rock. If you use a hot rock, try to hide or disguise the electrical cord by taping it out of sight, cutting a hole through the backdrop, or placing it under something.

Next, you should turn your attention to the lighting design. The basis of this pet-photography lighting setup is flexibility. The use of a broad light source means that the exact position of the subject isn't critical. So you can get great results, even if your subject refuses to sit still.

First, you position a large, diffused light source, such as a 4 x 4-foot softbox, to one side of the camera, so that it is at an even height or slightly above the pet's head level. Next, place a large, white card or set of "bookends" on the opposite side of the camera in order to kick fill light back into the shadows on the subject. This soft lighting will make the fur or feathers

Pets and animals hold a special place in the hearts of many people. If you aren't convinced, walk down the pet-food aisle of any grocery store, and you'll be astounded at the choices of food and toys available. You can also look at the number of dogs and cats that show up in advertisements or on television shows.

Pet photography can take the form of portraiture, for the home market; advertising, for selling pet products or services; editorial, for magazine articles; or general stock, for calendars or greeting cards or for illustrating such concepts as loyalty, puppy love, or childhood.

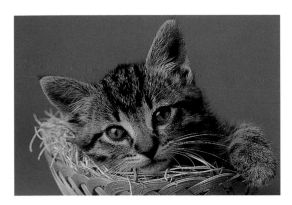

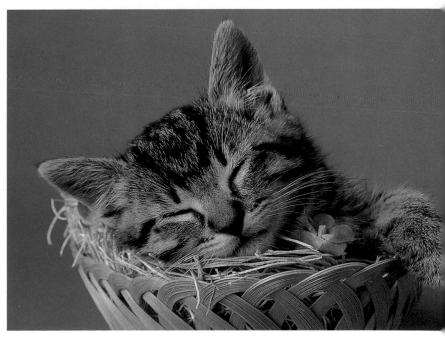

In an animal portrait, open eyes are cute (above). But by waiting quietly and patiently, the photographer ended up with an even more salable picture of this snoozing kitten (right). It is much less of a portrait because the closed eyes give you less insight into the cat's personality. The photograph does, however, succeed on a different level. It communicates the warm, cozy, and safe feelings associated with sleeping babies, human or feline.

appear soft rather than coarse, but still offer some definition of form.

Set up your lights and take your exposure readings before the pet arrives; do the best you can without seeing the subject. If you're using studio flash, operate it at maximum power to achieve the smallest aperture possible. Maximizing depth of field will help cover up focusing errors that might occur if the animal moves a lot during the shooting session.

If using a handheld incident meter, be sure to stand at the posing area and point the white hemisphere toward the main light. Then make sure that there is enough fill (one to two stops less light) by taking a meter reading with the dome hemisphere pointing at the fill card.

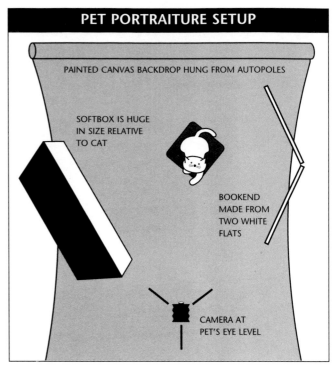

PET PORTRAITURE SETUP

PAINTED CANVAS BACKDROP HUNG FROM AUTOPOLES

SOFTBOX IS HUGE IN SIZE RELATIVE TO CAT

BOOKEND MADE FROM TWO WHITE FLATS

CAMERA AT PET'S EYE LEVEL

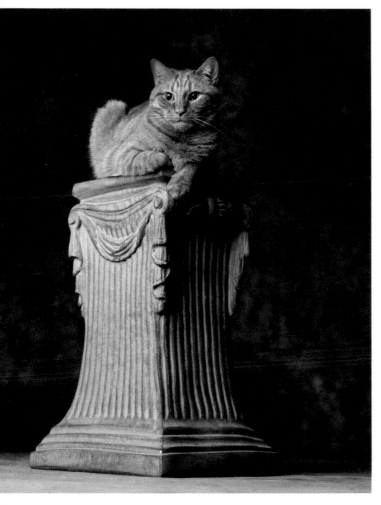

The photographer shot this image at the cat's eye level for an intimate portrait. The trick with cats is to make them feel comfortable. Because she was shooting during the summer, she placed her subject on a cool, marble column.

Selling Pet Portraiture

Pet owners tend to get attached to their animals, often treating them like members of the family. But not all portrait-photography studios offer pet portraiture as an option, perhaps because it is such a specialty and/or requires so much patience. Check with local portrait studios. Do they offer pet portraiture? If not, you may have found yourself an ideal marketing niche in your community.

Regardless of what competition you have, try being ingenious when it comes to promoting your services to local pet owners. Pet stores and veterinary offices often have community bulletin boards on which you can advertise your services. Another marketing possibility is to offer to supply free, framed pictures to decorate the veterinarian's waiting room. Of course, you should put a small tagline on each picture with your business name and telephone number. If the pet owners like what they see, you are likely to get some business.

Another great way to establish direct contact with pet owners is through local enthusiasts' or breeders' clubs. If the organizations have newsletters, it might be inexpensive and cost-effective to advertise your services in it. Similarly, local pet and sporting animal shows might charge you only a nominal fee to set up a booth at their event—especially if you donate contest prizes.

Working with Animals

A zoom lens will enable you to quickly recompose if the animal moves during the session. Longer lenses, such as an 85-180mm zoom lens for a 35mm camera, let you shoot from a distance away, so you aren't as likely to disturb the pet. Select the longest lens you can before you run out of studio space. Since you'll be far away from your subject, you'll need to rely on an assistant or the pet owner to stop the pet if it tries to leave (see below).

For small animals, like a mouse, use a macro or close-focusing lens. A 200mm lens that has close-focusing capability lets you take a frame-filling photograph of these little subjects without being right on top of them. This option also comes in handy when you photograph, for example, a disagreeable or skittish reptile.

Some animals are afraid of flash units. Surprisingly enough, it isn't the light flash that startles most of them, but the popping noise that the power surge and strong studio-style flash units make. If the flash upsets your subject, you might want to switch to tungsten or quartz-halogen lights, both of which are often referred to as hot lights.

The downside is that these lights are usually less powerful than flash. As such, they require slower shutter speeds, which can result in blurred images, or wider apertures, which can result in out-of-focus portions of the image. And as their name suggests, tungsten and quartz-halogen lights are also quite hot and make the studio warm very quickly. This can work in your favor in the wintertime, when cats and other creatures love to bask in the "sun."

If possible, have the animal's owner or your assistant nearby to help calm and control it. Ideally, this person will stand behind you, so the animal will look toward the camera. But if necessary, the person might have to stand next to the animal, just out of camera view, in order to keep it under control or to prevent it from falling or jumping down. In these situations, keep a noisemaker or a favorite toy in your hand, so that you can attract the subject's attention away from the handler.

But the most important requirement for pet portraiture is patience: patience to calm the animal, patience to wait for the behavior or expression you want, and patience to take numerous breaks during which the animal is removed from the set and then returned. Good animal photography also relies heavily on animal psychology. If you aren't familiar with the way a particular species or breed reacts, be sure to read up on the animal before the shoot or carefully interview the owner.

Well-trained dogs are the simplest subjects to photograph. When the owner commands the pet to stay, it does. Chances are, though, that you won't be this lucky all the time. So you should plan to take numerous breaks with less-than-well-trained dogs. When their attention wanders and they become restless, walk them around the studio or even outside, and then start over. For cats, it is important to make them feel at home on their perch. Start by feeding them treats on the shooting platform. Then have the owner comfort them.

Good pictures of puppies and kittens involve even more patience and film. As the subject wanders during the shoot, keep repositioning it where you want it. Eventually, that moment of perfect composition and expression will occur.

The photographer chose ribbons to distract this kitten, as well as to add a cute and colorful compositional element. When she was ready to shoot, she made an intriguing noise from above the camera to draw the cat's eyes up.

SLOW FLASH SYNC

Slow flash sync is a technique most commonly applied to photographing people. You can, however, use it just as easily for product photography, assuming that either the subject or the camera moves. To understand how slow sync works, you must understand the nature of flash photography.

A flash, assuming it is powerful enough, freezes your subject at about 1/500 to 1/10,000 sec., or even faster. But most cameras can't react quickly enough to offer shutter speeds in this range. With focal-plane shutters, such as those found in most 35mm SLR cameras, the shutter simply can't move quickly enough across the film plane in order to be open all the way for 1/10,000 sec. That is why most cameras offer a flash sync speed of only 1/250 sec. or even 1/60 sec. As you know from available-light photography, shutter speeds from 1 second or longer to 1/8000 sec. are available for many cameras, and only the brightness of the situation and the speed of your film prevent you from using virtually any of them.

Ambient Exposures

When shooting in ambient light, you can take a 30-minute exposure of a subject if the lighting is dim; the aperture is small, such as $f/22$; the film is slow; and you add ND filters. But even if you hold your camera dead still, your subject would move—if only to breathe. In fact, it wasn't that many generations ago, in the early days of photography and the daguerreotype, that a standard piece of portrait-photography gear was a head clamp. This kept the subject's head still during exposures that often crept into the 30-minute range.

Half an hour is extreme, but even at 1/30 sec. you'll get some blurring in most pictures of people doing anything but holding still. Slow flash sync takes advantage of this fact by intentionally blurring the picture.

In this shot, a slow sync speed enabled the window lights to shine through. And since the swimmer moved only slightly during the exposure, only a faint black halo is visible on her left side (as seen from the camera).

Flash Exposures

In the studio or in the field, you can use on-camera and large, studio flash units to freeze your subject. You simply must shoot at the shutter speed that is equal to or longer than the flash sync speed. If you decide to use a slower shutter speed than the sync speed, you'll get different results.

The quickest change you'll see with slow shutter speeds is the elimination of the black-background syndrome typical of indoor-party snapshots. The flash illuminates the subject but isn't bright enough to light the background. But with a slow shutter speed, you give the film the chance to record the ambient room lights of the background as well. So, if both the subject and camera are still, the final image will look more normal.

Flash-Blur

The real difference and creative spark starts when you intentionally ask the model to move, move the still-life subject, or move the camera. You can also combine these three possibilities. You'll then get a frozen image on film from the flash, superimposed with a blurred ambient-light exposure.

For the shot of a man on a hobby horse (actually a hobby giraffe), photographer Alan Farkas used a shutter speed of about 1/4 sec. and a powerful flash unit (below). Together, the strong modeling light on the flash and a second tungsten hot light on the background were able to record the blurring during this time, while the flash itself froze an instant in time. Since the model was moving while he bounced on the hobby giraffe, Farkas could have mounted the camera on a tripod to obtain a perfectly sharp background. This way, it wouldn't move in relation to the background. This would leave the model and hobby giraffe as the only elements moving—and, therefore, blurred—during the exposure. But he preferred to have the stationary background appear blurred as well. So he handheld the camera and exaggerated its movement during the long exposure.

Ghosting

The ghosting quality of a black halo or "melting" subject is typical of this technique, especially if the flash and ambient light come from different directions. In the case of on-camera flash, the direction of the flash is frontlighting. But your subject might move during the exposure, thereby enabling a silhouette (black) or strong lighting (any color) to shine through and overpower where the flash illumination was on the film.

To understand this, you must think of it as two separate photographs on one piece of film, even though they may be taken at the exact same time. The "first photograph" is the flash, which instantly freezes the subject on the film. The "second photograph" is the image created as the lower-powered ambient lights record the subject. Note that if the subject or the camera moves during the exposure, this portion of the

Think of this photograph as two pictures taken simultaneously. In the first shot, the photographer used a flash to freeze the cowboy on the film. In the second picture, the photographer used a long exposure to silhouette the subject against the background. If the cowboy had stayed perfectly still during the exposure, this picture would look "normal" because the two pictures would match up identically. But since he was wildly riding a bouncing hobby horse, ghosting occurred. This can be seen in the arms. Everywhere that the body moved and let the background shine through, the flash image was superimposed with the background and looked like it was dissolving. Everywhere the body blocked the background (and silhouetted it) during the lengthy exposure, the flash portion appears fine.

141

picture will be blurred. And if this light comes from behind, it will create a black silhouette of the subject.

Now put these all together on slide film. The shadow areas on the subject in the flash photograph might appear to melt into the background if the lit background now overlaps it on the film. This is because in the "second" picture, the subject or camera has moved in relation to the "first" picture. If a silhouette is produced during the "second" image but doesn't quite match to the flash image, you'll see a black halo where they no longer overlap.

The head-and-shoulders portrait shown here is a good example of ghosting (opposite). It is hard to believe that this picture was made with a point-and-shoot compact camera on an amusement park ride. Since I was in the same car on the ride as the subject, the camera and I didn't move in relation to him. However, the world around us went by in a blur of flashing colors that recorded on the film behind him. If my subject had kept his head perfectly still in relation to me, no ghosting would have occurred because he would have blocked all the ambient light behind him. But he moved his head to the left (as seen from camera position), thereby enabling the ambient light to superimpose itself over the flash picture on the right-hand side of his face.

In photographer Alan Farkas's carousel picture, the subject was moving past him at a high speed (below). Farkas made this shot on location using a huge softbox with another softbox beneath it, making one

giant light source. The flash froze the horse head, while a shutter speed of 1/15 sec. recorded the spinning background lights.

Then to both reduce the amount of ghosting around the horse and increase the background blur, Farkas panned the camera during the exposure. At the same time, he tried to keep the horse head centered in the viewfinder. He enhanced the distortion by using a 24mm wide-angle lens on his 35mm camera and moving in close to the subject.

Rear-Curtain Sync

One special note about slow sync flash because the number of rear-sync accessory flashes for 35mm and studio-style flashes is increasing. These units enable you to fire the flash at either the beginning or the end of a slow exposure. If your subject is stationary, this isn't important.

But what if your subject is moving forward? On film, it will look like it is going backward unless you use rear-curtain flash. In the "old days," photographers had to actually drive cars backward or ask models to walk backward to make them look right on film. Now all you have to do is flip a switch on some flash units.

Here, the large softboxes froze the horse with flash illumination. A long exposure enabled the background lights to record as a blur as the carousel moved. Ghosting surrounded the horse because the ambient lights were bright enough to record some of the horse as it moved.

LIST OF SUPPLIERS

Almost every major city in the United States and Canada has at least one professional photography shop that you can order specialized equipment from. And the back-page advertisements of photography magazines list countless other retail mail-order companies that you can purchase camera and lighting equipment, accessories, and film from. Two of the larger mail-order firms are Calumet Photographic Inc. and B&H Photo. Calumet has one of the best catalogs in the business, which includes detailed descriptions and photographs of many of its products. Other key suppliers of specialized equipment and services are listed below.

Camera and Lighting Equipment—Mail Order

B&H Photo
119 West 17th Street
New York, NY 10011
800-947-9943

Calumet Photographic Inc.
890 Supreme Drive
Bensenville, IL 60106
800-225-8638

Camera and Lighting Equipment—Rentals

Calumet Photographic, Inc.
Regional stores—call for locations
800-225-8638

Lens & Repro
33 West 17th Street
New York, NY 10011
212-675-1900

Photographic Rental Service (PRS)
931 North Highland Boulevard
Hollywood, CA 90038
213-467-1212

Samy's Camera
200 South La Brea
Los Angeles, CA 90036
213-938-2420

Camera and Lighting Equipment Repairs

Flash Clinic
9 East 19th Street
New York, NY 10003
212-673-4030

Professional Camera Repair
37 West 47th Street
New York, NY 10036
212-382-0550

Digital Services for Photographers

Duggal
9 West 20th Street
New York, NY 10011
212-242-7000

ZZYZX
949 North Highland Avenue
Los Angeles, CA 90038
213-856-5260

Dupes (6 x 9 Repro Quality)

Repro Images
243 Church Street, NW
Vienna, VA 22180
800-998-2606

Framing and Presentation Equipment

Light Impressions
439 Monroe Avenue
Rochester, NY 14603
800-828-6216

Props and Special Effects

Photographers' Specialized Services
650 Armor Road
Oconomowoc, WI 53066

The Set Shop
37 East 18th Street
New York, NY 10003
212-979-9790

Trengrove Products
60 West 20th Street
New York, NY 10010
212-255-2857

Used Equipment (Buy or Sell)

KEH Camera Brokers
188 14th Street NW
Atlanta, GA 30318
404-892-5522

Workshops

Bobbi Lane Photography Workshops
900 East First Street, Studio 105
Los Angeles, CA 90012
213-626-7807

INDEX